The Gourmand's Egg
A Collection of Stories and Recipes

The Gourmand's

Egg

A Collection of Stories and Recipes

TASCHEN

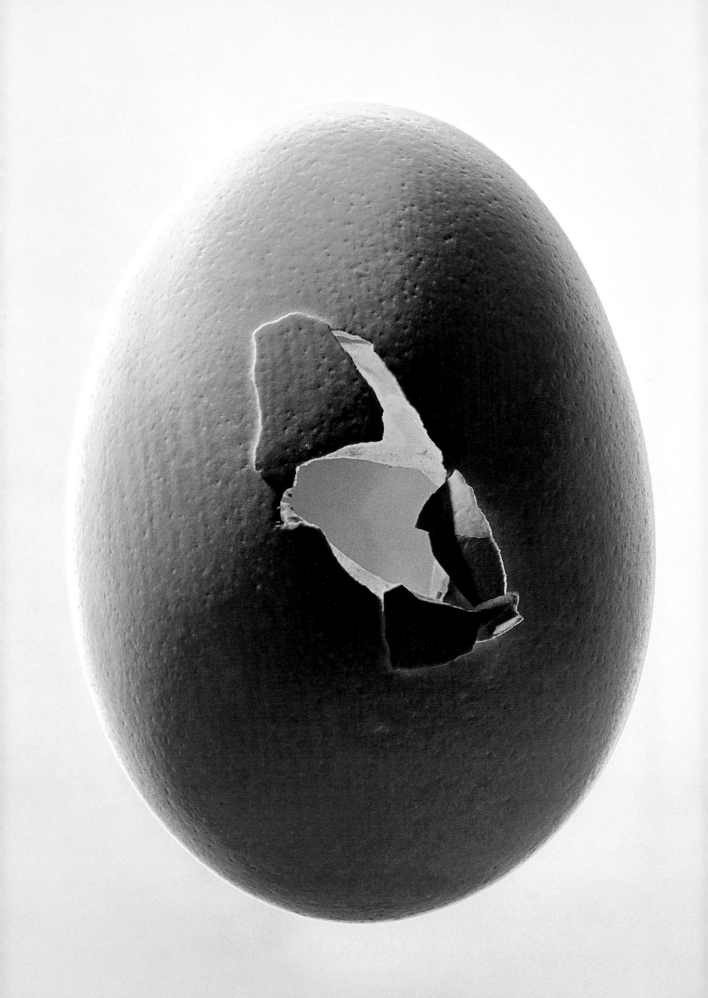

For Jacob & Frank

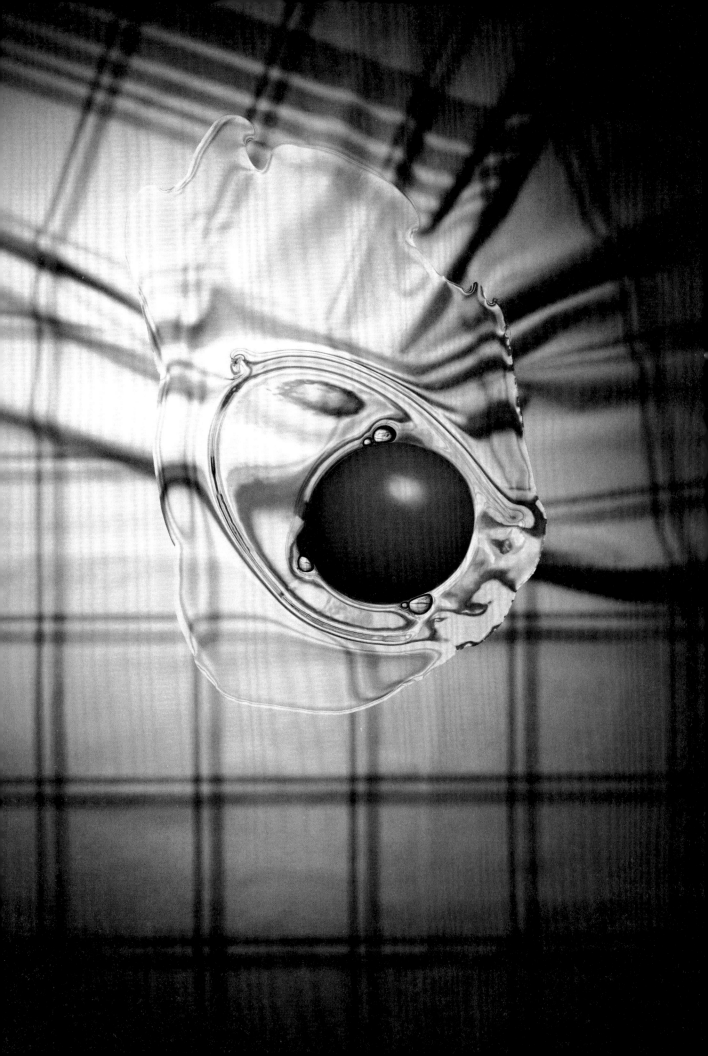

Contents

Stories

OPPOSITE **Kate Jackling**, *Unititled*, 2015,
set design **Gemma Tickle**
From *"The Angle of Incidence"*, *The Gourmand*, Issue 06, 2015

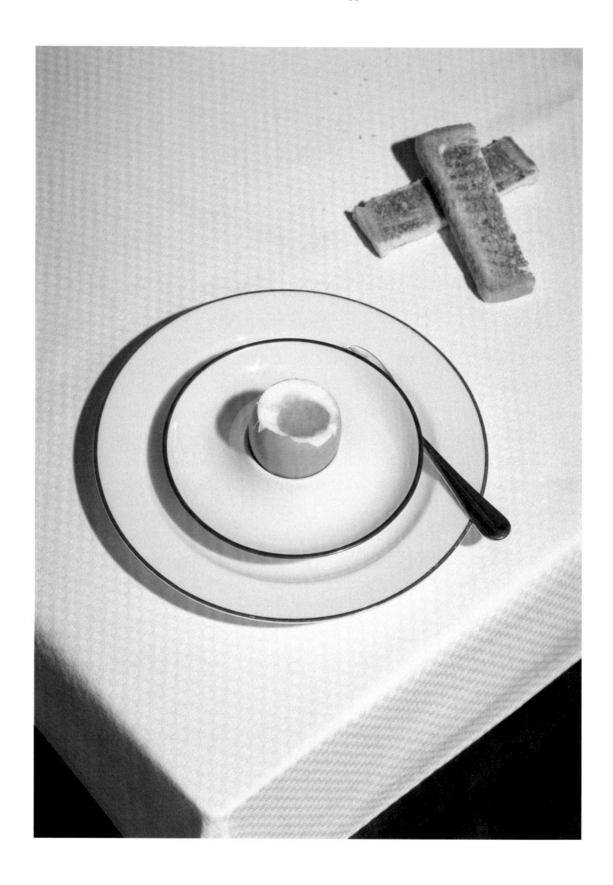

Matthieu Lavanchy
Soft Boiled Egg, 2021

Recipes

FOLLOWING **Bobby Doherty**, *Bug Egg*, 2018
PAGE XI **Gustav Almestål**, *Ägg*, 2017

Foreword

Fights, illness, drama…when things got bad my parents took us out to eat. Mom was convinced the trattoria around the corner could cure anything that ailed us. We'd walk in to find the owner parading around the dining room, rhythmically whipping up his signature zabaglione in a large copper bowl, and everyone's mood would instantly improve. The sound of that whisk hitting metal still echoes through my dreams: it is, to me, the sound of comfort.

Convinced that food was magic I decided to become a cook. I was seven. My very first attempt was zabaglione. I had never cracked an egg before, never separated yolks from whites, but I was mesmerised by the beauty of those sunny yellow orbs falling from the clear, thick whites. I enjoyed the hypnotic motion of the process. My mom had no whisks, no copper bowls, but I pulled a chair up to the stove, climbed on top and beat the yolks over simmering water with an old-fashioned eggbeater. I watched, fascinated, as the yolks foamed and blossomed, turning themselves into a delicious fluff.

Obsessed, I made zabaglione three nights in a row (indulgent parents), and then wondered what to do with all those forlorn egg whites. "Meringues", my mom suggested.

The ingredients were the same — eggs, sugar, heat and air — but the results could not have been more different. I was hooked. On a sudden whim I combined the two, piling soft zabaglione into stiff meringues. "Eggs in eggs", I announced as I served my chef d'oeuvre; the grown-ups were enchanted.

If these are the first dishes you ever cook, you are a very lucky person. Sadly, you soon discover that few recipes are equally exhilarating; compared with the alchemy of eggs, everything else is rather boring. I spent some time pursuing other recipes, and then decided to stick with eggs. By the age of eight I was the queen of custard. Then I discovered the sauces: mayonnaise, hollandaise and béarnaise flowed from my kitchen. I perfected angel food cake and omelettes and went on to tackle soufflés.

"They're supposed to be difficult", I wailed to my mother as my first effort went into the oven. I was disappointed: it had been so easy to prepare.

"Just wait." Mom knew that while they may not be as difficult as their reputation, you cannot underestimate the moment when you look in the oven to find your soufflé puffed up in all its regal glory.

In the end, of course, I moved on. Still, I have always been grateful that my cooking career began with eggs. I'm convinced it's the reason that, after almost 70 years, I still find comfort in cooking. As *The Gourmand* embarks on a series of books celebrating the culinary and cultural significance of single ingredients, they could not have chosen a better beginning. In cooking — as in almost everything else — it all starts with an egg.

Ruth Reichl

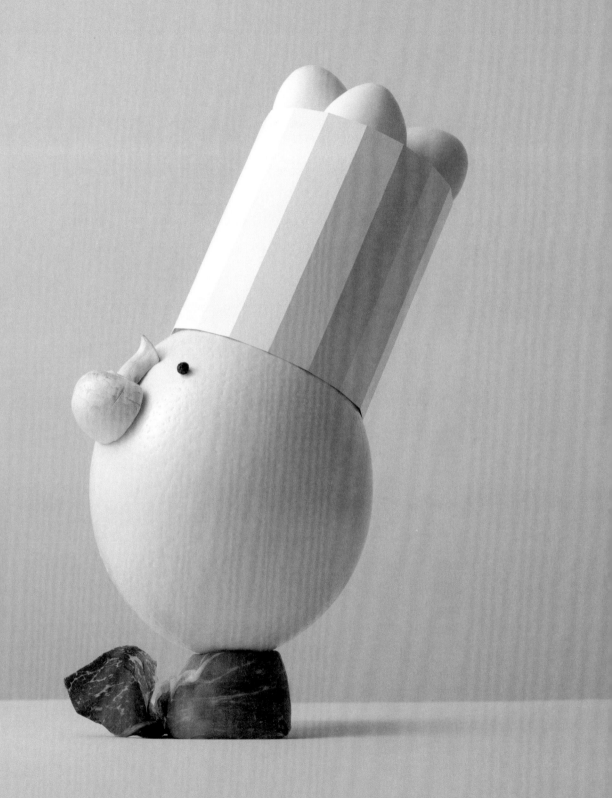

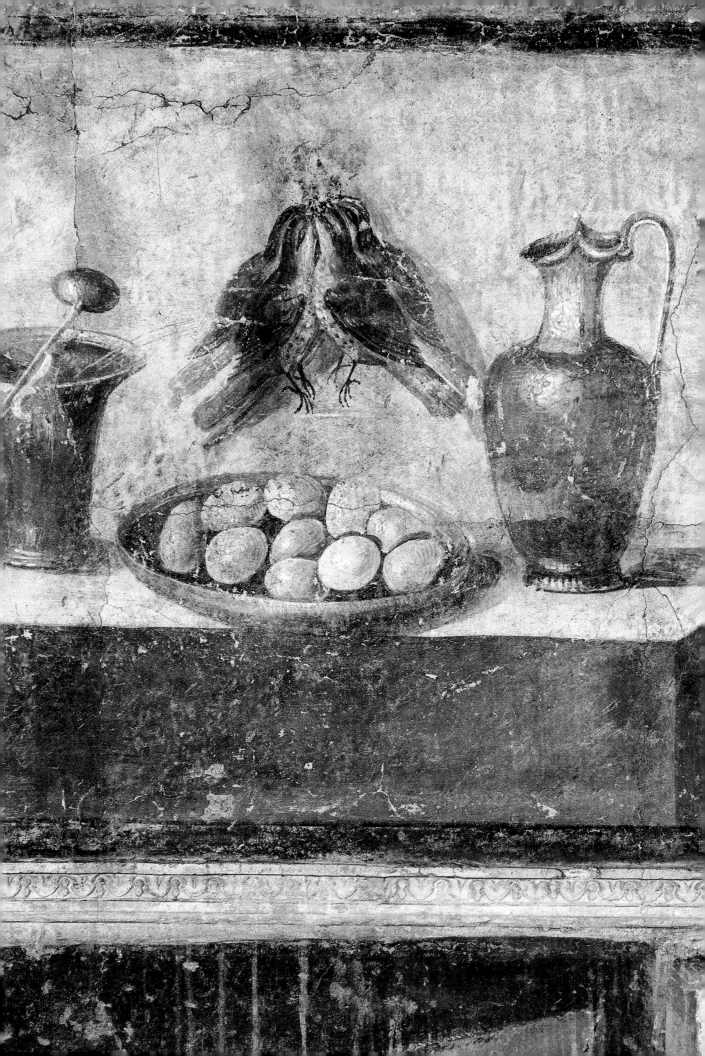

Introduction:
Eggs Are Everywhere

An egg is a deceptively simple object. It is a symbol and a shape-shifter, a food and a metaphor, an industry and an inspiration, a millennia-old, cross-cultural expression of rebirth, fertility and potential. It's also a star of literature, music, design and film.

From the Golden Egg of *Aesop's Fables* to West Egg and East Egg, the two main locations in *The Great Gatsby*; to Alice hunting Easter eggs in *Through the Looking Glass,* and the gleeful absurdity of Dr Seuss's beloved children's book *Green Eggs and Ham*; to song lyrics, from the Beatles' "I am the Eggman" and Ella Fitzgerald and Louis Armstrong duetting "I'm Putting All My Eggs in One Basket"; to the embodiment of the unknown in *Alien* or a symbol of resistance in *Cool Hand Luke*, when Paul Newman famously eats 50 hard-boiled eggs for a bet.

The egg is also at the crux of the oldest question around, "What came first, the chicken or the egg?", and an insult, "You've got egg on your face", as well an expression of encouragement to do something unwise, "Egg her on." And that's hardly touching upon it.

The creation story of the cosmic egg, the idea that the world was hatched by a greater power, is a recurring theme in many societies; it was first written down around 1500 BCE in Sanskrit scriptures, and in origin myths from Australia to China to Greece. In the Persian Empire, the spring equinox was celebrated by the decoration, sharing and eating of eggs. A carved relief from the ruins of the capital Persepolis (c.500 BCE) depicts noblemen holding coloured eggs. Later, Christian cultures adopted many of the pagan spring rituals as

John Tenniel
'Alice meets Tweedledum and Tweedledee', *Alice Through the Looking Glass*, 1871

symbols of Christ's resurrection at Easter. Now, eggs at Easter are ubiquitous, from the elaborately decorated Ukrainian *pysanky* — eggs painted using beeswax and dyes — through to the *l'uovo di Pasqua* in Italy: large hollow chocolate eggs wrapped in colourful foil with a gift inside. Of course, there's also the endless mass-market chocolate versions, the most notable of which has to be Cadbury's Creme Egg, which celebrated its 50th anniversary in 2021.

In Egyptian mythology, the bird goddess Isis, the daughter of Geb, the earth god, who was represented by a goose, was known as the "Egg of the Goose". In Thebes, rendered on the walls of the tomb of Horemheb, the last pharaoh of the 18th Dynasty (1306–1292 BCE) is a painting of a man carrying a bowl of eggs, while a small sculpture of an egg-filled nest was found in Tutankhamun's tomb — an indicator, perhaps, of life after death.

In 2010, a cache of 60,000-year-old crushed ostrich eggs was found in South Africa. There was evidence that they had once been engraved and possibly painted, although what the marks signified is still unknown. There are so many tales of eggs in history that it's dizzying. What is clear is that, for centuries and across continents, their significance extends far beyond food.

The symbolic power of bird's eggs — from the smallest (hummingbird) to the largest (ostrich) — which varies in meaning from culture to culture, has not quashed our desire to consume them. The Ancient Egyptians ate the eggs of most birds, including pelicans; the Romans loved peafowl eggs; the Chinese favoured pigeon eggs; and the Phoenicians revered ostrich eggs. The demand for eggs was such that the Ancient Egyptians invented an ingenious system of mass incubators so remarkable that the 18th-century French scientist René Antoine Ferchault de Réaumur declared, "Egypt ought to be prouder of them than her pyramids."[1]

Alabaster lid with bird and eggs,
found in the tomb of Tutankhamun, Egypt, c.1323 BCE

3

Today, the most popular egg by far is laid by a chicken, while quail eggs have gained in popularity from the US to Japan. Around the world, the eggs of plovers, partridges, gulls, turkeys, ducks and geese are eaten in surely as many different variations as there are imaginations.

In Ancient Greece and Rome, eggs were not only consumed but were also part of Bacchic and Dionysian rituals, used to cast spells and to offer protection. Romans apparently crushed the shells in their plates to prevent evil spirits from hiding there. Unsurprisingly, given their significance to Christian cultures, eggs make a few appearances in the Bible as well, notably in Job 6:6 ("Is there any taste in the white of an egg?"), Luke 11:12 ("If he asks for an egg, will they give him a scorpion?") and Isaiah 10:14 ("As people gather abandoned eggs, so I gathered all the countries").[2]

In Eastern Orthodox traditions, the story is told that when Mary Magdalene brought eggs to Jesus' tomb, they turned blood red when she realised He had risen. In Jewish tradition, a roast egg is part of the seder plate at Passover, and mourners eat eggs at the wake of a funeral to honour the circle of life.

Given that an egg's meaning is as varied as the ways in which it can be cooked, it's unsurprising that it has featured so frequently in art history, and not only as a subject. From the first to the 16th centuries, egg tempera, a mixture of pigment, egg yolk and vinegar, was the medium of choice for painters across Europe. In Italy it was nicknamed "la pittura al putrido" (the putrid painting) because of the smell of the slowly rotting eggs.

The egg also had an impact on photography. In the mid-19th century, Louis Désiré Blanquart-Evrard developed albumen silver photographic prints, which involved mixing egg whites with salt. The technique — which offered greater resolution than what had come before — was a hit; it became the main method of producing photographs until the early 20th century, when silver gelatin prints took over.

H. C. White Co.
Modelgraph No. 4, "Egg in cup and box", 1909

4

Louis Désiré Blanquart-Evrard
*Vase of Flowers,*1853

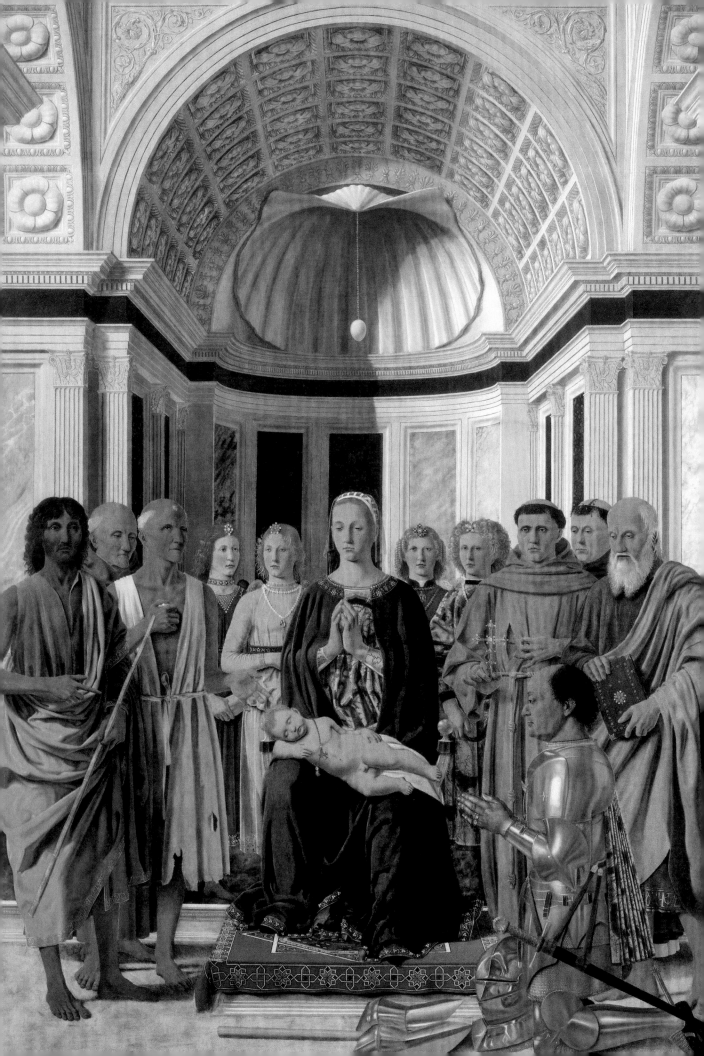

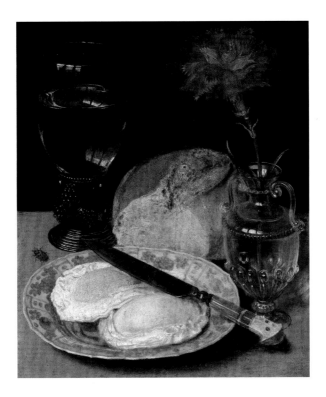

One of the earliest representations of an egg is a Roman fresco of a still life with eggs and thrushes, painted by an unknown artist on the walls of the Villa di Giulia Felice in Pompeii, which is still visible there today. But it was during the Renaissance that the creative possibilities of the egg really took hold. It appears again and again in various guises; in still lifes and allegories, as well as religious, historical and domestic scenes.

One of its most beautiful incarnations is in Piero della Francesca's *Brera Madonna* (1472–1474). A single ostrich egg, here intended as a symbol of creation and purity, is suspended from a shell above a group of saints and angels who surround Mary, the sleeping Christ Child stretched across her lap. The fact that the ostrich was a heraldic sign of the Montefeltro family who commissioned the tempera panel was undoubtedly a handy compositional prompt.

Many artists, of course, have decided to focus not on the egg's metaphorical possibilities, but instead on its day-to-dayness. In the German painter Georg Flegel's *Snack with Fried Eggs* (c.1600), an egg is an egg and no less glorious for it. The artist is displaying his talents: he can paint a reflective glass, a red flower, a loaf of bread and a couple of oily fried eggs with such vivid realism that it encourages hunger pangs.

Similarly, Diego Velásquez's *An Old Woman Cooking Eggs* (1618) is also something of a celebration of the everyday. Painted when he was still a teenager, even at a distance of 400 or so years, the picture is as vivid as a film still. The cook holds an egg in her left hand; in her right is a wooden spoon that hovers above the two eggs frying in a terracotta pot. A young boy waits beside her with a flask of wine and a pumpkin. Velásquez's prodigious talents are highlighted in the textures he

OPPOSITE **Piero della Francesca**, *Brera Madonna*, 1472–1474
Georg Flegel, *Snack with Fried Eggs*, 1580

evokes with the most economical of means: the white plate, the silver knife, and the gleam of the frying eggs that you can almost hear spit and hiss.

Realism was not held in much esteem by some painters, however. One of the strangest works of the 16th century is a Flemish painting, *Concert in the Egg* (c.1561) by Gielis Panhadel, a follower of Hieronymous Bosch. Like a premonition of the egg-obsessed surrealism of Salvador Dalí, in Panhadel's demented scene ten musicians (including a nun with an owl on her head) are crammed into an eggshell — perhaps a play on the familiar subject of a ship of fools. They perform a work by the composer Thomas Crecquillon that is inscribed in a large book; they sing, play a harp and a flute. Distracted by the music, a monk is pickpocketed by a mystery hand while various animals, including a monkey, a cat and a turtle, lurk in the margins. Other worlds are intimated by a tiny crowd scene in the bottom right of the picture. Panhadel was clearly in thrall to Bosch, an artist to whom the

egg had limitless creative potential. In perhaps Bosch's most famous painting, the triptych *The Garden of Earthly Delights* (c.1490–1510) — which moves from depictions of Eden to sensual abandonment and then Hell — an unhatched egg floats in the dead centre of the middle panel, surely a symbol of unrealised hope, or potential, in the midst of riotous human folly.

The egg has long been an indicator of secrecy and erotic possibility, or failure. A joke once doing the rounds: a sleazy man in a bar asks a woman how she likes her eggs in the morning. Dead-pan, she replies: "Unfertilised." In Jean-Baptiste Greuze's painting *Broken Eggs* (1756), a young girl sits despondently on the floor; eggs have tumbled from the basket beside her and some have cracked; a child beside her attempts to put them back together, while a young man holds back an old woman who berates her. The painting is commonly understood to be an allegory about virginity — the broken shells a reference to the girl's loss of innocence.

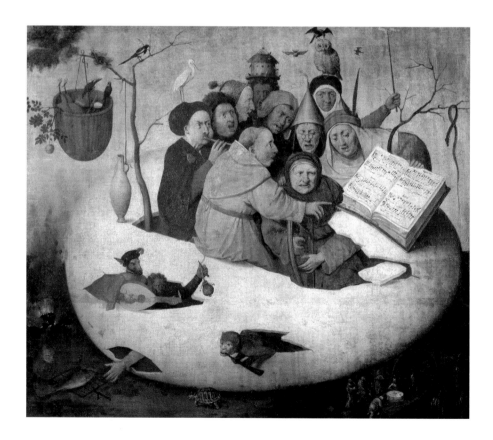

Gielis Panhadel, *Concert in the Egg*, c.1561
OPPOSITE **Jean-Baptiste Greuze**, *Broken Eggs* (detail), 1756

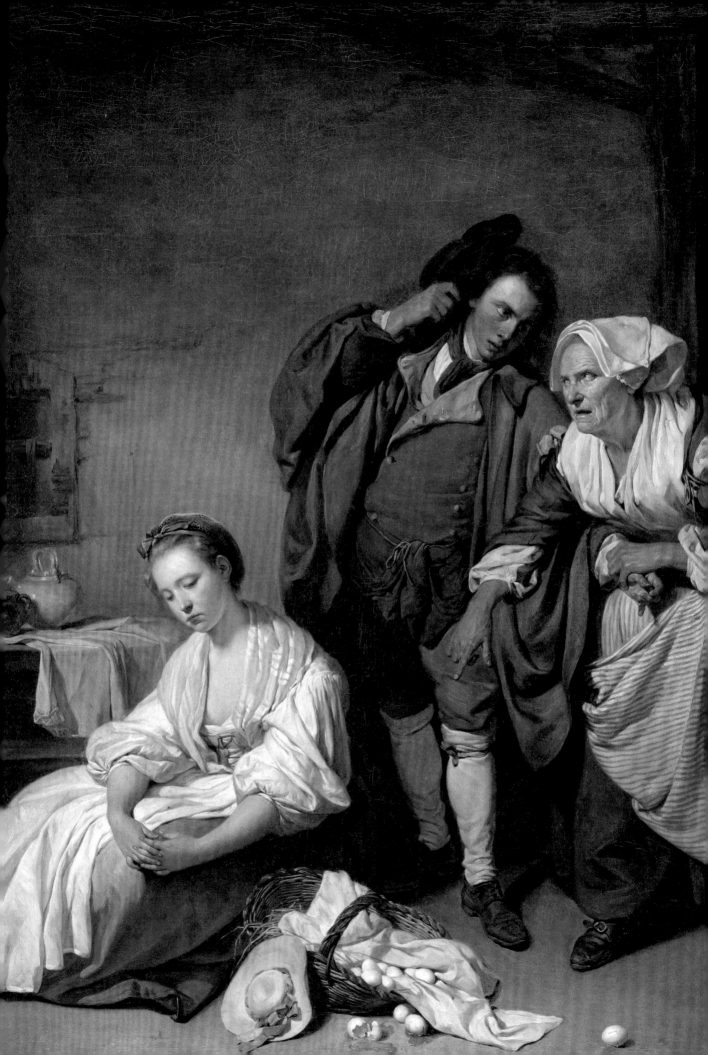

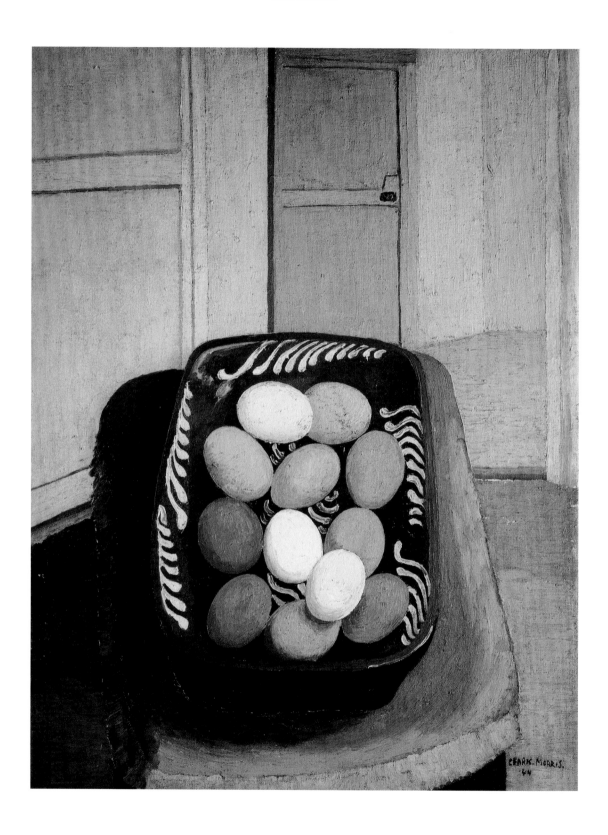

Sir Cedric Morris
The Eggs, 1944

As in so many pictures, the egg often features not only as an everyday foodstuff but as a container of myriad meanings. To paint an egg is to fuse simplicity of form and shape with the resonances around mortality that lurk at the heart of still life. Giovanni Battista Recco's *Still Life with Chickens and Eggs* (1640–1660) is case in point. It combines 11 eggs, one of which is broken, two live chickens and two dead ones. A knife hovers on the edge of the table, a nod to the precariousness of life.

In the 19th century, even as artists were pushing against tradition, the egg as a popular subject persisted. In Paul Cézanne's muscular *Still Life with Bread and Eggs* (1865), the motif of the single knife returns, linking a crisp white cloth with a crusty baguette, a glass and two eggs. That it emerges from darkness lends this everyday scene an otherworldly atmosphere. Just over 40 years later, Claude Monet banished any intimation of gloom with his *Still Life with Eggs* (1907), a pinkish, light-filled composition that blurs at the edges; it's like squinting into the sun on a summer's day. And it surely inspired the English artist Cedric Morris's joyful still life *The Eggs* (1944), which was painted during the dark days of World War II: its bright palette of blues, lilacs and yellows, and the 12 colourful eggs arranged in a basket, are a sign of hope for new beginnings. The great postwar cook and food writer Elizabeth David bought the painting in 1953, and in 1984 it was chosen as the cover image for the first edition of her classic book *An Omelette and a Glass of Wine*.

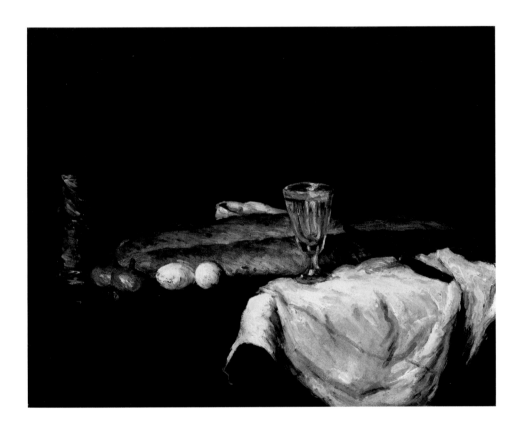

Paul Cezanne
Still Life with Bread and Eggs, 1865

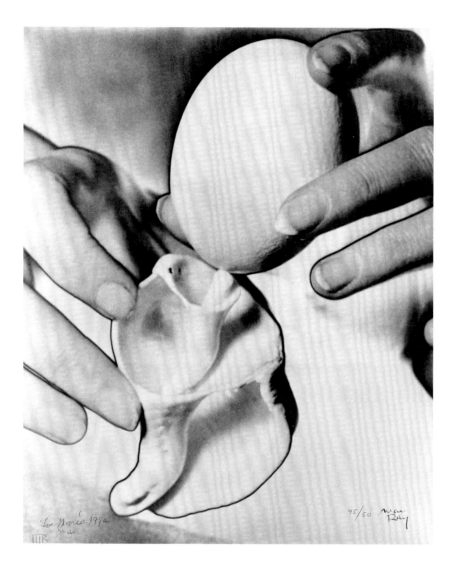

Despite its self-containment, the egg is the most pliable of subjects. In the 20th century, it was many things to many artists and designers. Constantin Brancusi mined the border between abstraction and figuration in his marble, nickel, silver an stone sculpture *The Beginning of the World* (c.1920), a simple ovoid form that he repeatedly returned to that was suggestive of fertility and infinity — a motif that Frida Kahlo also summoned in her feverish meditations on birth, life and death. In Man Ray's *Egg and Shell, Solarization* of 1931, two hands bring an egg and seashell together in a gesture that is both unremarkable and moving in its linking together of something very old and very new.

In her 1963 work *The Moment (Egg)* the artist Agnes Martin — who believed that "art is the concrete representation of our most subtle feelings" — employed the shape of the egg as the expression of limitlessness, and in 1969 David Hockney illustrated a story by the Brothers Grimm with a series of 39 etchings, including the enigmatic *The Boy Hidden in an Egg*.

Man Ray
Egg and Shell, Solarization, 1931

Agnes Martin
The Moment (Egg), 1963

David Hockney
The Boy Hidden Inside an Egg, from *Six Fairy Tales from the Brothers Grimm,* 1969

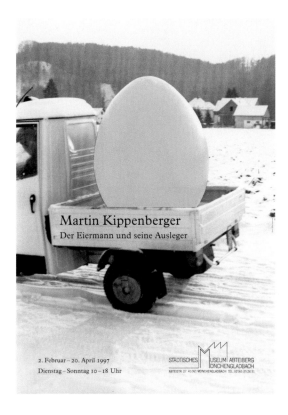

For Salvador Dalí, the egg was a malleable metaphor for the strangeness of everyday life, an intimation of the erotic, and the rebirth of vision that surrealism promised. In the one-minute film *Salvador Dalí Gala Born from an Egg*, two large eggs sit side by side on a sunny beach. As the artist and his wife burst out of one, he exclaims "Bonjour!" and then proclaims that he is born "without any kind of traumatism". He scatters "symbolic blood, milk and fish" around the base of the egg, "the blood of Gala and the blood of the Divine Dalí". In homage to the significance of the egg to the artist, large sculptures of eggs decorate the roof of the Dalí Theatre and Mus-eum in Figueres in Spain, and a single giant egg sits atop the artist's Casa-Museu (House-Museum) in Port Lligat in Cadaqués.

It's unsurprising that the egg is such a popular motif in Pop Art, which reframed the everyday as something heightened and hallucinatory. Straddling painting and sculpture, one of the movement's stars, Claes Oldenburg, was fascinated with both the simplicity and the comic potential of eggs, and they appeared in many of his works.

One of the most prolific late-20th-century explorers of the egg was the German artist Martin Kippenberger. His final exhibition in 1997, the year he died, was *Der Eiermann und seine Ausleger* (The Eggman and His Outriggers) at the Städtisches Museum Abteiberg in Mönchengladbach, Germany. Comprising paintings, drawings and objects organised around the theme of the egg, the artist restlessly explored "rebirth, reproduction and the ideal of the cicle", both as a serious cipher and as a "banal comedic device". More recently, the Swiss artist Urs Fischer took the joke and ran with it in his series of *Problem Paintings* (2013): giant photographic portraits in which the subject's face is obscured by photorealist painted eggs. The US artist Jeff Koons has also taken things to a whole new level in his dizzying, gleaming sculptures of blindingly shiny eggs cracked or wrapped in bows.

Martin Kippenberger
The Eggman and his Outriggers, 1997

The echo of a breast in the shape of an egg yolk has long been remarked upon, and some of these works, including Vicki Hodgetts's *Eggs to Breasts*, are explored in this book. From the 1970s until her death in 2017, the Italian feminist artist, poet and curator Mirella Bentivoglio employed the egg as a stand-in for the letter "o": if her body was an "I", together they would make "io"— Italian for "I". In the 1990s, the French-American artist Louise Bourgeois created monumental sculptures of spiders — which she saw as a maternal figure— guarding their eggs, like the guarantee of something to come. The British artist Sarah Lucas, who has returned to the motif of the egg again and again, created the participatory *One Thousand Eggs: For Women* for her 2018 solo exhibition at the New Museum in New York. A take on both the history of egg tempera and the pagan fertility rite of egg throwing, it involved women smashing 1,000 eggs against the gallery wall to make the work.

In the past few years, the popularity of the egg is as strong as ever. From Wolfgang Tillmans's and Stephen Shore's contemplative photographic still lifes to Christopher Chiappa's hyperrealist sculptural work of 7,000 fried eggs installed on the walls and the floor of a gallery, and Heather Phillipson's wonderfully bonkers commission for a London Underground station in 2018, the egg has become something of a one-stop shop for inference and ambiguity. Titled *my name is lettie eggsyrub*, Phillipson's installation comprised a bouquet of giant unhatched eggs, eggs on a conveyor belt, farting eggs, a chick emerging from a cracked shell, a whisk, chicken feet, fried eggs and multiple digital screens that flashed statements such as "a gibbering omelette" and "a quivering splodge of protoplasm". That Phillipson is a vegan shapes the work: she employs humour to highlight the absurdity — and cruelty — of what we often take for granted.

Over the past 25 years or so, it would seem that architects across the globe have also been endlessly inspired by the egg's minimalist and metaphorical potential. The Japanese architect Tadao Ando's 1995 Nagaragawa Convention Centre swells with the form of an egg. In 2017, his compatriot Shigeru Ban completed his auditorium La Seine Musicale in Paris: an ovoid-shaped building that appears to float on the water. In Zwolle, Germany, Hubert-Jan Henket conceived the neo-classical Museum de Fundatie, which is topped by a golden goose and an enormous, egg-like superstructure adorned with 55,000 tiles. In Hong Kong, the science and technology park centres around the egg-shaped Charles K. Kao Auditorium designed by Leight & Orange.

In 2019, a photograph of an egg was posted on the Instagram account World Record Egg, the brainchild of advertising creative director Chris Godfrey. It was captioned: "Let's set a world record together and get the most liked post on Instagram." To date, it has more than 55 million likes. Godfrey said he chose the egg because it's "simple and universal, and has no gender, race or religion".[3] Despite the popularity of the post, I have a feeling a lot of people, past and present, would disagree with him.

Jennifer Higgie

1. Traverso, Vittoria. "The Egyptian Egg Ovens Considered More Wondrous Than the Pyramids", *Atlas Obscura* (April 2019). atlasobscura.com/articles/egypt-egg-ovens.
2. Killgrove, Kristina. "The Curious History of Easter Eggs from Birth to Burial", Forbes (March 2016). forbes.com/sites/kristinakillgrove/.2016/03/26/the-curious-history-of-easter-eggs-from-birth-to-burial/
3. Powell, Sukayna. "An Egg Is for Art, Not Just for Easter". *Elephant* (April 2019). elephant.art/egg-art-not-just-easter/.

OPPOSITE **Vicki Hodgetts**
Eggs to Breasts, 1972. Photo by Lloyd Hamrol

Stories

Eggtymology

The world of the short-order cook is one of enforced economy of space, time and movement. Orders roll in quick, and things happen fast. Often cramped, always hot, short-order kitchens rely on an economy of the spoken word, too. And nowhere does that apply more than to the shorthand between people whose job it is to cook hundreds — maybe thousands — of eggs every day.

It all starts with the words regularly spoken by the wait staff at self-respecting diners everywhere: "How would you like your eggs?" And with this seemingly prosaic question, a world of almost infinite possibility is offered up.

Things might seem straightforward enough. Eggs can come poached, boiled, scrambled, fried or baked. Quick and clear with room for individual preference. You can add runny (if you must), soft (OK then) or firm (show a little respect). From sunny side up to eggs over easy, over medium or over hard, the fried egg lingo is pretty much set.

So far, so easy to call out over the hubbub of a busy dining room and kitchen. But thanks to the pervasiveness of the egg, and innate human creativity, things can get much crazier. If you were to order "smashed cackle berries", your eggs would come scrambled, as would "wrecked eggs". If those wrecked eggs were also "crying", they would come with a side of onions. And if you wanted the order to go, you could ask the wait staff to "put legs on it".

Rich linguistic territory comes along with the dish otherwise known as "egg in the hole". Cut a hole into the centre of a slice of bread, pop it in the pan, crack an egg into that hole and — hey presto — you've just made "toad in the road", "egg in jail", "hen in a nest" or "ojo de toro" (eye of the bull). In the 2005 film *V for Vendetta*, Evey Hammond (Natalie Portman) gets her fill of this particular dish, when she is served it for breakfast first by the masked V (Hugo Weaving) and later by talk show host Gordon Deitrich (Stephen Fry), who calls it "eggie in the basket".

There's also a darker side to egg prep terminology. Instead of boiled eggs, the callous could ask the kitchen to "drown the kids". Instead of a poached egg, you could get your toasted muffin with a "dead eye". But those sorts of straight-up macabre descriptors are few and far between. Though there is a darkness to what could also, paradoxically, be described as the most heart-warming of orders: the "reunion", aka a chicken and egg sandwich.

Lights, Camera…Egg

The egg is a cinematic chameleon. In its many filmic incarnations, it has been a token of brotherly love, a Freudian red flag, a portent of a ghoulish presence, a symbol of life or, simply, a hangover cure, as in the 1988 movie *Cocktail*, when Tom Cruise as an aspiring bartender learns the secret to a redeye: beer, raw egg, tomato juice and aspirin.

Eggs have sometimes required feats of stamina from their co-stars, most famously Paul Newman, who eats 50 of them, hard-boiled, to win a jailhouse bet in *Cool Hand Luke*. The actor wisely regurgitated the eggs the instant the director shouted "Cut!" Sylvester Stallone as Rocky withstood similar torture, downing five eggs raw to fuel his 4 am cross-Philly training runs. The future heavyweight champ cracks his eggs single-handed, a trick author Len Deighton, a consummate home cook who also penned the *Action Cook Book*, tried to teach Michael Caine during the filming of espionage thriller *The Ipcress File*. Caine couldn't quite master the technique, so the hands you see cooking Harry Palmer's date a spanish omelette are actually Deighton's.

On film, eggs tend to offer plot clues in subtle and not-so-subtle ways, entwined as they are in the culinary mesh of family life and relationships. They are a melancholy symbol of a family's implosion in *Kramer vs. Kramer*, when Dustin Hoffman's sorry attempt at making french toast for his son renders the absence of his soon-to-be-ex-wife achingly felt. While the five-minute, near-silent finale of restaurant drama *Big Night*, tracking one brother's unshowy cooking of an omelette for his older sibling, says more about brotherly love and the shouldering of disappointment than any dialogue could. They play a pivotal role in Michael

Haneke's *Funny Games*, too, when a family holidaying in a remote spot makes the fatal error of opening the door to a soft-spoken young man who has an apparently innocent request to borrow some eggs. When he "accidentally" breaks them all, they spill with a pervading sense of dread, foreshadowing the grimmer events yet to unfold.

Whether for their perceived fragility, or the unknown kernel of life within, eggs have also been used on screen as a sign of impending danger. Few actors could make a simple boiled egg quite so chilling as Robert De Niro's infernal character in *Angel Heart*, who peels away at its shell with long, pointed fingernails. "You know some religions think that the egg is the symbol of the soul, did you know that?" he says to his unsettled companion, before baring his teeth and taking a bite. While in Kubrick's dystopian *A Clockwork Orange*, Alex's spontaneous outburst at the sight of "eggiwegs", as he calls them, says all too much about the droog's fractured state of mind.

More comically, there's an early inkling of demonic happenings in *Ghostbusters*, when the eggs Sigourney Weaver brings back from the grocery store begin jumping out of their carton and cooking themselves on her kitchen counter. An experience not quite as nightmarish as Weaver's other cinematic egg encounter, in Ridley Scott's *Alien*: the film's glowing, throbbing eggs (and the facehuggers that grow inside them) were designed by Swiss artist H. R. Giger, who stuffed them with sheep intestines. The late artist's work was something of a feast for the psychiatrist — he used it to dredge up and externalise his feverish terror of the female body, of reproduction and the messy realities of childbirth.

OPPOSITE
Paul Newman in *Cool Hand Luke*, 1967

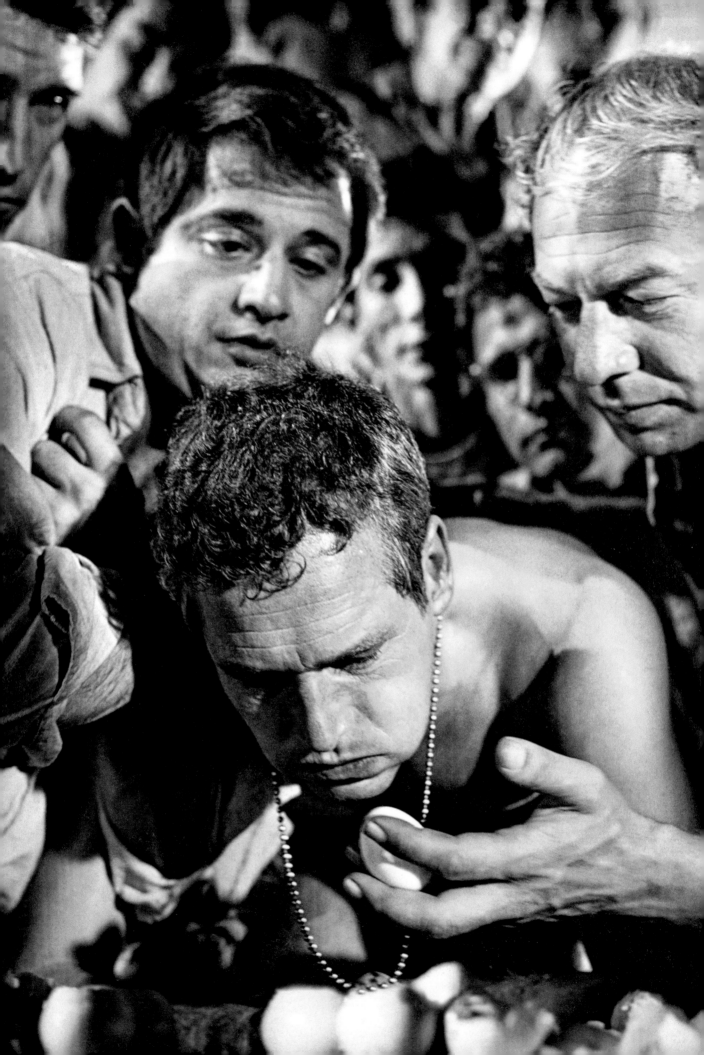

Robert De Niro in *Angel Heart,* 1987

Giger tapped into a phobia surrounding the egg and its gooey contents that no one understood more than famous ovophobe Alfred Hitchcock. The director made his hostility clear in *To Catch a Thief*, when a rich widow decisively stubs out her cigarette into a congealing egg yolk. It is almost as stomach-turning as the fried egg, dripping in oil and slapped between two rubbery slices of bread in a Camden greasy spoon, that ignites something of an existential crisis for the out-of-work actor Marwood (Paul McGann) in *Withnail & I*.

Ramping up the absurdity, eggs abound in trash king John Waters' 1972 *Pink Flamingos*, as grown woman Edie (Edith Massey), with bouffant hair and dirty negligee, screams for eggs from a baby's playpen. She strikes up a romance with an egg salesman, whose suitcase contains all types of eggs ready to be consumed; maybe a comment from the queer director on the commodified sexual exchange of heteronormative relationships. Massey went on to found punk band Edie and the Eggs, while her ovophobe character has been revisited by drag queens ever since.

But the egg has also been rendered with breathtaking beauty, notably in two animated films. In Mamoru Oshii's bewitching hand-drawn anime *Angel's Egg* — a precursor to its more famous sibling *Ghost in the Shell* — a girl shepherds a giant egg under her dress through a gnarled, dystopian wasteland as huge fish-shaped shadows flit silently above her. Created during a period when the director was struggling with a crisis of faith, the film's egg has been interpreted in myriad ways: as an emblem of hope or a symbol of reality, a sealed fate or a sign of renewal.

Impossible to fully decipher, Oshii's unsung masterpiece is as ambiguous as the egg itself, and mines its enigmatic, nascent potential to perfection. In a very different anime, Studio Ghibli's film *Laputa: Castle in the Sky*, there is more straightforward pleasure to be found in a fried egg atop an outrageously thick slice of toast, shared by two friends mid-adventure. This culinary combination is now referred to in Japan as Laputa bread, and has inspired a host of amateur chefs to recreate this most simple of dishes in real life.

Malcolm McDowell in *A Clockwork Orange*, 1971

Saucy Eggs

When filmmakers want to hint at sexual desire on screen, they could do worse than reach for an egg. Think of Luca Guadagnino's sun-dazed romance *Call Me by Your Name*, when the sight of jet-lagged American houseguest Oliver wolfing down a soft-boiled egg presages something more than a hearty breakfast appetite, a feeling captured in the darkly complicated look on the face of his soon-to-be lover.

Or the symbolic hard-boiled egg offered by a lonely janitor to a scaly fish-man that precipitates an unconventional romance — and interspecies sex — between woman and amphibious creature in Guillermo del Toro's fantasy *The Shape of Water*. Even the poisonous mushroom omelette meticulously prepared and served in Paul Thomas Anderson's *Phantom Thread* is a twisted gesture of love, as is its recipient's willingness to eat it.

Some directors have been more explicit. In Juzo Itami's paean to ramen, *Tampopo*, a raw egg plucked from a room service trolley is inventively put to use by a yakuza gangster and his moll, who pass the yolk back and forth between their mouths before it finally breaks all over the woman's white blouse. They follow this up by commandeering a live prawn to tickle her flesh.

More slapstick is the sex scene in *Hot Shots!*, in which Charlie Sheen fries eggs and rashers of bacon on his paramour's sizzling stomach — which is, of course, a spoof of cinema's most famous use of food as foreplay: Mickey Rourke feeding a blindfolded Kim Basinger a gut-churning smorgasbord of appetizers by the light of an open fridge in *9½ Weeks*. Doing his best to cover all the food groups, Rourke serves up eggs, olives, maraschino cherries, strawberries, jelly, honey, jalapeño peppers, cough syrup and a mammoth glass of milk. Basinger didn't find the experience quite as seductive as her character appears to. "Jesus, it was sickening", she told *Rolling Stone*. "I tried to spit everything into a bucket, but some of it slipped down."

OPPOSITE **Harry Peccinotti**
from "The Princess & the Pea", *The Gourmand*, Issue 08, 2016

Can You Believe It?

Being the endlessly symbolic objects that they are, it's not difficult to find superstitions casting eggs as both good and bad omens. And like all superstitions worth their salt, beliefs about the ineffable power of the egg come from scanty folk sources and whispered histories.

Esoterically speaking, it's considered reckless to eat a dove's egg, which will bring you bad luck, or a mockingbird's egg, which will give you loose lips, and, perhaps most ominously, by eating an owl's egg you may end up screeching for eternity. But not so fast — hold on to that uneaten owl's egg and use it to whip up an omelette for someone with a drinking problem, as consuming this is said to put them off the booze for good.

You're encouraged to carry eggs around in your bonnet to get the best baby hens, or nestle eggs in a hat so that they all hatch as roosters. Meanwhile, keeping an egg in your possession that was laid on Good Friday will ensure your house doesn't burst into flames.

Bedtime is a good time to get some intel out of an egg about your love life. Place one next to the fireplace on a blustery evening before you retire. The person who comes in from the storm and touches that hot egg is the person you'll marry. Or try boiling one and replacing some of its yolk with salt to chow down before bed. Whoever offers you a glass of water in your dreams is your future partner. Or, in another variation, whoever tries to quench your thirst in dreamland will forsake you in the waking hours. Different still, if you eat an egg white, go to bed parched, then hear a name uttered aloud, pay attention because that's the name of your future spouse. Whatever the case, make sure you do all of this on Halloween. Or not.

Eggs, of course, are also a symbol of fertility, and superstition shores this up. Found two yolks in one egg? You're having twins! Want to encourage a bountiful crop? Scatter shells on your field (there's truth to this: the calcium in eggshells acts as a fertiliser). More advice for farmers hoping to avoid bad luck includes doing all your egg collecting while the sun is still shining, and not letting any eggs out of the house after dark. But don't even consider touching eggs in a professional capacity on a Sunday.

Arcane egg superstitions and fears about witches go hand in hand. An imaginative one claims that since witches travel in vessels made of eggshells, wreaking havoc on the seas, it's crucial you don't leave your shells in pieces large enough for a witch to use. To avoid this predicament, it's recommended you either break the shells down or, if you have some time to kill, poke holes in them. To keep a child safe from witchcraft, it's advised you crack shells over their head. But if you're looking to ingratiate yourself to a witch instead, leave an egg for them on your roof. You'll just have to risk the witch turning it into a magical ship.

PAGE 28, **Robin Broadbent**, *Untitled,* 2001; PREVIOUS **Robin Broadbent**, *Untitled,* 2004
OPPOSITE **Marius W Hansen**, *Eggs in a Hat,* 2021

Eggs Go Pop

At a mammoth three metres in diameter, Claes Oldenburg's *Sculpture in the Form of a Fried Egg* (1966/1971) is a freakishly exaggerated yolk surrounded by a mass of creased egg white. He made the giant soft sculpture from cotton canvas and polystyrene in collaboration with his then seamstress wife, Patty Mucha. They also created huge cheeseburgers, fries and ice cream cones, exploding these foodstuffs' commonplace quality with outsized scale. Eggs were a playful and frequent character in Oldenburg's work, appearing as appetizing morsels fresh from room service in *Fried Eggs Under Cover* (1962) or from the heat of the stove for *Fried Egg in a Pan* (1961). The latter was among a variety of items for sale at Oldenburg's landmark event The Store, a shopfront he opened in New York's Lower East Side during the winter of 1961. On sale were plaster sculptures of consumer goods spanning lingerie and eggs to cakes, it was an installation that circumvented the gallery process entirely.

Almost always vividly coloured, eggs are a recurring feature in work by artists associated with Pop Art, a movement that coincided with the rise of mass production in the 1950s and 1960s, and its accompanying proliferation of advertising and brightly packaged goods. Pop artists often transformed everyday items into works of art to make powerful statements on popular culture and consumerism. Bringing the egg, a mass-produced, cheap ingredient, into the gallery questioned the hierarchy of "high" and "low" culture, and what constituted art anyway. Ed Ruscha, the artist best known for his deadpan depictions of American life, harnessed eggs as a material, too. He used a mixture of orange-yellow yolk to write the words "Cotton Puffs", "Baby Cakes" and "She Gets Angry at Him" directly onto taffeta or satin for a series of artworks inspired by advertising copy. Tackling ideas about materials and their value, he used the everyday kitchen ingredient to subvert the banal phrases and add a sensory element to the language,

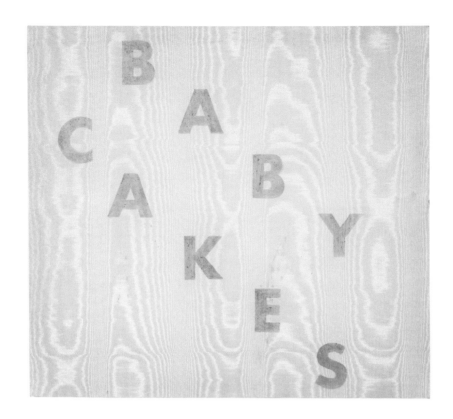

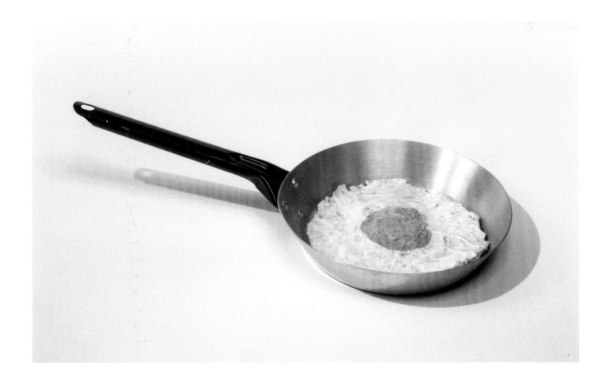

Ed Ruscha, *Baby Cakes*, blueberry and egg yolk/moire, 1974
Claes Oldenburg, *Fried Egg in Pan*, painted plaster and aluminum frying pan, 1961

Hard Boiled Eggs
recommended by Steve Elliot

This may seem an unimportant matter to the ordinary cook,
but this may seem an unimportant matter to the ordinary cook, but
significant art. It is essential that all eggs be immersed in the
water at precisely the same time. From the time the water begins
to boil boil eight minutes should be allowed for medium sized eggs
and ten minutes for larger ones. This time limit must never be exceeded
as any excess cooking makes the whites tough and therefore unetable.

Andy Warhol, illustration from *Wild Raspberries*, 1959
OPPOSITE **Andy Warhol**, *Eggs*, 1982

James Rosenquist
Coenties Slip Studio, 1961

an experiment he explored in his more overtly eggy work *Egg Yolk* from *Stains* (1969), a simple yellow smear on white paper that formed part of a portfolio of stains ranging from Coca-Cola to chocolate syrup. A deceptively peaceful egg also appears, suspended in mid-air, in *Egg from Domestic Tranquility* (1974), part of a wryly titled four-part series of monochromatic lithographs stemming from a very heated argument in which an egg, a plate, a clock and a bowl were thrown at his head.

Andy Warhol illustrated eggs early on in his career, in a 1959 spoof cookbook titled *Wild Raspberries*, created in collaboration with interior decorator and society hostess Suzie Frankfurt. Much later, his *Eggs* series (1982) encompassed rare abstract pieces, and were a diversion from the artist's usual work that appropriated and repurposed advertising visuals and celebrity culture. This series depicts technicolour eggs that look like giant jelly beans floating against a black back-drop, and were given as Easter gifts to his family and friends. Warhol also collaborated with neo-expressionist artist Jean-Michel Basquiat on the work *Eggs* (1985), which shows a large oval plate against a warm purple background (more on Basquiat on the following pages).

In the case of James Rosenquist, eggs partly symbolised ideas of trickery, fuelled by memories of his father, who fabricated fake eggs to play pranks on the farm where Rosenquist grew up. An artist with a background in billboard painting, Rosenquist's style often employed fragments of advertisements and cultural imagery with surrealist elements — all of which are present in *Vent* (1978). The collage depicts a shiny sunny side-up egg, a pole and a turquoise-tinted image of a laughing woman. *Coenties Slip Studio* (1961) is another collage by Rosenquist, this time of everyday objects. In the top right corner, a yellow yolk that resembles a summer sun shines bright.

Rosenquist ducked explanations about the work, saying it was simply a reflection of objects in his lower Manhattan studio at the time, and that he depicted "a fried egg and a fork, because I was hungry". But he returned to the egg frequently throughout his career: in *Green Flash* (1979), juxtaposed with a woman's naked back; and in an untitled 1980 painting, cracked raw into a glass bowl. An egg for Rosenquist — and other Pop Art artists — was perhaps the perfect item. Rich with complex symbolism, it was also an everyday staple that spoke to modernity.

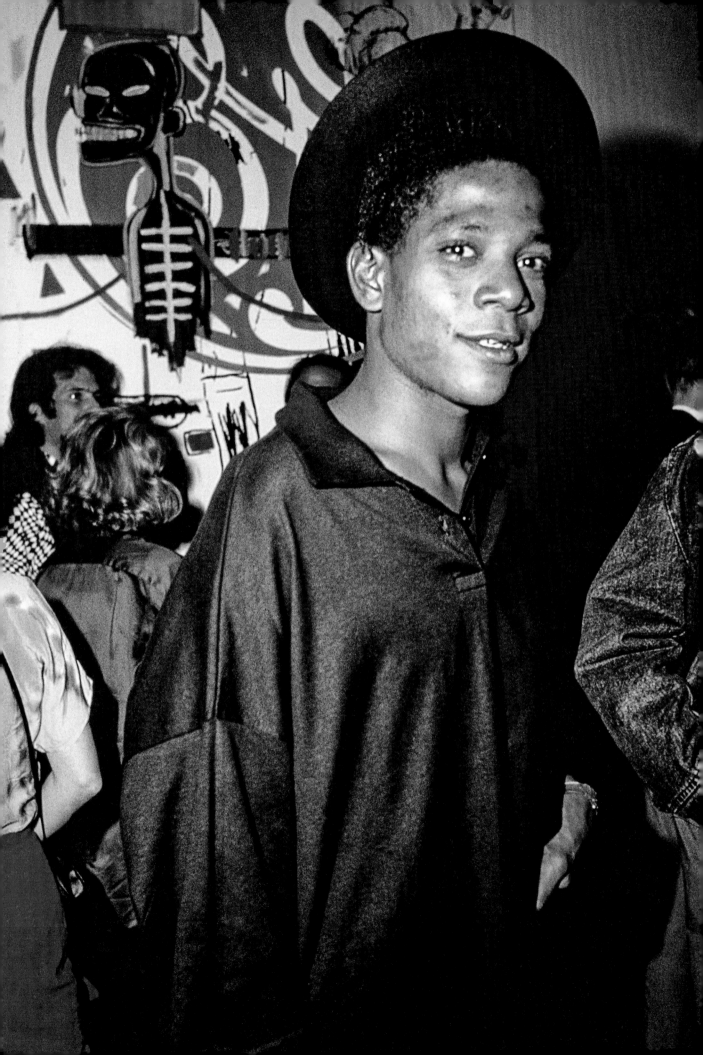

Basquiat's Eyes and Eggs

Jean-Michel Basquiat's *Brown Eggs* (1981) was conceived at a seismic turning point in the prodigiously talented artist's short, prolific career. Depicting a giant black cranium (they soon became a recurring motif), surrounded by cryptic symbols and chaotic, mischievous explosions of colour, the eyes of the floating, skull-like head are echoed in six brown eggs lined up at the bottom of the canvas. It combines elements of self-portraiture with a blurring of inner and outer worlds, and, as with much of Basquiat's work, hints at a Black history rife with injustice and exclusion. It's a visceral work he executed fast with his virtuoso command of oil sticks.

An artist who consistently challenged notions of race and class, Basquiat examined the ways power worked in society, and in whose favour. He was just 20 when he painted *Brown Eggs*, crackling with creative energy and on the cusp of art-world fame. As a teenager, he had co-opted the then ravaged streets of nocturnal lower Manhattan as his canvas, spray-painting enigmatic assaults against the art establishment across burnt-out

buildings, doorways and the subway trains that took him home to Brooklyn. *Brown Eggs* marked a moment when Basquiat was making the transition from the streets to the gallery. After a defining group show at PS1 rocket-fuelled his ascent, dealers and collectors began jostling to purchase his electrifying, politically charged works for increasingly high figures.

By 1983, Basquiat was a Downtown art star, working out of a Great Jones Street studio leased to him by friend and collaborator Andy Warhol. (The pair had first met when Basquiat was camping out in Washington Square and selling painted T-shirts for $10.) Another egg painting, *Eyes and Eggs*, was completed during that year, and is markedly less frenetic than *Brown Eggs*. Painted on a drop cloth that stretches three metres across, with the outline of the artist's shoe prints stamped over it, the Black figure in *Eyes and Eggs* holds a frying pan with two sizzling eggs. While Basquiat often celebrated notable Black Americans in his paintings—Langston Hughes, Sugar Ray Robinson and others—in *Eyes and Eggs* he depicts what

appears to be a short-order cook called "Joe", wearing a collared shirt with name tag and two-pointed hat that resembles an army uniform. It's possible that this figure was based on someone that Basquiat knew in real life, and it could also broadly represent the types of kitchen jobs that were available to many Black men at the time — even if they had served in the military. The red yolks of the eggs mirror the figure's red-rimmed eyes, both eyes and eggs fixing themselves squarely on the viewer as though this man is serving up a hackneyed image of himself. (Or, if we see Joe as a veteran, the red eyes could signify PTSD.)

As one of very few African American artists in tan overwhelmingly White New York art world, Basquiat's ongoing commentary on racial oppression chimed with realities he confronted every day. Though he had grown up in a middle-class home and had achieved success through his art in his own right, he struggled to hail a cab back from his own shows, and occasionally made satirical comments on his isolated status by wearing African chieftain outfits to the parties of his wealthy collectors.

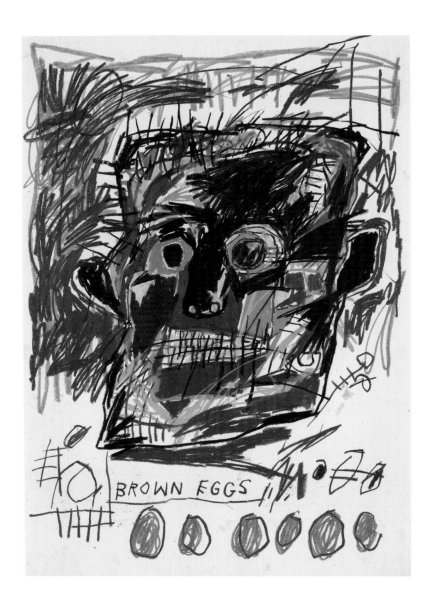

Jean-Michel Basquiat
Brown Eggs, 1981

There are further eggs in Basquiat's work in the shape of collaborations with Andy Warhol, after the pair built a symbiotic relationship: Basquiat, the precocious wild child, refreshed Warhol's image with his underground credentials, while Warhol served him with a world-famous accomplice and patron. Basquiat doodled on some of Warhol's silkscreened eggs, and together they created joint paintings, including 1985's *Eggs*. "They are truly an invention of what William S. Burroughs called 'the third mind' — two amazing minds fusing together to create a third totally separate and unique one", said fellow artist Keith Haring. It's been told that Warhol was one of the few able to reign in Basquiat's drug habit, which money and notoriety only accelerated. "I guess he wants to be the youngest artist to go", Warhol wrote in his diary, as early as May 1983. Five years later, aged 27, Basquiat died of a heroin overdose, leaving behind an extraordinary legacy of more than 1,000 paintings and 2,000 drawings that dug at fundamental truths behind the chaotic onslaught of everyday experience.

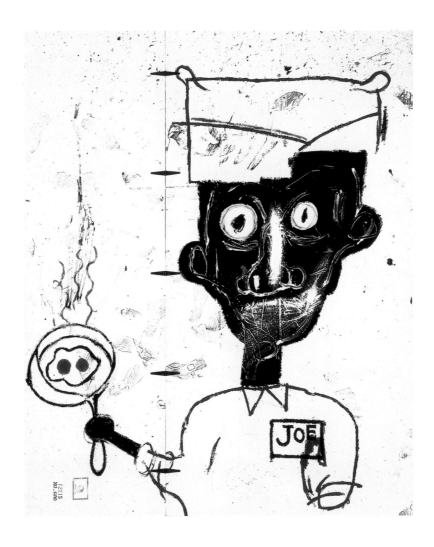

Jean-Michel Basquiat
Eyes and Eggs, 1983

41

"Between a high, solid wall and an egg that breaks against it, I will always stand on the side of the egg."

HARUKI MURAKAMI

Ovophiles and Egg Sluts

There is more than one way to love an egg. Some wish to eat, some to own, and some to secret their eggs away.

When the adoration is culinary, when someone feels the urge to put an egg on everything from asparagus and ramen to — more outré — hummus and spaghetti bolognese, this person might be called out by some as an "egg slut".

According to chef Alvin Cailan, the term gained traction in the mid-2000s, used by kitchen denizens for colleagues who just couldn't get enough. The LA-born Cailan knows of what he speaks. He is the palate behind, yes, Eggslut, a chain that needs no further introduction. Still, to hit the point home, its egg-worshipping menu includes big hitter "The Slut", a dish of coddled egg on top of potato purée, poached in a glass jar and topped with grey salt and chives.

Indie culinary zine *Put A Egg On It* captured the zeitgeist with its first issue in 2008. But identifying the wanton use of an egg as a lifestyle choice was arguably popularised by the late, great culinary rover Anthony Bourdain on his TV show *No Reservations*. The 2009 event prompting this declaration was Bourdain's visit to The Silver Palm in Chicago. The now-defunct restaurant had a notorious item on its menu: the "Three Little Pigs" — a brioche bun stuffed with smoked ham, breaded pork cutlet, strips of bacon and an onion ring, drenched in gruyère and topped, of course, with a fried egg. One bite of this bully and Bourdain's confession of harlotry all but spilled out from his — very full — mouth: "I'm a total egg slut", he said.

Despite all this free love, egg sluttery is not a modern invention. Writing in his essay "Ovophilia in Renaissance cuisine", history professor Ken Albaba gives the obsession a name, and identifies the 16th century as a time when egg recipes snowballed, arguably beyond reason, with novelties including eggs fried in capon fat, or stuffed with hot almond and verjuice sauce. "Egges in

moneshyne", from 1557–1558's *Proper Newe Book of Cokerye*, was egg yolks poached in melted sugar and rosewater, "a conceit intended to resemble a bright moon in a limpid sky", Albaba writes. This watery treat was not to be outdone by the intriguing "Egg as big as twenty eggs," from 17th-century British chef (and pioneering egg slut) Robert May.

Beyond culinary confines, ovophilia has, of late, found expression in a pastime enabled by the "Brogoth ovipositor", a sex aid designed to emulate impregnation by an otherworldly being. "If you've seen the *Alien* movies, you'll get the picture", said Lone Wolf, the founder of the company. Inspired by nature's very own ovipositors — organs that some insects have — this synthetic version allows you to deposit gelatin ova inside your body, then let them drop out to experience the thrill of a slimy extra-terrestrial birth. If left in place, they'll eventually dissolve.

Obsession is also undoubtedly at play for those who illegally collect bird eggs. While some collectors just snap photos of eggs in the wild, rogue oologists (those who study eggs) seize eggs from nests, leaving the birds unable to relay for the season. Full of secret societies, hotshot investigators and notorious outlaws, the shadow world of egg snatching includes sensational cases like the theft of 10,000 eggs from the Natural History Museum in the market town of Tring, Hertfordshire, and the exploits of a hardened Londoner who has served three prison sentences, including one resulting from a raid uncovering his cache of almost 600 eggs, some of which were hidden inside a bedframe.

Perhaps egg lovers of every description would be wise to heed the words of Lone Wolf, who, though he claims not to share his global clientele's particular kink, professes to have used the ovipositor without any hitches. "Frankly", he said on the issue of safety, "it is up to the person using it to know their own limits".

Chris Floyd
Anthony Bourdain at Brasserie Les Halles, New York, 2001

Ovophobia

An egg may be a thing of simple beauty, but for some it can provoke a deep and unshakeable dread. It is often said that such people suffer from ovophobia. As a somewhat niche fear it is understood to be "specific", meaning it is unlikely to cause significant disruption to a sufferer's daily life. Still, it is a recognised anxiety disorder nonetheless.

The term "ovophobia" covers all manner of discomfort and unease that eggs might inspire. Like other phobias, it is possible that the root cause can be linked back to a particular, negative experience involving the phobic source in question. This could include having to eat a woefully undercooked egg as a child. Or an egg cracked on the back of the head on the last day of school.

It's impossible to say how many ovophobes there might be roaming the earth, but we do know that one of the more famous ones was Alfred Hitchcock. The son of a grocer, the film auteur's aversion to eggs was little known during his lifetime, but has since become a topic of comment and speculation. It is rumoured, for instance, that the British-born Hitchcock never actually ate a single egg.

"I'm frightened of eggs", he once told a journalist. "Worse than frightened; they revolt me. That white round thing without any holes, and when you break it, inside there's that yellow thing, round, without any holes…Brr! Have you ever seen anything more revolting than an egg yolk breaking and spilling its yellow liquid?" Based on this visceral reaction, it's possible to conjecture that Hitchcock's

fear of eggs was compounded by an aversion to the colour yellow, known as xanthophobia.

The list of potential ovophobia-associated nightmares goes on. The otherworldly texture of a raw egg white could have slime-hating blennophobics running for the door. And, if the blennophobe who cracked the egg has left the stove unattended, then you'd have to keep your eye on the leukophobe hired to replace them. These folks shudder at the sight of anything white, and their terrors would overwhelm them as the pan warmed and the glistening albumen slowly turned opaque.

And that's not all. The yolk holds just as much potential to repulse. Cook the eggs over-easy, and the leukophobe would leave the yellow-hating xanthophobe to face their fear alone.

If there are other famous ovophobes, they have kept their own counsel, though a fear of eggs seems less of a peculiar phobia to reveal to the world than, say, Billy Bob Thornton's fear of antiques, Adele's fear of seagulls or Eminem's reported fear of owls.

If it's the case that Hitchcock remains the highest profile ovophobe, his work is evidence that there were a number of phobias he didn't appear to have. Ornithophobia would have prevented him directing *The Birds*, surrounded as he was by half-drunk crows and gulls. And his description of blood as "jolly" strikes out any possible trace of haemophobia. But, he did confess to finding his own movies too scary to bear…Surely there has to be a phobia to cover that?

OPPOSITE **Gustav Almestål**, *Ovophobia (after Hitchcock)*, 2021
FOLLOWING **Carl Kleiner**, *Egg on Pencil*, 2017; PAGE 49 *Pressure*, 2009

Toklas's Eggs, Stein's Appetite

A 1922 photograph by Man Ray shows Gertrude Stein and Alice Toklas at home in Paris, surrounded by the avant-garde art Stein bought with her sizeable family inheritance. Both stare at the camera, Stein sturdy and ample on a large floral armchair while Toklas perches on a tiny, low-slung Victorian one. The pair, who met in Paris in 1907, made a singular couple. Toklas reserved and watchful, Stein exuberant and magnetic, bumping around the city in a battered Ford she refused to put in reverse.

A pioneering American author of modernist novels and language experiments, Stein was a self-described genius, untouched by modesty. She was the flame around which her salon on the Left Bank revolved in the interwar years, when she would spar with the likes of Picasso, Matisse, Fitzgerald, Joyce and Hemingway (the last's work owes an enduring debt to Stein's preference for one-syllable words). While Stein held court with her formidable opinions of a painting or novel, the more practical roles fell to Toklas, who made the omelettes and plucked the pigeons that fed the stream of artists and writers who rang the bell at 27 rue de Fleurus.

Toklas's devoted catering to the international avant-garde is the focus of her repository of recipes and anecdotes, *The Alice B. Toklas Cook Book*, published in 1954. Packed with egg recipes of every description, there are also delicious musings on the culinary minutiae of life with her partner and their circle. There is Picasso's impossible diet — which seemed mainly to be spinach soufflé — Francis Picabia's preferred style of eggs, Cecil Beaton's iced apples, Dora Maar's laurel-leaf soup, and hashish fudge from Bryon Gysin.

The recipes Toklas recommends can be daunting: "Gigot de la Clinique" involves injecting a leg of mutton with orange juice every day for a week and then finally serving it with a sauce that requires two tablespoons of hare's blood. But contending with the cooks they employed often proved even more difficult. As Stein related in her book *The Autobiography of Alice B. Toklas*, the pair's one-time cook Hélène enforced idiosyncratic rules of etiquette. A Frenchman staying unexpectedly to dinner, for example, was an unforgivable faux pas. Told that Matisse would be doing just that, Hélène is withering: "In that case I will not make an omelette but fry the eggs", she is meant to have said. "It takes the same number of eggs and the same amount of butter but it shows less respect, and he will understand." Another cook, Jeanne, was more genial, boasting she could cook eggs "a hundred different ways" — Toklas gathered recipes for mirrored eggs, omelettes in overcoats and more in her cookbook — but Jeanne disappeared from their lives one day without explanation.

OPPOSITE **Carl Mydans**
Gertrude Stein and Alice B. Toklas in France, 1944

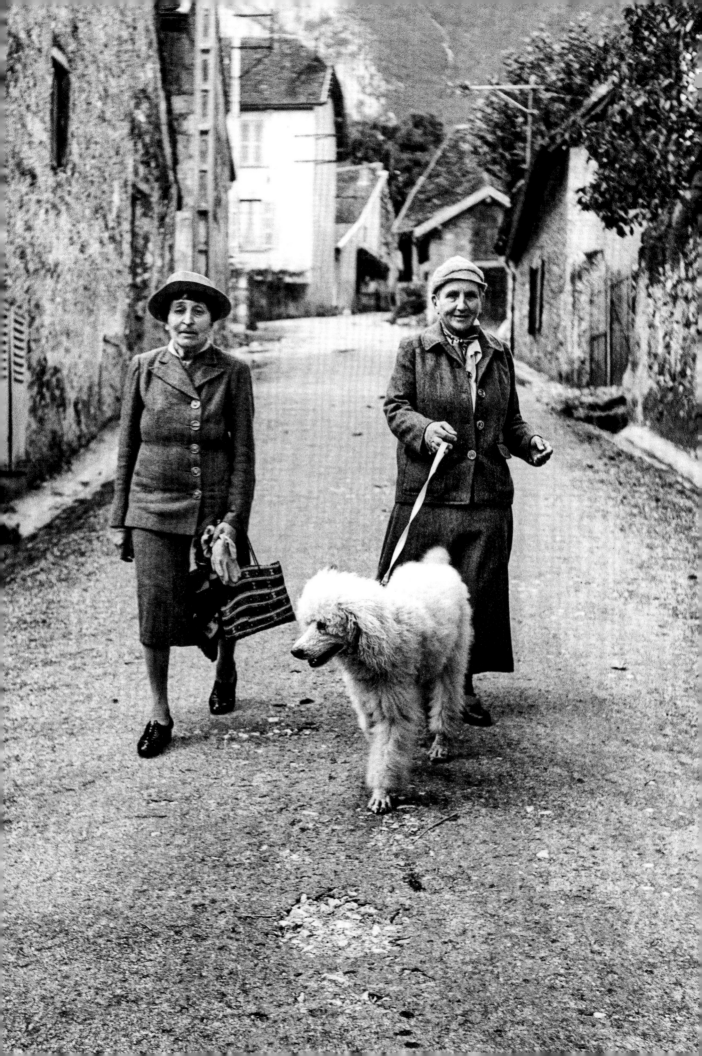

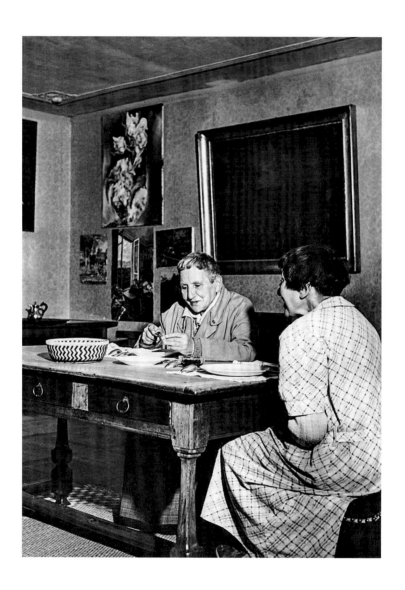

Thérsè Bonney
Gertrude Stein with Alice B. Toklas, 1941

In addition to the convivial meals chez Stein, Toklas faithfully records the dishes they were served in French high society, including an extravagant supper on a Lyons mountaintop and lunch at an ancient royal hunting lodge with an Italian movie star. But one portion of the book is devoted to the necessarily leaner meals under the German occupation of France during World War II. Stein explained her decision not to flee the country as the Germans advanced in apparently straightforward terms: "It would be awfully uncomfortable and I am fussy about my food." (The couple's appetites reflected their temperaments. Art patron Mabel Dodge said Stein "loved beef, and I used to like to see her sit down in front of five pounds of rare meat three inches thick and with strong wrists wielding knife and fork, finish it with gusto, while Alice ate a little slice daintily, like a cat".) What goes unmentioned is Stein's troubling closeness to Bernard Faÿ, a prominent Vichy regime collaborator. It's likely she received favourable treatment during the war years because of this relationship — explaining the conundrum of how a Jewish American lesbian couple felt safe enough to stay in Occupied France.

In 1940, as German and French planes battled overhead, the duo left Paris with two large hams and Basket, their poodle, in tow. They sheltered in Bugey, a region nestled in a loop of the Rhône river, with salad-green hills and plentiful vineyards. There seemed always to be a bottle or two of dry white wine in the cellar of the various houses they inhabited, but with strict rationing Toklas hatched ingenious schemes to liven up their daily menu. Her laborious gardening supplied them with some vegetables and fruit, crayfish were caught using an open umbrella, but eggs could be scarce — until the pair discovered the secrets of the black market and began negotiating its networks of rumour and innuendo.

At times, Toklas says, they would swap their dishwater for an egg from the neighbour's hen. Sometimes a prized cake, discreetly wrapped in newspaper, was dropped off by a bus driver in a designated spot. There was the windfall of a lamb clandestinely killed, or "odd bits of frequently unknown food — that is, pigs in pokes". Success required a constant ear to the ground and a knack for negotiation, Toklas writes: "it is not with money that one buys on the black market but with one's personality. Gertrude Stein when no one else did would return from a walk with an egg." Stein's relationship with Faÿ and even Vichy head of state Marshal Philippe Petain, whose anti-Semitic speeches she translated, surely had a hand in their luck.

It was Stein's annual tradition to give Toklas an "important" cookbook as a Christmas gift. Even during occupation, the 1,479-page *Le Grand Livre de la Cuisine* by Montagné and Salle was smuggled out of Paris and presented to "wifey", so that she could read "elaborate recipes there was no possibility of realising" by the light of their meagre fire. "In the beginning, like camels, we lived on our past", Toklas writes. "We had been well nourished." The dream of a silver dish of succulent ham floating in the air above her is described with a yearning born from subsisting on birdseed coffee and garden tobacco. After five long years of austerity, Toklas notes her most celebratory culinary creation as requiring a dizzying eight eggs she was happy to squander for a huge, square frangipange tart. It had tiny French and American flags flying at each corner and was baked in 1945 to welcome the liberating soldiers.

Post-war, the pair returned to their beloved Paris apartment, but life at rue de Fleurus would never return to the golden pre-war afternoons of copious food and literary badinage. Stein died the following year, leaving Toklas without her lover's considerable appetite to quench. The cookbook, masquerading as a very informal hotchpotch of French recipes gathered by an intrigued immigrant, was also Toklas's way of enshrining her integral role in supporting Stein for 39 years, and reliving their unique relationship in her absence. The eggs encountered within its pages are used to feed illustrious painters, or to show them disrespect, acquired by immoral means and shady negotiation, cooked in hunger and in celebration — each revealing more than one might expect from the humble oval foodstuff.

That Difficult Second Albumen

Raw, cooked or metaphorical, the egg has a polymorphic musical history. Highlights include 1967 surf-pop hit "The Little Black Egg", with the earworm riff every Daytona-Beach-teen learned to play, to Leadbelly's prison work song "Ham and Eggs": "Ham and eggs / pork and beans / I would have more / but the cook was so mean".

A Tribe Called Quest were torn about eating the same dish on their own, more nutrition-conscious "Ham 'n' Eggs". In the lyrics, the hiphop philosophers are caught between a mother's meal of veggies and fish, and the heartier, cholesterol-raising fare rustled up by grandmother: "Eggs was frying, ham was smelling / In ten minutes, she started yelling (come and get it) / And the gettins were good / I said, I shouldn't eat, she said, I think you should". Perhaps it's no surprise that one-quarter of ATCQ, Jarobi White, ended up in culinary school.

And while Lou Reed was known for anthems written about harder substances, "Egg Cream" is his nostalgic ode to the quintessential New York beverage of milk, seltzer and chocolate syrup, invented in the Lower East Side in the early 1900s. Lou's favourite came from Becky's, a Brooklyn diner that was blocks away from his primary school, and which offered an escape from the neighbourhood bullies. His one-time buddy Iggy Pop also recorded an egg-related song, 1981's "Eggs on Plate". Written at notorious rock 'n' roll hotel The Iroquois, it was Pop's verbal attack on music industry execs and a parting shot to his then label Arista, which at the time was trying and failing to turn him into a commercially palatable prospect.

Eggs are ammunition in The Beastie Boys' frenetic skirmish "Egg Raid on Mojo", which recounts the true story of revenge meted out when the doorman of a downtown NYC club wouldn't

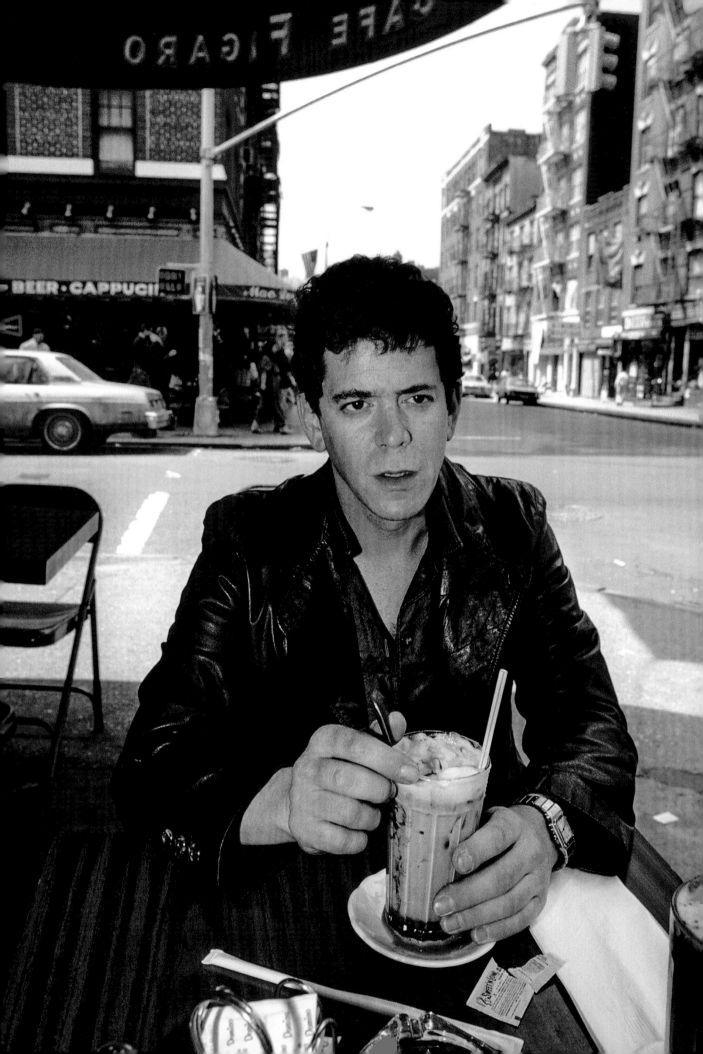

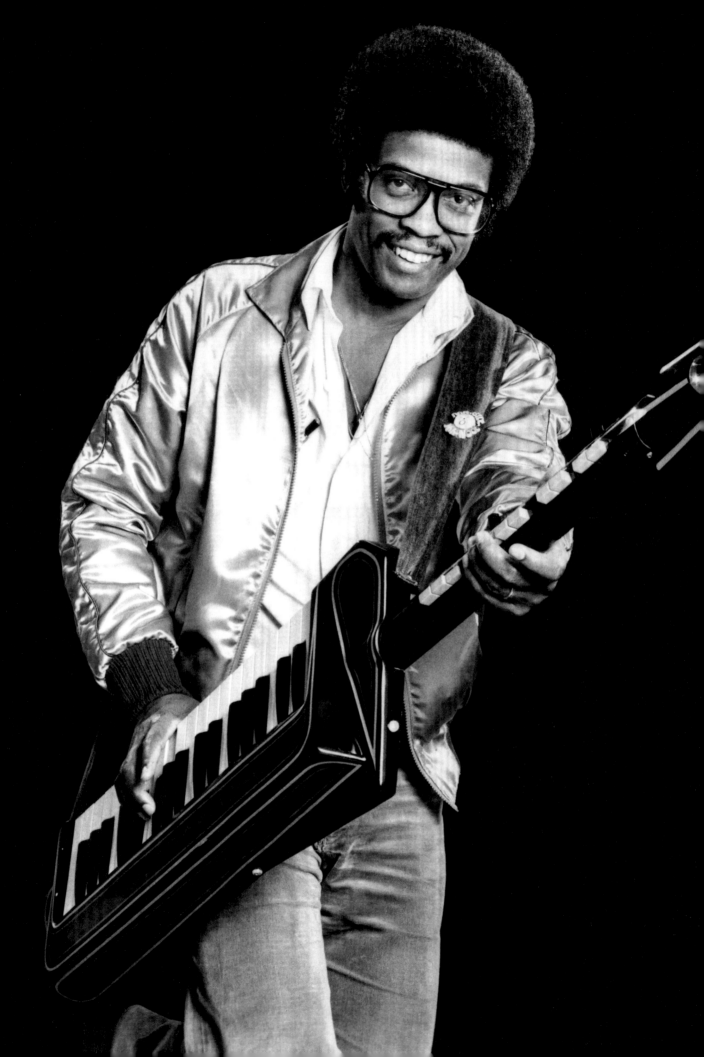

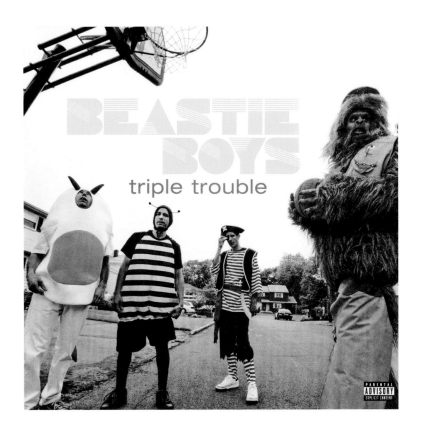

let them past the velvet rope. The boys had a reputation for egg pranks, targeting innocent bystanders from hotel room windows and the back of limousines while they were recording their seminal 1989 album *Paul's Boutique* in LA, as described on its fourth track, "Egg Man": "Not like the crack that you put in a pipe / But crack on your forehead, here's a towel, now wipe". In fact, their passion for throwing shells extended to employing a toy designer to create a Beastie Boys-branded egg gun, which sadly never made it past the prototype stage.

The Walrus may have been Paul McCartney, but the identity of "the eggman" in the Beatles' absurdist "I Am the Walrus" has never been definitively cracked. Suspects include Humpty Dumpty and frontman Eric Burdon of The Animals, with his alleged fetish for breaking eggs over naked women's bodies.

Ella Fitzgerald and Louis Armstrong are more monogamous in "I'm Putting all My Eggs in One Basket", agreeing to reign in their roaming ways for love, while Dean Martin and Helen O'Connell turn the innuendo-heavy pickup line, "How d'ya

OPPOSITE Herbie Hancock with his keytar, c.1981
Beastie Boys, *Triple Trouble*, album cover, 2004

like your eggs in the morning?" into a swinging jazz duet. Johnny Cash got cheers and whistles from the inmates of Folsom Prison in California, when he performed "Dirty Old Egg Sucking Dog" for them live in 1968: "Now if he don't stop eatin' my eggs up / Though I'm not a real bad guy / I'm gonna get my rifle and send him / To that great chicken house in the sky".

Cash's former housekeeper Peggy Knight shed some light on the Man in Black's favourite vittles in her recipe book *Cooking in the House of Cash*, featuring a smorgasbord of down-home, Cash family recipes: fried bologna and eggs, iron pot chilli and a wonderfully vague leftovers dish known as "stuff".

Another food-loving bard, Tom Waits, conjures nighthawks around the coffee urn with his insomniac ballad "Eggs and Sausage (In a Cadillac with Susan Michelson)", its lyrics fuelled by the songwriter's queasy gastronomic adventures around Los Angeles: "I...consider myself kind of a pioneer of the palate", he said of the song in 1975. "I've had strange-looking patty melts at Norm's. I've had dangerous veal cutlets at Copper Penny."

Finally, king of the keytar Herbie Hancock plays us out with his 14-minute jazz improv invention "The Egg". According to liner notes, the title refers to a mythical egg-shaped mountain on an enchanted isle full of giant, immortality-granting cantaloupes.

OPPOSITE **George Dubose**, Tom Waits for *Spin Magazine*, 1985
Louis Armstrong playing the trumpet, c.1953

In Your Face

A well-aimed egg can be an eloquent form of protest, arcing across political divides to pierce an inflated ego, or condemn a poor acting performance. In Elizabethan England, Shakespeare understood the necessity of keeping Globe pit crowds entertained with bawdy jokes to spare his actors a shower of eggs and other foodstuffs.

In the 19th century, the deed was equally popular across the Atlantic. "Actor demoralised by tomatoes", announced a *New York Times* headline in 1883, noting one John Ritchie as the victim of a revengeful audience when he failed to complete a somersault. "A large tomato thrown from the gallery struck him square between the eyes, and he fell to the stage floor just as several bad eggs dropped upon his head." Ritchie fled for the exit and vowed never to return to Hempstead, Long Island.

In feudal Japan, *metsubushi* (eye-closers) were a more precise weapon — eggs hollowed-out and filled with ash or pepper used by Samurai warriors to temporarily blind their opponents. English wrongdoers in the Middle Ages were clamped in pillories and forced to suffer even worse — missiles of rotten eggs and offal.

A cheap, accessible projectile, an egg can cause maximum damage to pride with minimum physical injury. George Eliot enshrined the act of egg throwing in her 1871 novel *Middlemarch*, subjecting the bumbling Mr Brooke to a hail of eggs during his ill-starred election speech. "The frustration would have been less exasperating if it had been less gamesome and boyish: a serious assault of which the newspaper reporter 'can aver that it endangered the learned gentleman's ribs' …has perhaps more consolations attached to it." Eliot's observation pinpoints the power of an egging: it's a forceful protest that is nonetheless faintly comical, leaving its victim grappling for an appropriate response.

Arnold Schwarzenegger managed to see the funny side when he was egged during his run for governor of California: "This guy owes me bacon now", said the Terminator. One-time UK Deputy Prime Minister John Prescott had a less amused reaction. The former heavyweight boxer landed a left jab on a pro-hunting citizen of North Wales who egged him at close range.

Still, the act of egging can be a form of celebration as much as admonishment. It has a long history as an element of mostly harmless mischief on Halloween night. And in Mexico, breaking *cascarones*, hollowed out eggshells filled with confetti, over a person's head on their birthday or on feast days is a symbol of good luck. This is a tradition reportedly stretching back to 13th-century China, when hollow eggs were sometimes filled with scented powder, resulting in a spillage that was infinitely more fragrant than the rotten eggs historically endured by politicians, criminals or criminally bad actors.

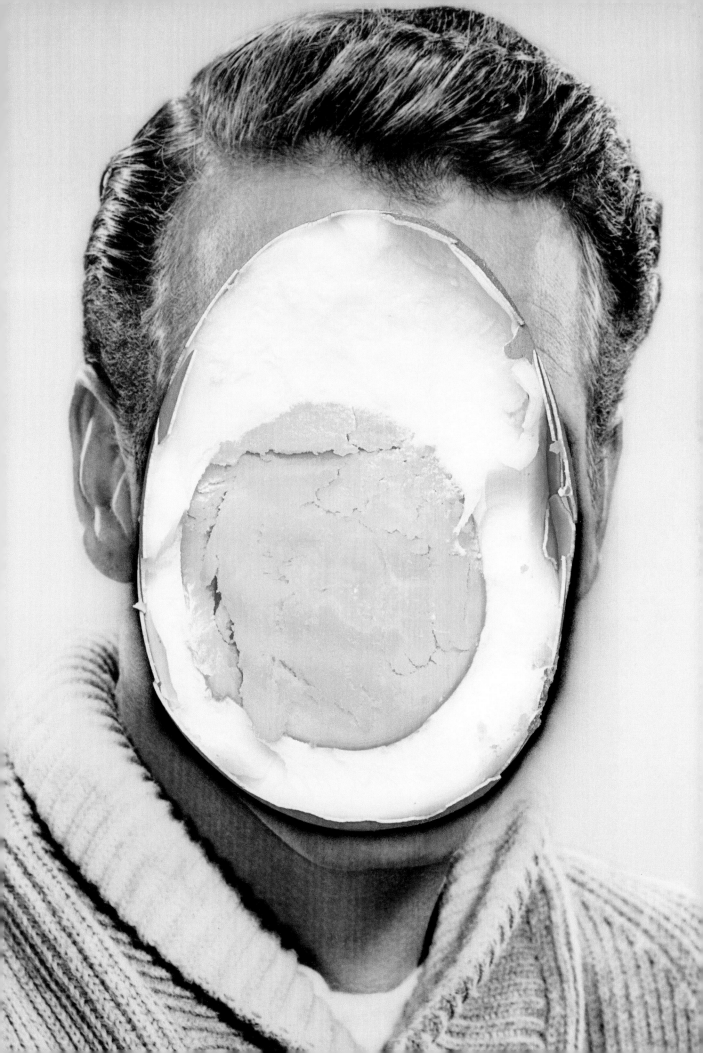

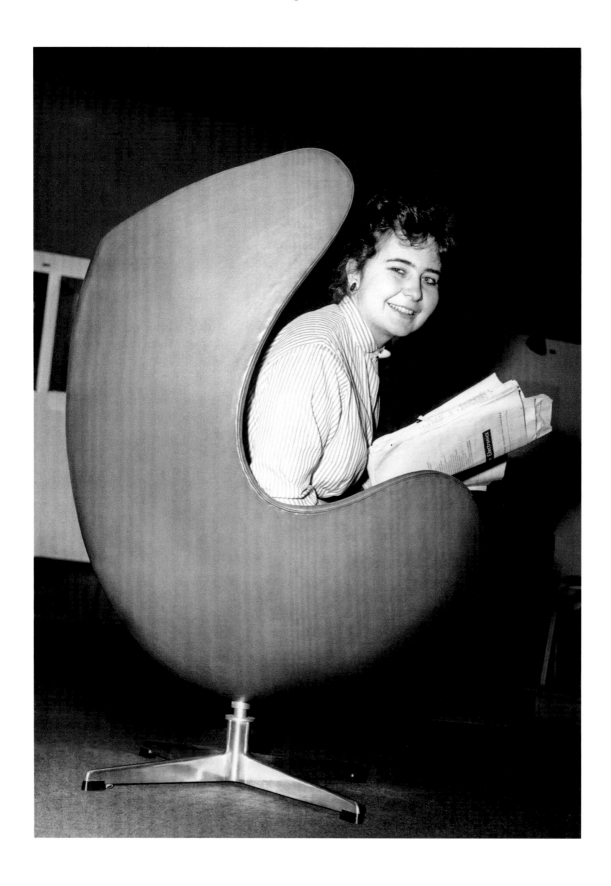

Exhibition at the Royal Institute of British Architects, 1959

Cracking Modernism

From its very first appearance in 1958, Chair 3361 was a sight to behold: a smooth, generous open-backed design that appeared to be a product of nature, not manufacture. Its serpentine, meandering curves seemed to converge beneath the chair's cushion; you wouldn't quite sit "on it" but very much "in it". The upper wings gave the sitter a sense of enclosure and privacy, and a hint of what it might feel like to be inside an egg, or at least freshly hatched. For these remarkable qualities, and more besides, the 3361 became immediately and affectionately known as "the Egg".

The Egg chair was one element of a much larger design enterprise, the building of the Royal Hotel in Copenhagen, commissioned in 1955 by Scandinavian Airlines (SAS). The project was masterminded by architect and furniture designer Arne Jacobsen, one of the foremost exponents of Nordic Functionalism — a type of modern design combining functionality with the restrained use of materials.

For Jacobsen and his well-established practice, the project truly represented the idea of the *Gesamtkunstwerk* ("total artwork" in German), where a designer is responsible for every aspect of a project, uniting many disciplines in its realisation. This approach was explained by the Italian design historian Ernesto Rogers as encompassing everything "from spoon to city" — an apt description in the case of the Royal Hotel, as Jacobsen would design everything, including the spoons.

Arne Jacobsen, c.1960

From the outside the Royal Hotel was a standard piece of International Modernism (the stripped back, step-and-repeat style that began in Europe), and it was also Copenhagen's first skyscraper. When sketches of the building were published in Danish newspapers, it was not well received. Critics warned that 22 storeys would destroy the city's skyline, while the building was pejoratively nicknamed the Glass Cigar Box. Jacobsen did not appear to mind. In fact, he seemed pleased when the building came out on top in a newspaper competition for the "ugliest building in Copenhagen".

The project's long-standing legacy, however, would prove to be inside the building, where Jacobsen exercised his fascination with the possibilities of new techniques and his guiding theory that "economy plus function equals style". Many pieces were informed by their basic purpose and function, right down to the organic silhouette of the AJ 660 cutlery. Photographs show the original lobby layout to be sparse and functional: a dozen or so Egg chairs and a couple of sofas grouped in clusters on rugs, and little else.

This functional approach to design flowed from Jacobsen's careful creative process. For the

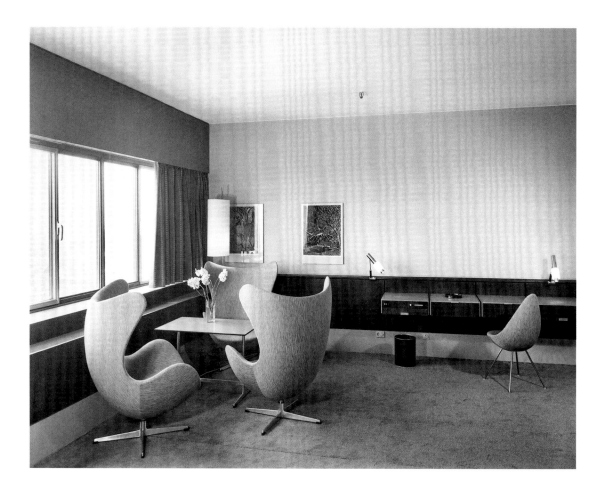

Room 606 at the Royal Hotel Copenhagen

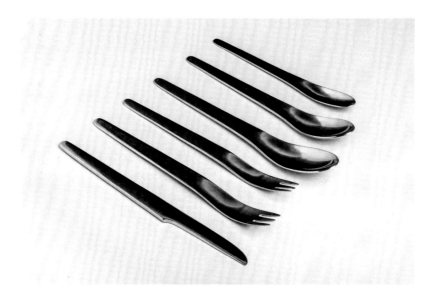

Egg, Jacobsen went from modest sketch straight to full-size plaster model, so as to sculpt it. With help from his assistant, he worked carefully on the plaster model of the chair, adding and taking away material before reaching what he felt was the perfect outline. As the assistant would later reminisce, Jacobsen's movements were so precise that splashes of plaster were seldom to be found on the master's clothes.

The chairs were made at the Fritz Hansen workshop, the official manufacturer of Jacobsen's chairs since 1934, and were first unveiled in Paris on 7 November 1958 as part of an exhibition at the Musée des Arts Décoratifs. The Egg, alongside the Swan and Drop chairs that Jacobsen had also designed especially for the Royal Hotel, were part of a display demonstrating the hotel room of the future, and caused quite a stir.

The chairs proved such a success that their production became an enterprise, while the press found ways to comment on its design. One contemporary cartoon poked fun at a customer in an interior design showroom who had collapsed into a chair, shattering it, with pieces of broken "shell" strewn across the shop floor. Another had Jacobsen dressed in full chef's uniform, fretting over the sight of an obviously underdone chair while another is placed into an oven, in what the cartoonist titled the "chair bakery".

Soon egg-ish chairs began hatching everywhere. Nanna and Jørgen Ditzel's Hanging Egg Chair appeared in 1959; Eero Aarnio's Ball Chair, a padded three-quarter sphere on a circular plinth, was introduced in 1966. Perhaps the best known was Henrik Thor Larsen's Ovalia chair, released two years later and arguably the most egg-like of them all.

Simultaneously retro and futuristic, the Egg has enjoyed a similar influence on popular culture. It made an appearance as Agent Zed's chair in *Men in Black*, Ringo Starr's preferred seat in the Beatles' movie *Help!*, and the chair on which Detective Martin Rohde sits and ponders in the Nordic noir TV drama *The Bridge*.

The Royal Hotel, through at least one major refurbishment, remains a brooding edifice at the heart of Copenhagen, but Room 606 has been kept in its original state. Available to book like any of the hotel's other rooms, the Arne Jacobsen Suite contains a number of innovations in their original form, including, of course, Egg chairs. As one newspaper put it at the time of their launch, "Even though it is imperfect as an egg, it is almost perfect as a chair".

AJ modernist cutlery made by Anton Michelsen and
designed by Arne Jacobsen in 1957 for the SAS Royal Hotel, Stockholm

The Birth of Breakfast TV

The 12 eggs that break the north London skyline south of the Regent's Canal towards Camden are a happy reminder of a revolution at the British breakfast table.

This dozen were once vibrant yellow eggs, in blue and white striped eggcups, and are fixed to the roof of a one-time TV studio complex, built on the site of a former car showroom, that once was a brewery. Despite several changes of ownership, significant demolition work, and a fiery blaze in the 40 years since they were installed, the eggs remain intact and in place.

Even now, repainted to match the building's current "tasteful" greige colour scheme, the eggs represent so much more than architectural whimsy. Because this was no ordinary TV studio, and these were no ordinary eggs.

In the UK of the early 1980s, the news made for a dismal start to the day. Although greed was supposed to be good, business was bad, unemployment high, and the nation was at war in the South Atlantic. As the bleary-eyed tuned in to their radios or read the papers to get the early bird headlines, the most excitement television could offer over breakfast was a transmission test card or an Open University lecture. It was all very grey.

Then, in 1983, came breakfast television, bringing sunshine to the overcast dawn. TV-am, the franchise for the UK's first commercial breakfast show, promised to be more up-to-date than the newspapers and offered a side of entertainment with your morning coffee. But before any programming could begin, the franchise needed a home, so the practice of architect Sir Terry Farrell was brought on board.

One of the leading postmodernist architects of his generation, known for his crowd-pleasing constructions, Farrell set to task designing a structure that would embody the spirit of the new channel. When a site in south London fell through, Farrell found an alternative location in Camden, and set about transforming a 1930s industrial unit into a fully operational broadcast studio.

Inside, a central atrium followed the path of the sun, and a succession of bubble-gum pink and mint green structures followed architectural styles from east to west: including loose interpretations of a Japanese temple, which doubled as the station's green room, a Mesopotamian ziggurat and a stretch of Western desert, which sat alongside the nuts and bolts of the TV station.

PAGE 66 **Baker and Evans,** *Untitled,* 2017
PREVIOUS **Carl Kleiner,** *Hommage to Calder,* 2011

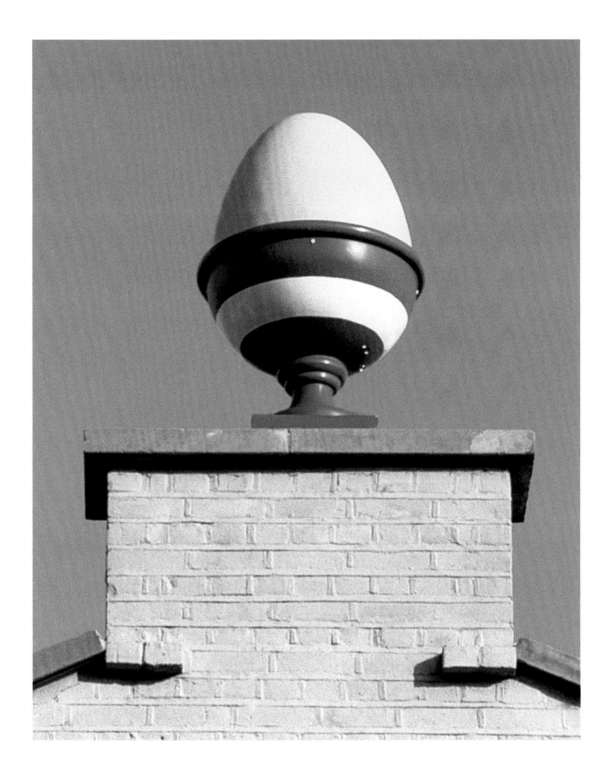

Egg cup on the TV-am building

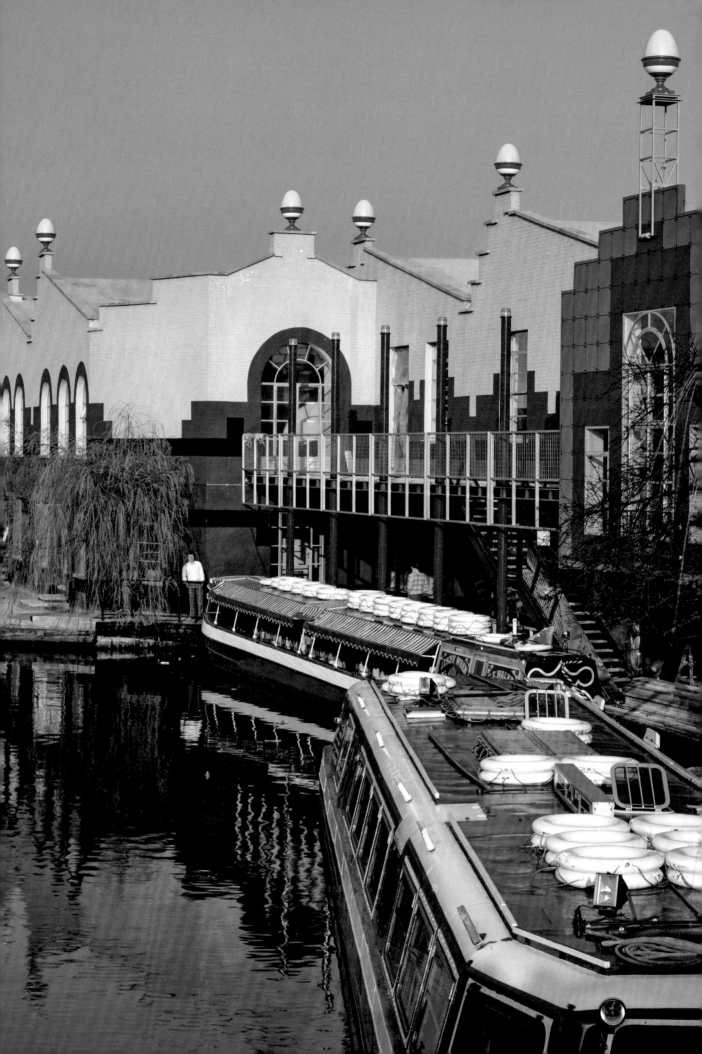

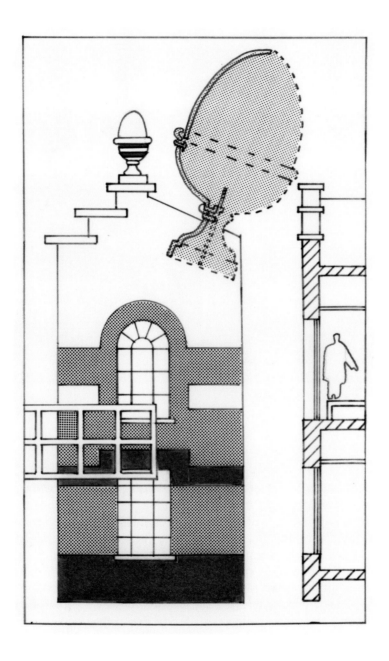

OPPOSITE **Richard Bryant,** view of the back of the
TV-am building from the Regent's Canal
Sir Terry Farrell, drawing of the TV-am building, 1983

71

But it was the exterior that Farrell brought to life with his belief that architecture had the power to delight. On the front façade, strips of vibrant colour were used to imitate the changing shades of a sunrise, and a TV-am logo sat proud at each long end of the building. The rear of the structure faced the canal, and was distinguished by its original sawtooth profile. Crow-stepped gables led to a series of pinnacles, and on each pinnacle was a plinth. For most of the period of development the plinths remained bare.

Then Farrell called his office from a hotel room in Venice. "What we really need for the roof of this studio", he told his team, "is a dozen three-feet-high egg cups, with eggs to match." His moment of inspiration, prompted by the decoration of the buildings he was surrounded by in Venice, came late in the day. No budget was left to produce them. The team had to come up with options, and find the cash.

In the end they were fashioned in glass fibre. The maker worried that the effect was "a bit too eggshell", but the team was impressed. At £1,200 for the dozen, they became some of the most expensive breakfast eggs in history.

Alas, the builders didn't quite share Farrell's sense of fun. They told the architects not to be so silly. And so it fell to members of Farrell's team to buy the bolts, scale the building, and install the eggs themselves.

Richard Bryant
Phone booths at TV-am

Almost an afterthought, the boiled egg was in fact the perfect symbol of a sunnier start to the day. And when TV-am went to air in February 1983, the eggs quickly became the symbol of the station, spawning their own range of merchandise and popping up in the end credits of the show. The building also became known locally as Eggcup House. One architectural commentator even described it as "one of the high points of postmodernism".

On and off screen, things were less rosy. The show suffered poor ratings and management fallouts. The arrival of Roland Rat, a new puppet intended to entertain children during the holidays, steadied things a little, but the station continued to be dogged by difficulty and misfortune.

In the end, TV-am did not survive the test of time. Its final broadcast was on 31 December 1992, and the building was subsequently sold to MTV Networks. The Japanese temples were removed, and the pink interiors completely overhauled. Today, the 12 eggs that were originally installed, although painted, are still in place. Just one egg, the one that makes the baker's dozen, remains in its original guise. Never installed on the building, it once graced the entrance of Farrell's architectural practice and is now held in the collection of the Royal Institute of British Architects, where it no doubt still brings joy to those who are lucky enough to see it, ideally on an otherwise dreary morning.

Richard Bryant
Reception desk at TV-am

"The egg, space for nesting, introduces the theme of the surreal in the genetic logic of biology. We can live inside an egg, but we can also eat it."

RICARDO EMILIO BOFILL

OPPOSITE
Carl Kleiner *Untitled,* 2017

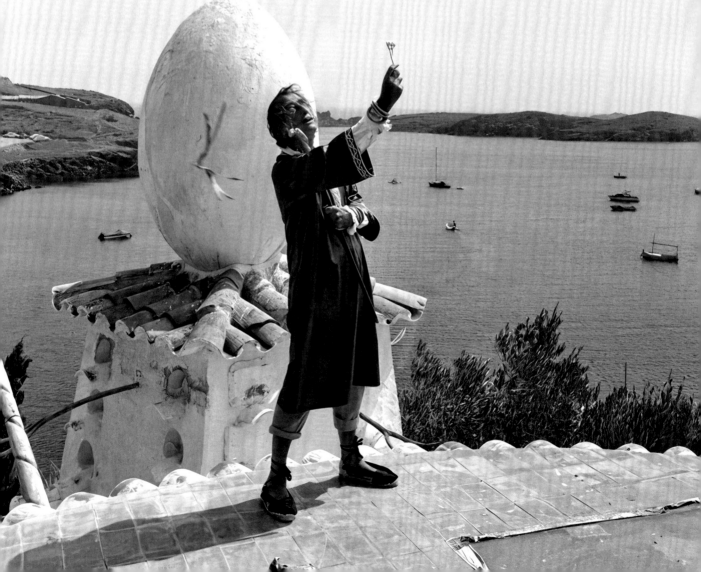

Surrealist Eggs

Eggs proliferate in the works of surrealist artists in a multiplicity of ways. They can symbolise new beginnings, life-cycles and the passage of time, the slippage between physical and metaphysical worlds, and, for surrealism's most famous egg-obsessive, Salvador Domingo Felipe Jacinto Dalí i Domènech, aka Dalí, they connote sex and "intrauterine" memories. His *Eggs on the Plate (Without the Plate)* (1932) was inspired by one such 'memory', summoned by applying pressure with his fingers to his eyes, stimulating phosphenes to create bright images of the inside of his mother's womb. In the painting, two sloppy fried eggs sit on brown a plate beneath a blistering fluorescent yellow sky, while another melting embryonic form dangles above, attached to an umbilical cord. The scene hints at Dalí's fascination with and terror of the female body — he was notoriously afraid of vaginas.

When it came to sex, eggs played a role in the artist's bizarre seduction — or anti-seduction — techniques: "Dalí seduced many ladies, particularly American ladies", said his friend, filmmaker Luis Buñuel, "but these seductions usually consisted of stripping them naked in his apartment, frying a couple of eggs, putting them on the woman's shoulders and, without a word, showing them the door."

OPPOSITE Dalí floats a chair against the sky, with *The Highest Egg in the House* behind him on the roof of his villa, 1970

As his flirtatious egg frying suggests, Salvador Dalí loved food, and he loved to cook — he declared at the age of six that he wanted to be a chef. His obsession with eggs is no more obvious than in his sumptuous 1973 cookbook, *Les Diners De Gala*, in which he shared recipes for the extravagant dinners that he hosted with his wife and muse, the Russian poet Gala, and eggs take a central role. Recipes include thousand-year-old eggs, a traditional Chinese delicacy, and there's even a section dedicated to eggs and seafood titled after his painting *Autumnal Cannibalism*, which depicts two faceless figures devouring each other with knives and spoons. The cookbook contains the type of eccentric recipe imagery you'd expect from Dalí, including a Joan of Arc figure presented as a cake-topper on a mountain of crayfish, blood spraying from her amputated arms onto a plate of severed heads. It also features sketches of limbless dwarves eating eggs; an egg soufflé topped with a tower of 11 frogs' legs; and whipped and glazed eggs — at least, they look like eggs — lurking in the margins of a table elaborately laid out with hand-painted hams and dusty bottles of red wine.

Dalí also experimented with eggs as a herald of new dawns. *Metamorphosis of Narcissus* (1937) shows the mythical Greek hunter mirrored in the shape of a giant stone hand holding an egg that sprouts a narcissus, referencing his metamorphosis into a flower. Continuing the theme, in *Geopoliticus Child Watching the Birth of the New Man* (1943), a man spills out of a glowing, globe-like egg. Painted during Dalí's eight-year stay in the US, it has been interpreted as his commentary on the country's emergence as a new power after World War II. (Writer Aylin Zafar has suggested Lady Gaga's surreal, space-age "Born This Way" video was partly inspired by the work.). Eggs are also a symbol of transformation and new beginnings in a self-portrait by René Magritte, *La Clairvoyance* (1936), which shows the artist painting a bird on a canvas while looking at an egg sitting on a table — he is perhaps painting its future.

For Magritte, eggs could symbolise the hatching of creative ideas, too. His golden-hued painting *Elective Affinities* (1933) shows an egg sitting in a cage instead of a bird, and was inspired by a night-time vision. That the egg about to hatch is stuck in a cage suggested the limits of our free will, and the fact that we are ultimately governed by external forces.

Similarly dreamlike imagery abounds in the genre-defying work of artist Dorothea Tanning, who plumbed the depths of her subconscious to conjure woozily fantastical reveries. She and other surrealist artists have used the egg to represent experiences relating to perceived female vulnerability or fragility, as in her *The Guest Room* (1950–1952), in which broken eggs are littered on a bedroom floor beside a naked pubescent girl, who stands beside a mysterious masked figure. The cracked eggs seem to suggest a gateway between adolescence and adulthood, a metaphor for the fear society has taught teenage girls to have about their own bodies. *The Minutes* series by the American artist Kay Sage is also a surreal illustration of the dangers faced by women in our society. It features geometric enviroments in which pencil-drawn eggs — readable as women's bodies — perch in an array of perilous situations: at the edge of a cliff, or at the top of a staircase. In *Minutes no. 14* (1943), an egg rolls down a mountain on a steep ramp as sharp objects fly aggressively towards it.

For some surrealist artists, eggs represent the movement between physical and metaphysical worlds. Three luminous egg-like forms appear in Afro-Cuban artist Wifredo Lam's *Sur les Traces* (1945). They are surrounded by supernatural figures that draw on cross-cultural influences such as Chinese ink-wash painting and the Santería religion, a belief system with roots in West Africa (Lam's godmother was a Santería priestess).

The idea of merging worlds also fascinated the British–Mexican artist and novelist Leonora Carrington, particularly the ancient Celtic worldview that lands, animals, people and divinities were interdependent. Carrington's Irish mother had told her stories from Celtic mythology and folklore, which the artist explored in her 1947 painting *The Giantess (The Guardian of the Egg)*. Featuring a large female figure whose tiny hands emerge from behind a cape holding an egg, Carrington explained the egg represented "the macrocosm and the microcosm, the dividing line between the Big and the Small which makes it impossible to see the whole".

René Magritte, *La Clairvoyance,* 1936
Salvador Dalí, *Eggs on the Plate without the Plate (Oeufs sur le Plat sans le Plat),* 1932

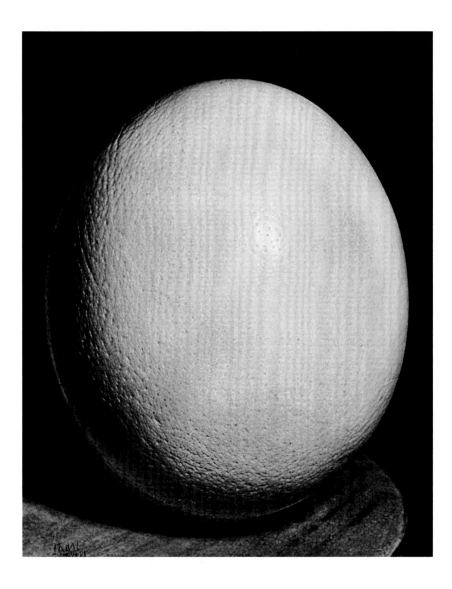

The so-called prophet of the avant-garde, Man Ray, adopted the egg for similar purposes, most memorably with *Ostrich Egg* (1944), a work that transformed the micro into the macro: a beautiful black and white photograph of an egg, the artist zooms in so close that the shell looks like a lunar surface, the origins of the universe detectable in a tiny fragment of eggshell.

Mexican artist Sergio Bustamante's own ostrich eggs, made from papier-mâché, carry miniature universes too, in this case intricate scenes of flora and fauna hand painted onto their shells. He translated his flights of egg fancy into miniature by creating egg-faced pendants and necklaces; tiny, wearable surrealist art pieces. They echo Salvador Dalí's own foray into surrealist jewellery — bejewelled eyes, hearts and lips — that are today collected in the Dalí Theatre and Museum, located in his home town of Figueres in Spain. A red-painted, fortress-like structure designed by the artist, the museum is a work of art in itself, with a façade that features several giant white eggs dolloped on top and circling its turret. It is a gloriously bizarre spectacle that makes the significance of eggs to the extravagantly moustachioed artist abundantly clear.

OPPOSITE **Kay Sage**, *The Minutes no. 14*, 1943
Man Ray, *Ostrich Egg*, 1940

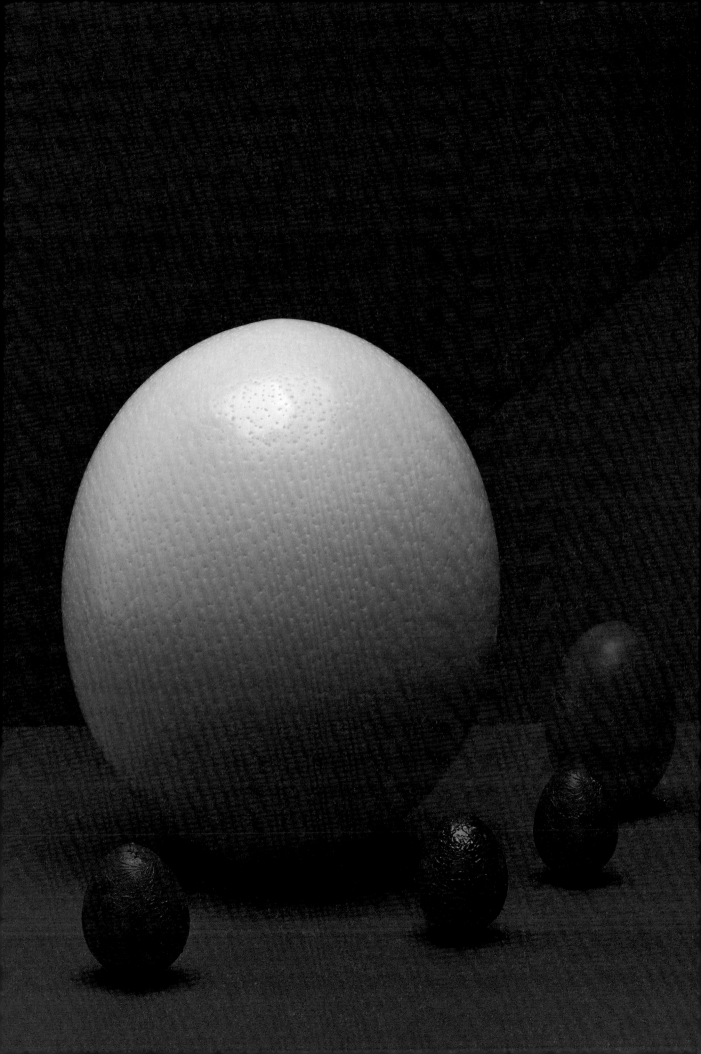

The Morning After

When he was hungover, Romantic poet Samuel Taylor Coleridge swore by six fried eggs and a glass of laudanum with seltzer (whether it was the eggs or the opium-laced fizzy water that did the trick, we'll never know…).

A century and a half later, Jeeves, that paragon of British butlering dreamed up by author P. G. Wodehouse, served a prairie oyster — a concoction of raw egg, worcestershire sauce and hotsauce — to consummate bachelor Wooster, to contend with his heavy heads.

Meanwhile, an all-the-trimmings morning-after breakfast has long been the choice of those greeting the new day with dark circles under the eyes and misshapen memories in their minds.

So while the idea of eggs as an antidote for the overconsumption of alcohol regularly circulates in popular myth, it's reassuring to discover that in this case, folk wisdom has a basis in fact.

It is a scientific reality that the egg is the hero in a duel between two chemicals. The first is left lurking within our innards through overindulgence, while the second, introduced via eggs, may bring relief to this disquiet.

First and foremost, the body really doesn't like alcohol. From the moment it enters our system, it does so as an invader. The higher the concentration, the worse the impact and the harder the body has to work to get itself back to square one. When our delicate chemistry senses alcohol, our liver starts to produce a toxin called acetaldehyde, which helps get the worst elements of the alcohol out of our system, but adds to the symptoms of the hangover, causing us to dehydrate and experience headaches and nausea.

Of the many things we could do to feel better, drinking water is the simplest and the best. But the humble egg is also capable of adding to a renewed sense of self. From a chemical point of view, eggs, cooked or uncooked, contain some very helpful substances to assist in the repair of our brain and body.

One is cysteine, an amino acid that steps in to help break down the beastly acetaldehyde. Cysteine is naturally produced in the body, but it spends most of its time helping maintain healthy nails, skin and hair. Eggs can bring us an additional boost of it. Eggs also contain choline, which can help reconnect the neurotransmitters that our indulgences have left scrambled.

Jeeves' insistence on raw eggs does have some advantage in that an uncooked egg contains a higher concentration of the good chemicals. But beware. Raw eggs also bring an increased risk of salmonella — compared with which a hangover is immeasurably preferable.

So in the long run, it's perhaps best to follow Coleridge and take that order of six fried eggs, hold the laudanum, and steadily make your way back towards the land of the living.

PREVIOUS **Gustav Almestål**, from *"The Birds Odyssey"*, *The Gourmand*, Issue 02, 2013
OPPOSITE **Gustav Almestål**, *Prairie Oyster*, 2021

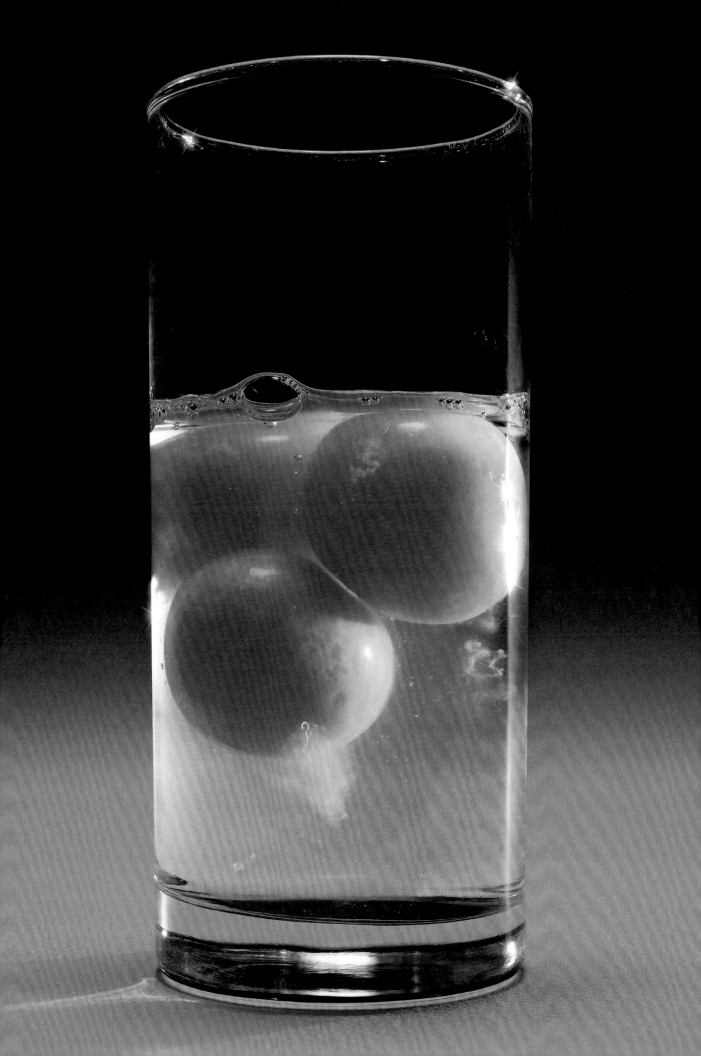

Mr and Mrs Benedict

For a privileged few, so-called Gilded Age New York was an era of opera boxes, palm gardens and candlelit soirées under triple-height ceilings. As the first towers began to shape the Manhattan skyline, 1890s high society circled around a handful of grand, turreted hotels filled with guests "as richly upholstered as the furniture", as Edith Wharton wrote in her sharp-eyed novel *The House of Mirth*.

One morning in 1894, Wall Street stockbroker Lemuel Benedict directed his carriage to one such hotel — the newly risen Waldorf on Fifth Avenue and 33rd Street — in search of breakfast. The Waldorf, built by the richest man in America at the time, William Waldorf Astor, was a magnet for steel tycoons, railroad barons, presidents and maharajahs. They came to sip highballs and trade gossip about the pinball trajectory of the stock market, or the anarchists then throwing bombs around Paris. Benedict would have been at ease amid the hotel's many Olympic-length rugs and European antiques. He was a big-tipping regular of society columns, known to sport a raccoon-skin coat and own a cane that concealed a liquor flask. In fact, he was reportedly worse for wear on the morning in question, following a heavy night of revelry.

Seeking sustenance, he entered the hotel's Empire Room, modelled on the eccentric King Ludwig's palace in Munich, and put in a breakfast order that made culinary history: buttered toast, poached eggs, bacon and a pitcher of hollandaise sauce. The Waldorf's maître d' was Oscar Tschirky, also known as "Oscar of the Waldorf", a figure who was fast becoming as famous as his illustrious clientele of Vanderbilts and Rockefellers. Gifted with an exhaustive memory for his guests' every whim — their demands spanned ceremonial doves to model battleships — Tschirky was also credited as the inventor of both the Waldorf salad and thousand island dressing. He recognised a winning combination in Benedict's unusual request (hollandaise would have traditionally accompanied asparagus or fish), and soon "Eggs Benedict" appeared on the Waldorf's breakfast and lunch menus, with certain modifications. Tschirky swapped toast for an english muffin, and bacon for ham — and a brunch staple was born. Or so the legend goes.

But there are rivals to Lemuel Benedict's claim. That same year of 1894, Charles Ranhofer, the impeccably dressed chef of Delmonico's — the lower Manhattan institution still famed for its steaks — published his cookbook *The Epicurean*.

OPPOSITE **Paul Trebilcock**
Oscar of the Waldorf, c.1930

It included not only Ranhofer's brainchild, baked Alaska (invented to celebrate the US's acquisition of the territory), but also eggs à la Benedict, a dish the restaurant still claims he conceived when old-moneyed Delmonico patron Mrs LeGrand Benedict (no known relation to Lemuel) tired of the menu and asked Ranhofer to rustle up something new.

To entangle the mystery even further, Oscar of the Waldorf had previously been employed at Delmonico's, and Lemuel Benedict also dined there frequently. Whether it was the result of Manhattan culinary whispers or a single lightning bolt of inspiration, by the time *The New Yorker* caught up with Benedict in a "Talk of the Town" piece in 1942, eggs Benny had travelled the globe. (The Waldorf, meanwhile, had succumbed to the wrecking ball to make way for the Empire State Building, and moved its operations uptown.) The magazine had tracked Lemuel Benedict down to Stamford, Connecticut, where he was writing political articles, "Republican in tone", for the local newspaper.

He had retired in comfort with his opera singer wife Carrie Bridewell in 1927, just in time to avoid the Wall Street Crash. "His happiest memories, however, are gastronomical rather than financial", the article states. "He remembers W. K. Vanderbilt's chef…who claimed he put terrapin in a more cheerful frame of mind and improved

Alice Faye as Lillian Russell and
Edward Arnold as Diamond Jim Brady in *Lillian Russell*, 1940

their flavor by reading a newspaper to them before dropping them in the soup." Benedict also recounted vivid tales of extravagant Manhattan society, "of the Broadway lobster palaces, of get-togethers at Delmonico's with Diamond Jim Brady and Lillian Russell, and of informal Sunday afternoons at his own home, with Schumann-Heink or Caruso eating his food and spontaneously bursting into song."

On the subject of the ubiquitous mid-morning standby that carried his name, Benedict voiced strong reservations about Tschirky's adaptations.

English muffins, he grumbled, were "un-palatable, no matter how much they are toasted or how they are served."

Benedict died in 1943, a year after the piece was published. It's perhaps for the best he never lived to see further evolutions of his concoction —into a McDonald's favourite, for instance: wrapped in wax paper with a melted American cheese slice standing in for hollandaise sauce. The Egg McMuffin is eggs Benedict for the masses, which its namesake undoubtedly would have found an alteration much too far.

Restaurant at the Warldorf, 1902
FOLLOWING SPREAD **Gustav Almestål**, *Untitled*, 2021

Century Eggs

A Chinese comfort food dating back 600 years, the century egg, also known as a thousand-year-old egg, can conjure up images of ancient dynasties and multi-course imperial feasts. According to legend, the delicacy was accidentally discovered during the Ming dynasty, when a resident of Hunan province, in southern China, found a collection of duck eggs immersed in a puddle of slaked lime left over from housing construction. For reasons we can now only wonder at, this intrepid character decided to sample them, and, in that moment, an intensely flavoured dish was born.

The less imaginative theory is that the process was simply a neat way to keep a nutrient-packed meal from going rotten. Preparation usually takes two to five months (not the century the bombastic name suggests), and these days involves soaking duck, quail or chicken eggs in a solution of clay, salt, ash, quicklime and rice hulls. The ensuing chemical process makes the egg more alkaline and transforms it, turning the whites a translucent, gelatinous rust colour, and the yolks a rich, gooey shade of muddy green. While the whites taste much the same as a regular boiled egg, the yolks are supercharged into something closer to a soft blue cheese such as roquefort — and, consequently, are best enjoyed at a leisurely pace (although, despite their strong flavour and richness, the curing process actually lowers the cholesterol of the egg).

Today in Southeast Asia, century eggs can be found everywhere from five-star hotels to street food stalls, in a kaleidoscope of guises that conjure memories of childhood for many. It is baked into balls of pastry, mixed with congee, or served behind the vast gold frontage of Hong Kong's historic Yung Kee restaurant, where it makes a regular appearance as an appetizer, with pickled ginger.

Century eggs have also raised a few eyebrows. For one, their unconventional colours may startle eaters accustomed to eggs being white and yellow, while their pungent odour has landed them the nickname *khai yiao ma*, or "horse urine eggs", in Thailand.

But when examined up close, the unshelled surface of a century egg often has a rather beautiful, delicate leaf pattern — a result of the protein in the egg breaking down — that has won it another name: the "pine-blossom egg", a more elegant moniker for these venerable creations.

OPPOSITE **Marius W Hansen**
Century Eggs, 2021

"If a pebble or an egg can be
enjoyed for the sake of its shape only,
it is one step towards
a true appreciation of sculpture."

BARBARA HEPWORTH

Feminist Eggs

In Vanessa Engle's 1996 documentary *Two Melons and a Stinking Fish,* UK artist Sarah Lucas buys half a dozen organic eggs from a butcher's shop in Highbury, north London for £1.24. She later fries up two, and places them onto a varnished wooden table alongside a doner kebab — a pita bulging with strips of rotisserie meat. The foodstuffs were arranged by the artist to evoke the shape of a woman's breasts and genitals. Written on the table in black pen are the credits for the work: "Two fried eggs and a kebab, 1992, Sarah Lucas". The title echoes the kind of vulgar banter about women's bodies the artist remembers hearing while growing up in London, and she once referred to the work as a "defence mechanism", saying she had "live[d] with remarks like that all my life".

Lucas has spent a lot of time with eggs in her work. Perhaps the most famous is her *Self Portrait with Fried Eggs* (1996). This photo shows the artist sitting deep in a chair, her back straight, her denim-clad legs open at an acute angle and her gaze direct and unflinching. Two fried eggs have been gingerly placed on her khaki green T-shirt over her breasts, the yolks pointing in different directions. Of her ability to serve up provocation and humour at once, art critic Roberta Smith once wrote, "Over the years, I don't think any artist's work has shocked me — mostly in good ways — as often as Ms Lucas's."

Since a significant number of women's bodies produce eggs on a regular basis, it's not surprising to see them show up in feminist art; often as a visual eponym for the female body itself, and to explore everything from sexism and eroticism to themes of oppression and liberation. In 1967, Brazilian artist Lygia Pape hatched out of a white box onto a beach in her video *O Ovo* (The Egg). Readable as a comment on the rigid parameters of the art world, this escape from inside a white, oppressive cube into an organic natural scene was a prescient comment on the types of gallery spaces that would grow to ubiquity in the Western world — spaces in which women artists would be regularly under-represented.

Lygia Pape, *O Ovo*, 1967
OPPOSITE **Sarah Lucas**, *Self Portrait with Fried Eggs*, 1996

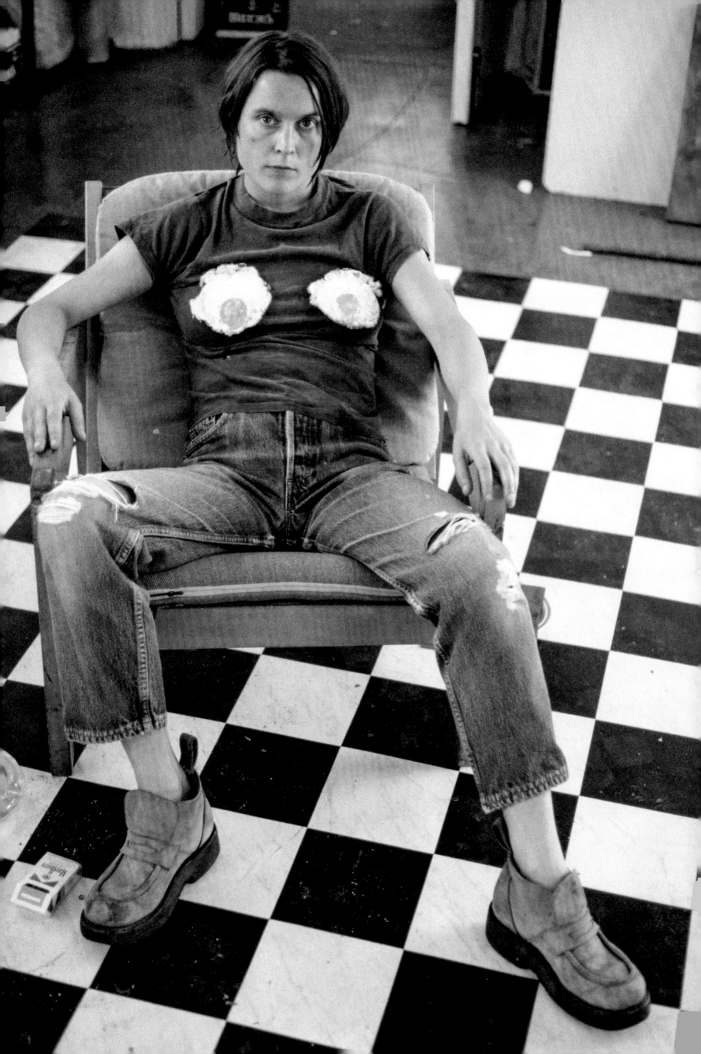

The indoors — the home in particular — is a recurring theme in feminist art featuring eggs, including the work of British artist Su Richardson. Her textile piece *Burnt Breakfast* (1975–1977), a crocheted plate of egg, sausage, bacon and tomato, was done as part of the Postal Art Event, a project intended to connect women artists across the UK through the sharing of mail art. Alongside postcards and other items, this full English breakfast eventually found its way through the letterbox of one of Richardson's contemporaries, and hints at the fact that a lot of the women artists that she knew, especially mothers with young children, worked from home rather than at a studio.

Feminist pioneer and consummate collaborator Judy Chicago also explores domestic themes. In 1971, she and Miriam Schapiro co-founded the Feminist Art Program at the California Institute of the Arts, and started work on what would become 1972's ground-breaking *Womanhouse*, a multiparticipant, multimedia installation set in a rundown Hollywood mansion. One of the big attractions was the walk-in installation by Susan Frazier, Vicki Hodgetts and Robin Weltsch, designed to mimic a carefully organised, modern Western kitchen. All the items and surfaces in *Nurturant Kitchen* were sickly Pepto Bismol pink, from the space-age gadgets to the stove and pantry items.

Foam fried-egg formations covered the ceiling and crept down the walls, growing pinker and pinker as they sunk; new iterations increasingly resembled breasts, the yolks eventually morphing into nipples. Camp and surreal, the installation hinted at the pressures put on women to be human dolls; to play house (cook eggs) and be sexually available on demand (show breasts).

Ablutions (1972) was a much more difficult work by Chicago and her collaborators, in this instance Suzanne Lacy, Sandra Orgel and Aviva Rahmani. The performance was about rape, and featured two women sitting in metal wash tubs filled with eggs, blood and clay. Another woman is bound from head to toe with gauze bandages. Scattered around the performers are broken egg shells, ropes, chains and animal kidneys. A pre-recorded soundtrack played in the room, testimonials spoken by women about their experiences of sexual violence. Chicago then returned to the symbolic power of eggs in the 1980s with her *Birth Project*, a collaborative series of multimedia works, including the embroidery *Hatching the Universal Egg E3* (1984). Done with needleworker Kris Wetterlund, the expressive piece features a symbolic figure holding a giant cracking egg; she is both the universal mother and an individual woman giving birth.

Su Richardson
Burnt Breakfast, 1975–1977

Judy Chicago, Suzanne Lacy, Sandra Orgel and **Aviva Rahmani**
Ablutions, 1972. Photo by Lloyd Hamrol

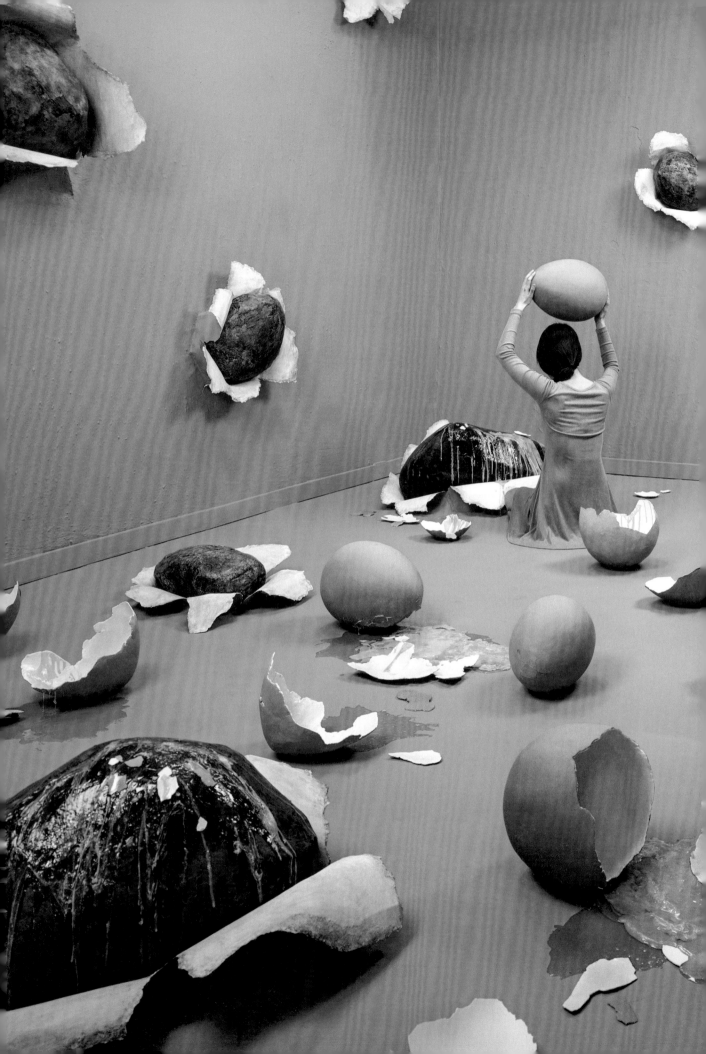

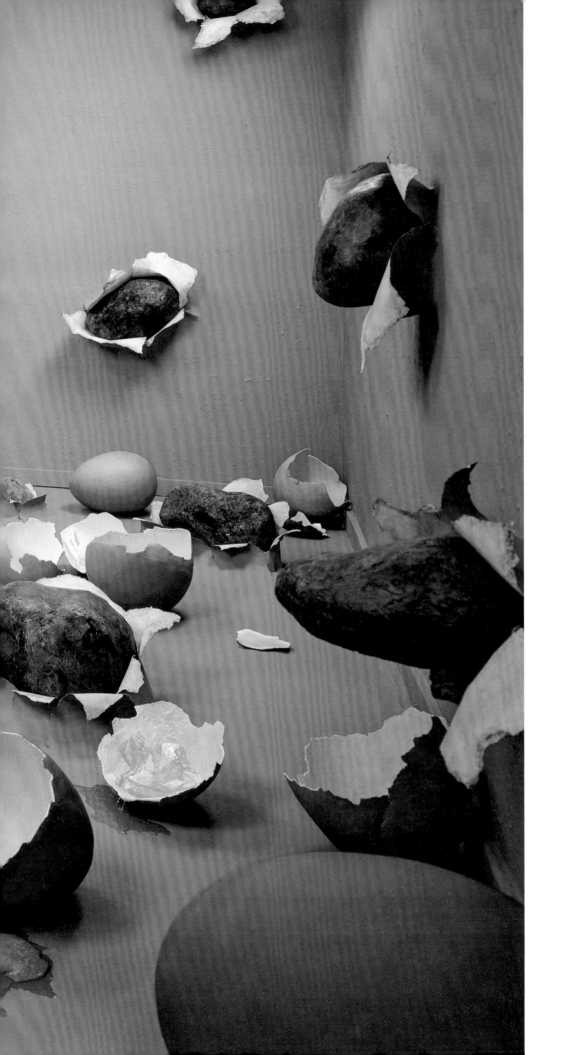

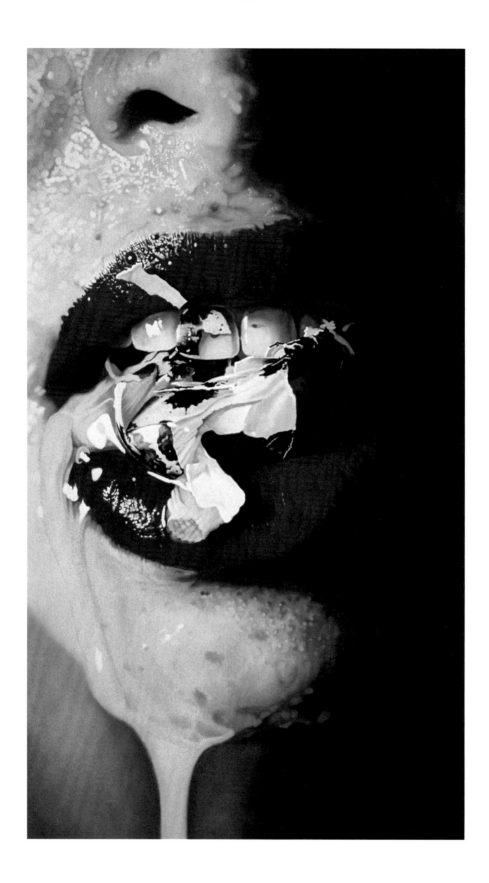

PREVIOUS **JeeYoung Lee,** *Broken Heart,* **2011**
Marilyn Minter, *Quail's Egg,* 2004

Flipping expectations about what type of anatomy an egg could embody, Austrian avantgardist Renate Bertlmann's *Exhibitionism* (1973), was an elegant but still bawdy sculptural optical illusion about masculinity. Comprising three astract mixed-media assemblages, it featured delicate lines, careful shading and two egg-shaped Styrofoam objects. A closer look reveals the outline of legs, bums and testicles seen from various angles. Bertlmann says the idea for the piece came to her after hearing about "militant feminists who wanted to cut off [men's] balls". Instead, she chose to present the male as an object of "sexual disrobement and denudation". This approach seems to have been effective. One gallerist refused to include the work in a show because it made him feel like he was "exposing himself".

Marilyn Minter offered a similarly zoomed anatomical view when she cast her critical eye on the world of commercial image production for *Quail's Egg* (2004). One of the American artist's hyperreal enamel-on-metal paintings, it shows a close-up of a woman's glossy red, slightly parted lips. She is crushing a small, brown-spotted quail's egg with her perfectly white teeth, while golden yolk dribbles down the side of her mouth. Intended as a provocation about the male gaze, it is also a presentation of unapologetic female carnality. What at first might seem like the usual type of objectified body-part imagery used to sell goods, quickly shifts into the beautiful and the grotesque, and back again.

Recent feminist art continues to harness the symbolic power of the egg. In 2018, British artist Heather Phillipson's cartoonish *my name is lettie eggsyrub* was installed at London's Gloucester Road Tube station to mark 100 years of women's suffrage in the UK. The installation included screens showing eggs being cracked, whipped and spread across sandwiches. It was reported that this stirred the hunger of some commuters, a fact that surprised Phillipson, who is vegan. Not only do the eggs represent fertility, strength, birth and futurity, she said, but also the other side of the coin: "(over)production, consumption, exploitation and fragility."

Renate Bertlmann
Exhibitionism, 1973

Shonibare's Egg Fight

Two headless figures with long-barrelled shot-guns square off in a peculiar duel. Positioned on either side of a wall made of eggs, the men wear musketeer boots and bright patterned Ankara fabric tailored to an 18th-century style. There's a scattering of bullet holes puncturing the wall's egg "bricks", and one larger blast that looks geographic in shape — like the outline of a country or continent. White, brown and dark-orange eggs lay burnt and scattered on the floor, casualties of the crossfire.

In Yinka Shonibare's monumental *Egg Fight* (2009) installation, these two figures are frozen in a dramatic but seemingly absurd power play, the cause of which is not immediately clear: what are they fighting about? And what do the eggs have to do with it?

London-born Shonibare has said he was inspired by Jonathan Swift's 1726 classic *Gulliver's Travels*, in which the titular character stumbles upon an ongoing civil dispute that has erupted between the inhabitants of fictional island nation Lilliput, about whether the larger or smaller end of a boiled egg should be cracked first before eating. Swift, an Irish-born cleric, is satirizing the centuries-old conflict between Protestants and Catholics, which could take issue with anything from high doctrine, scriptural interpretation or marriage laws to petty disputes that had little to do with the saving of souls.

Shonibare peppers his own visual language into this Swiftian scenario. The two combatants are mannequins without heads, a ploy that recurs in much of his work to avoid any specific racial associations. The decapitated bodies are also a gleeful reference to the fate of the nobility during the French Revolution: "The idea of bringing back the guillotine was very funny to me", the artist once said.

The use of Ankara fabric is another constant in the British Nigerian artist's work, representing as it does the long and convoluted history of colonialism, which brought about an explosion of global trade. Though Ankara (aka kitenge or Holland wax) fabric is now associated with several African countries, it was originally manufactured by a Dutch merchant, who styled it after a type of cloth worn in Indonesia; its origins are multifold.

"The idea that there is some kind of dichotomy between Africa and Europe — between the 'exotic other' and the 'civilized European', if you like — I think is completely simplistic", Shonibare has said. "I am interested in exploring the mythology of these two so-called separate spheres, and in creating an overlap of identities."

At first sight it might seem that Shonibare uses eggs to illustrate the tragicomedy of humanity's drive for dominance at all costs, and the brutal irony of power struggles — colonial or otherwise. The egg, a symbol of rebirth (and, historically, of Jesus' empty tomb at Easter), has been smashed to smithereens — the object of the conflict destroyed by the fight itself. But the installation hints at another aspect of Swift's work that captured Shonibare's imagination. "I am particularly interested in the question of Gulliver's empathy with the different cultures he encounters", he has said. Shifting the gaze from the extravagant fighters to the broken, multicoloured shells between them reveals another perspective: the possibility of compassion for the victims of the violence; the fragile eggs caught in the middle.

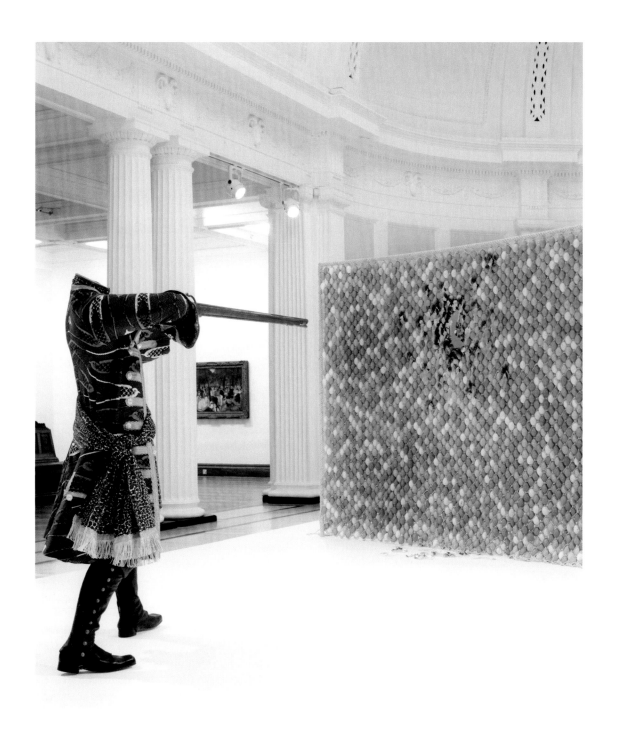

Yinka Shonibare
Egg Fight, 2009

House of Fabergé

Alexander III of Russia claimed to prefer the simple life, but for an autocratic 19th-century monarch, that notion was relative. He rambled around the 400-room Gatchina Palace, threw dazzling balls, and even had a cabin aboard his yacht for a cow, to have fresh milk at sea. Yet nothing symbolises the cavernous gulf between the Romanov dynasty and the citizenry as much as the Fabergé egg, a bejewelled, bombastic fancy that embodies the decadence of an entitled monarchy doomed to be toppled by revolution.

Alexander III commissioned the first egg in 1885 from the Imperial Court's goldsmith, Peter Carl Fabergé, as an Easter gift for his wife Maria Feodorovna. Crafted to the tsar's specifications, the egg's enamel shell opened to reveal a golden yolk, a hen, and a tiny diamond crown concealing a ruby pendant. The extravagant knick-knack was such a hit that the eggs became an annual tradition, enthusiastically taken up by Alexander's son and successor, Nicolas II.

Often requiring a year of craftsmanship, the eggs were created in secrecy by Fabergé and his team, who were given free rein to dream up increasingly lavish designs. Each was unique and contained a "surprise": an ivory automaton elephant embellished with rubies and diamonds; a clock-work singing bird emerging from a nephrite bay tree; a miniature gold Trans-Siberian Express with a diamond headlight.

About 50 imperial eggs were commissioned between 1885 and 1916, before Nicholas II and his family met their bloody end at the hands of the Bolsheviks. The eggs, however, proved more resilient. As Russia liquidated its assets post-revolution, the precious baubles scattered across the globe into museums or the private collections of vertiginously wealthy collectors such as Malcolm Forbes and King Farouk of Egypt. They also entered the public imagination, turning up in movies as a glittering plot device — most memorably in *Octopussy*, when James Bond plants a microphone inside the primrose-yellow, starburst-engraved Coronation egg, thereby unmasking a Soviet smuggling ring.

Admittedly, the eggs are not to everybody's taste. Author Vladimir Nabokov described them as "emblems of grotesque garishness". But few would dispute Fabergé's craftsmanship, and their rarity has won them eye-watering price tags. Some have vanished without a trace, but 43 Imperial eggs survive, the most expensive discovered by a lucky scrap-metal dealer at a flea market in the American Midwest. An online search revealed it to be the missing third Imperial egg, supported on gold lion paws, with a Vacheron Constantin clock inside. In 2014, it fetched $33 million at auction, and the charmed seller presumably no longer lives in a "modest home next to a highway and a Dunkin' Donuts", as the art dealer Wartski reported at the time.

As for Fabergé, patronage by the Romanovs fuelled the jeweller's fame across Europe, and the company's wares — hippopotamus nephrite cigar lighters, diamond-encrusted snuff-boxes — were prized by the cosmopolitan elite. That was until his business was nationalised with the 1917 revolution, at which point the jeweller fled using forged documents, dying in Switzerland not so long after.

The eggs that bear his name, though, are finding their way home. In 2004, billionaire industrialist Viktor Vekselberg made a small dent in his fortune by purchasing nine well-travelled Imperial eggs from the Forbes family for an estimated $100 million. He built a permanent residence for these symbols of Tsarist Russia in the Shuvalov Palace in Saint Petersburg, the city where Carl Fabergé was born. The eggs have been joined there by over 200 other Fabergé objets d'art, from bulldog bonbonnières to silver soup tureens, the giddy opulence of *fin de siècle* Russia repatriated by a contemporary generation of big spenders.

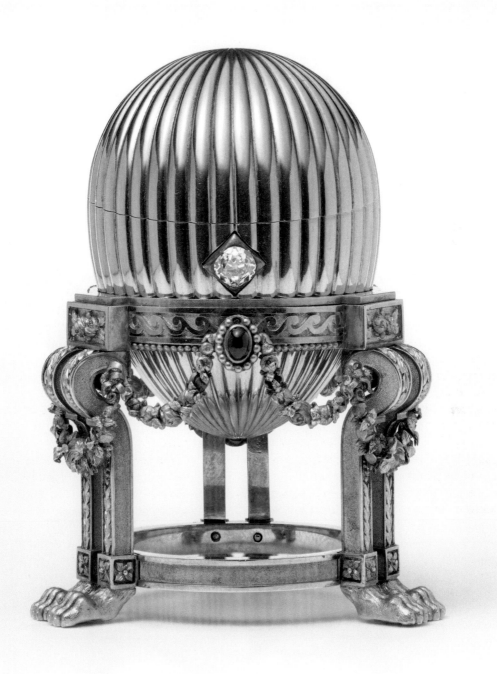

The third Imperial Fabergé egg

"What is inherited from others can
be nothing but egg shells.
We should treat the fact of their presence
with indulgence, but they will
not give us spiritual nourishment."

LUDWIG WITTGENSTEIN

An Egg for All Seasons

In 2001 Björk brought performance art and comic relief to the Oscars when she laid an egg on the red carpet. The gloriously eccentric Icelandic musician wore a swan dress accessorised with six ostrich eggs that sporadically plopped to the floor as security guards scurried to retrieve them. Created by Macedonian designer Marjan Pejoski, the ensemble landed Björk on multiple worst-dressed lists, which was, according to her, beside the point. "I thought my input should really be about fertility, and I thought I'd bring some eggs", she said.

Lady Gaga took that idea to bombastic heights a decade later by arriving to the Grammys inside a giant, temperature-controlled, Hussein Chalayan-designed egg (Gaga called it a "creative vessel"), inside which the singer claimed to have been incubating for 72 hours. Carried aloft by dancers clad in gold latex, she hatched onstage to perform "Born This Way" and take home three awards.

Fashion's hunger for the oeuf stretches back centuries, perhaps because it is a fitting symbol for the industry's own cycle of seasonal rebirth.

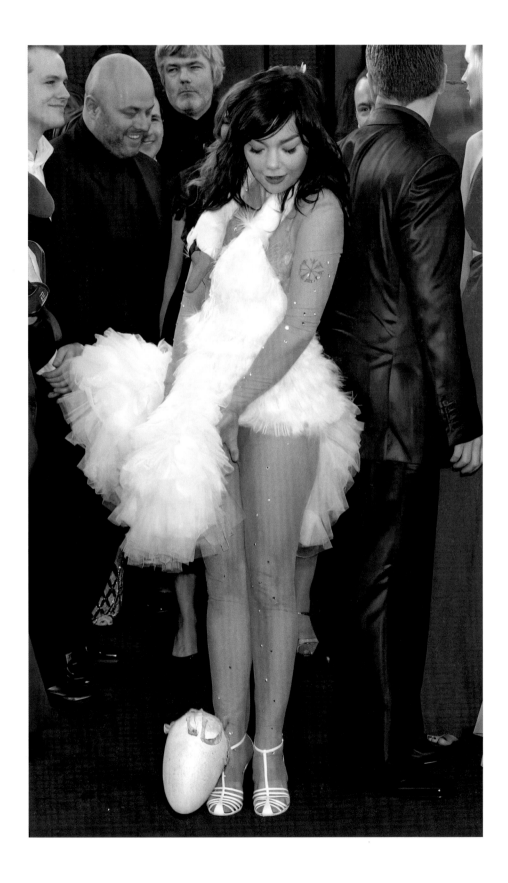

Björk at the Oscars wearing Marjan Pejoski

In the 1700s, French up-dos were styled and powdered into egg shapes, before hair ballooned into volumes large enough to support birdcages. In the 1960s, space-age designer Pierre Cardin unveiled a fuchsia "egg-carton" dress, created from a heat-moulded textile of his own invention that he named "Cardine". The concept was resurrected by Japanese designer Issey Miyake in 2000, when he sent models down the runway in a rainbow of bubbly egg-carton suits and floor-length dresses.

In the 1980s, the egg was deployed with a characteristic whimsy — Judith Leiber's rhinestone-encrusted Fabergé-egg bags were an apt accessory to that decade of excess. Then in the early 1990s, Swatch's eggs-and-bacon watch wrapped breakfast around your wrist, and the Swiss company followed this up with "Eggs Dream", a timepiece with miniature soft-boiled eggs on its plastic strap and a yolk-yellow second hand to time your meal to perfection.

For Alexander McQueen's "The Widows of Culloden" collection in 2006, the milliner Philip Treacy created a fiercely beautiful headdress of outstretched mallard wings framing a silver nest filled with speckled topaz eggs — precariously tipped forward, they allude to the fragility of life. A more exuberant mood reigned at Chanel in 2014, when Karl Lagerfeld recreated a supermarket inside the Grand Palais in Paris, with models wheeling shopping carts through aisles of Chanel-branded goods including CoCo Chanel Coco Pops and Haute Ketchup. One of the collection's prized creations was an acrylic egg-tray clutch bag with six spaces inside for storing one's jewels on the go.

Beyond the deliberate homages, there have been accidental ones, too. At the Met Gala in 2015, Rihanna's elaborately embroidered, 16-foot Yellow Empress cape inspired a torrent of omelette memes. Still, as Björk has discovered, history can prove detractors wrong: once the target of late-night talk show jokes, her swan dress has winged its way into exhibitions at both MoMA and the Metropolitan Museum of Art. Then in 2014, Valentino created an ode in tulle and hand-sewn feathers that originated unmistakably from the same flock.

OPPOSITE **Yoshi Takata**, Pierre Cardin's 'Cardine' dress, 1968
Chanel egg carton clutch bag, autumn/winter 2014 collection

113

Speaking of Eggs

You've got some egg on your face there. No, I don't mean it like *that*. Honestly, you have nothing to feel embarrassed about. Break-ups are so hard, but everyone knows it wasn't your fault. You're a good egg. Obviously he is saying you're the bad one, but we all know this is on him. He's totally the rotten egg here.

So, now that you guys aren't together, can I just say, he's always made me feel uncomfortable? It's like walking on eggshells with that egghead. He shoots you this look that implies "don't say anything", but then it's almost like he's egging you on. *Such* a tough one to crack. But what can you do? Eggs is eggs.

I know you really liked him, but you said so yourself, living with him was the worst — he couldn't even boil an egg. And not to over-egg the pudding, but do you remember what he did to his neighbour's house on Halloween? Don't you think he's a little too old for that? Do you think he will ever change? A wild goose never laid a tame egg, right? I hated to think, that with him, you had put all your eggs in one basket.

Well sure, maybe it *is* the eggnog talking, but I've been wanting to tell you this forever. You'd made all these plans — you had chickens in your hands, but he doesn't understand that the omelette isn't going to just break the eggs on its own?

I hope you don't mind but I told my friend about it because she just broke up with her partner. You know what she said? "What's that got to do with the price of eggs?" I could read right through her defensiveness. The split was her own fault anyway. She left that golden goose as soon it turned into eggs.

It's like what they say: the same fire that melts the butter hardens the egg. What's that? You want me to do what? How about *you* go suck on one?! I was just trying to be honest with you! How can you defend him after he's left your eggs to hatch like that? No, actually I think it's *you* that's got egg on *your* face!

OPPOSITE **Gustav Almestål**
Egg on Your Face, 2021

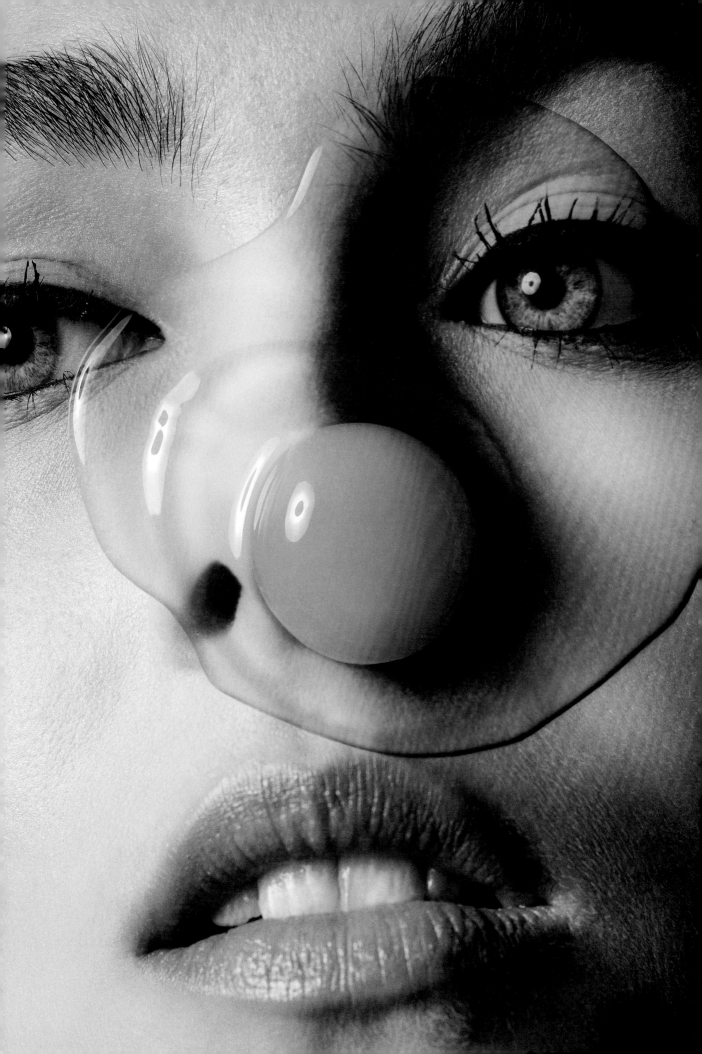

At the Savoy

There are two egg dishes that have long been staples on the breakfast menu of the Savoy in London: eggs Escoffier and omelette Arnold Bennett. Each is deliciously rich, and in their own way representative of a particular time in the history of this, the grandest of grand hotels, which first opened its doors in 1889. The former dish was made in tribute to a culinary legend, while the latter was a collaboration between a novelist and a chef, struck up at the end of the roaring 1920s.

Eggs Escoffier

This careful assembly of a poached egg and more than a soupçon of opulent accompaniments is a fitting evocation of the magnificent culinary heights to which the great Auguste Escoffier took the Savoy's dining rooms. The French-born gastronomic pioneer, described as the "Emperor of Chefs" by a real emperor, William II of Germany, arrived at the newly opened hotel at the invitation of César Ritz, already a dazzlingly successful hotelier.

The hotel was a marvel. Its electric lights and elevators were a sensation — and word travelled fast. Wealthy Americans disembarked from liners in South East England and made haste for the bright lights of central London, where the Savoy sat elegantly on the Strand, and where guests were rewarded with an impressive view over the River Thames.

From bustling breakfasts for potentates and panjandrums to post-theatre suppers that tumbled up to private suites, the hotel played host to wild parties and glittering balls. For the Prince of Wales, the Churchills and the Vanderbilts, this was the place to see and be seen. It is where Oscar Wilde, during an extended stay, had an adjoining room with his paramour, Lord Alfred 'Bosie' Douglas, drank copious amounts of champagne and spent his way into financial difficulty.

PAGE 116 **Bobby Doherty**, *Dippy Egg Snail Soldier*, 2019;
PREVIOUS **Bobby Doherty**, *Untitled* (*Gucci Shoe*), 2018; OPPOSITE Tea at the Savoy in 1890

Auguste Escoffier c.1925

It was also the place to eat, and Escoffier's revolution in the kitchen was the catalyst. He struck deals with suppliers of the finest produce. He overhauled the way the kitchen ran, organizing staff into brigades with specific responsibilities. Employees were required to dress formally on their way to and from the hotel. Profanity and alcohol were banned. The changes he had begun to develop previously in France, and which he now implemented at the Savoy, would transform hotel and restaurant kitchens forever.

Meanwhile the sheer inventiveness that emerged from Escoffier's kitchens was nonpareil. He created meals to delight guests and generate press. A 22-course menu was par for the course. He revelled in his reputation, and his presence was felt in the dining room too, as he regaled guests and admirers alike with expansive details about their dishes.

It is fitting therefore that Eggs Escoffier echoes the great man's penchant for creating eponymous dishes. He was so enamoured of Australian soprano Nellie Melba that he created Pêches Melba, peaches poached in vanilla-flavoured syrup, served on vanilla ice cream coated in a raspberry syrup, in her honour.

For Escoffier's titular egg dish you'll want an english muffin, a perfectly poached egg and hollandaise sauce, a lobster tail, a teaspoon of finest Oscietra caviar and a sliver of gold leaf. Other egg recipes carry Escoffier's name more informally, like the dish latterly referred to as scrambled eggs à la Escoffier, which first appeared in his *Guide to Modern Cookery*. But only eggs Escoffier, the creator of which is unknown, has been named in recognition of his time at the Savoy. To date, the only known place it can be ordered is at the Savoy Grill.

Alas, it would be eggs (alongside other produce) that marked the beginning of the end for Escoffier at the Savoy, and he was dismissed (along with César Ritz) for gross negligence in 1898. It was a decision exacerbated by suggestions of disappearing spirits and kickbacks from suppliers. And it would be some 30 years before the Savoy's other longstanding egg dish would first appear.

Omelette Arnold Bennett

Arnold Bennett was a writer of great popularity at the turn of the 20th century. A man about town, dividing his time in the main between England, France and his yacht, his London literary circle included H. G. Wells and George Bernard Shaw, and the poet Siegfried Sassoon. Bennett regularly dined at the Savoy. Then, in the late 1920s, he became a temporary resident at the hotel, and, with notebook at hand, he got to work on a new book.

The omelette was fine-tuned over conversations between Bennett and Jean Baptiste Virlogeux, who first presented the dish to the writer. It is the definition of a trencherman's meal, and the very finest eggs were its foundation. A single serving requires three eggs and an additional yolk, along with firm-fleshed smoked haddock, doublecream, butter and a good helping of cheese. As an open omelette, the base is left to catch as the top colours under the grill. This bubbling, golden, rich creation, punctuated by waxy slivers of fish and a hollandaise sauce might have been one source of salvation from what Bennett once described as his "intestinal caprices".

That this dish bearing his name is a breakfast one is no coincidence: Bennett regarded the first meal of the day as crucial, and that food at the start of a few hours of "brain-work" was more important than food before a day of activity in the open air.

The result of his residency, aside from a likely narrowing of the arteries, would be the 1930 novel *Imperial Palace*, a long work that described the day-to-day operations of a grand hotel in exhaustive detail. Many believe the character of Rocco, chef of the grill kitchens, with a deep voice and even deeper soul, to be a tip of the chef's hat to Virlogeux.

The dish, which was subsequently prepared at Bennett's request wherever he travelled, is now a standard, reinvented by chefs the world over. Some have even dared to create a "lighter" version. It is unlikely that Bennett would approve.

Egg,
How the devilled are you?

I'm sorry to be writing about this again but I just had the worst email from a journalist. They were all, "What's your hot take on the eternal question?!"

It's like clockwork. Every year around Easter they come out of the woodwork for a statement or whatever, and then I get into such a state. I completely realise I shouldn't care — and yet...

So, you know where I'm going with this, but I wanted to check before I write back to the journalist because I know they'll get in touch with you for a statement etc. I mean, unless they have already?

Apparently those scientists on TV — imagine! — Bill Nye and Neil deGrasse Tyson are all over the idea that you came first; something to do with the first chicken parents not being chickens themselves... but then there was an egg with a mutation that made it capable of creating a chicken, so the creature that came out of the fertilised egg was a chicken, and apparently that evolutionary step proves you're the original etc. etc. I mean, sure…

But as you and I know all too well, some scientists look at it the other way (maybe these ones aren't, ahem, on TV?). Basically, one of my jungle fowl ancestors may have laid an egg, and a chicken may have developed inside that jungle fowl egg, which means the creature that came out of that egg was indeed a chicken, and would only have produced its own egg once it was old enough to do that sort of thing. Which means I came first. Which I guess also makes sense... Either way, one of us was a mutation, right? Ha.

To be honest, I just want to say to the journalist that the very question of whether the chicken or the egg came first is in itself way more telling than the answer could ever be — it proves that humans are happy to wallow in endless debates about unanswerable questions; scratching heads and drumming up reasons to argue. They keep deluding themselves that one day they'll "figure it all out" — whatever "it" is. It's all so futile. I mean, I guess it is kind of funny when they try.

Anyway, to get to my point, I was just going to refer the journalist to Aristotle's idea about how we both existed forever together with neither of us coming first. I know it's pre-science etc., but I think it makes for a cracking riposte, as you would say.

I'm so over this.
Best, Chicken

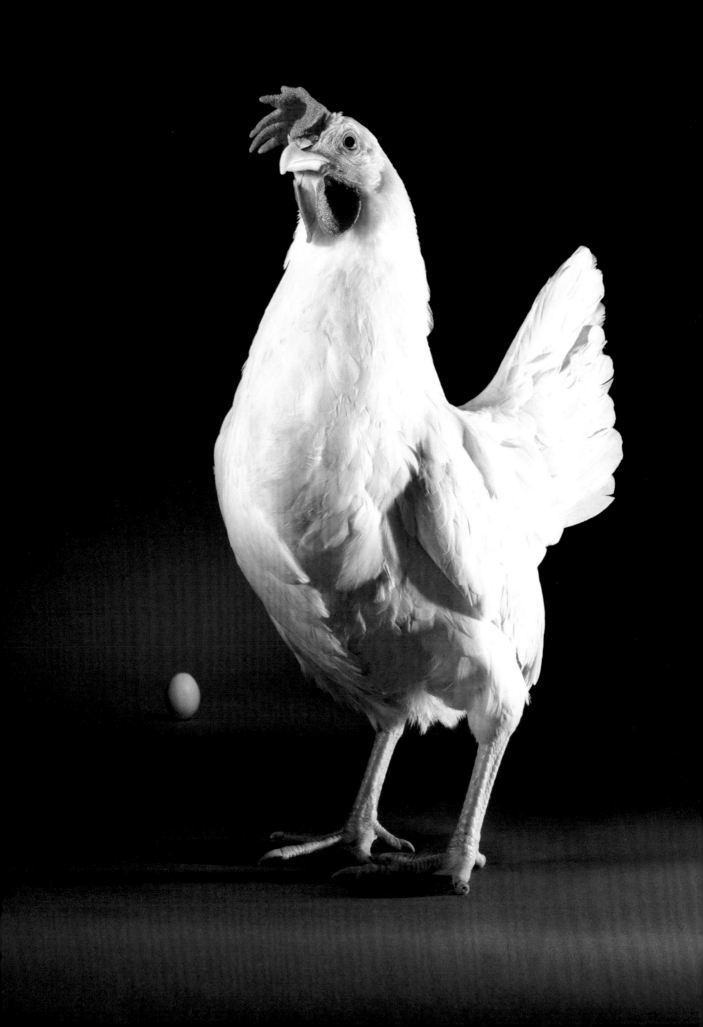

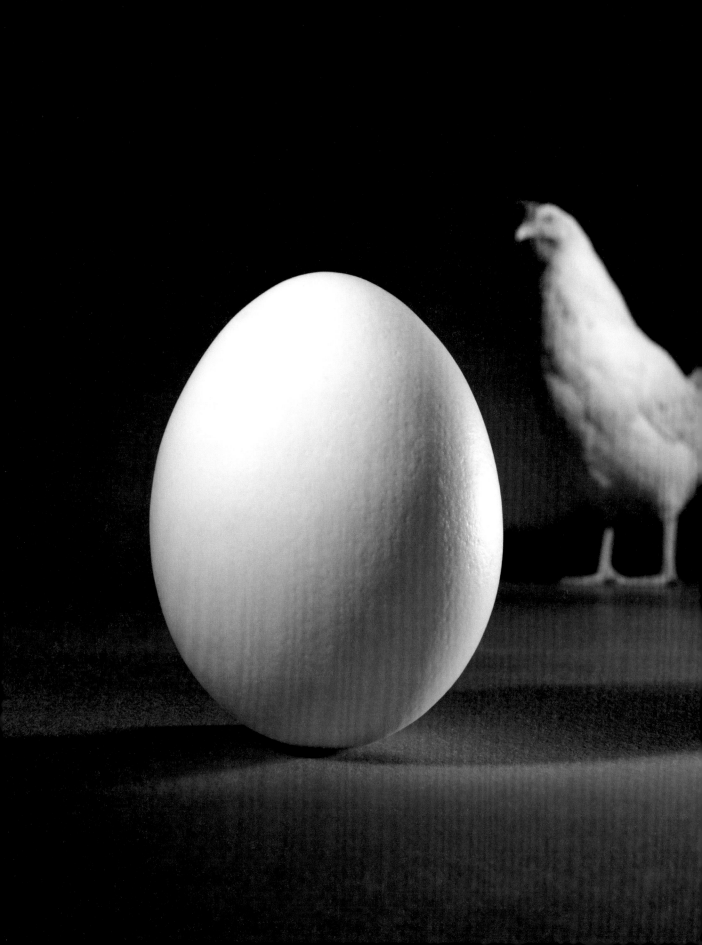

Hello my feathered friend,

As far as it goes with all of this eternal question drama, what a terrific bore indeed! Gosh I really do hate to see you getting into such a flap about it. The journalist hasn't been in touch yet, though I suspect you're right that they'll drop me a line, as per... At least it isn't another one of those creationists — do you remember that lot from a few years back? They thought both of us had appeared at the same time in the Garden of Eden! Don't get me wrong, it's a lovely idea, us frolicking in paradise, but I mean... seriously?

Of course, anyone with a passing interest in evolutionary biology would attest that eggs, as a general class of things, were around long before the kind of egg that might have contained the first chicken. We go far back into the murk of time — 380 million years or so ago. Mind, eggs that harboured chickens didn't crack open until some 58,000 years ago. So, eggs did come before chickens. But did chicken eggs come before chickens? Madam, I haven't a clue.

Whatever the case, where you see futility, my dear nihilistic bird, I see an unending spring of curiosity and thirst for knowledge. It really is the glass half empty, half full with us, isn't it?

As you know, I'm partial to Socrates, and any idea that leans on the eternal return, where a finite amount of matter recurs in a cycle across infinite time. The constant recurrence of everything would mean that there simply was no before, or a first, only an always. I say go ahead with that line with the journalist, and I'll do the same! On another note, I must say it's been tremendously dreary since you flew the coop.

How's city life treating you? Everyone running around like they have no heads? Pecking away on their phones? I suspect yes.

Take care and speak soon.
Egg

OPPOSITE **Marius W Hansen**, *Egg, Chicken*, 2021
FOLLOWING **Gustav Almestål**, from *"The Birds Odyssey"*, *The Gourmand*, Issue 02, 2013

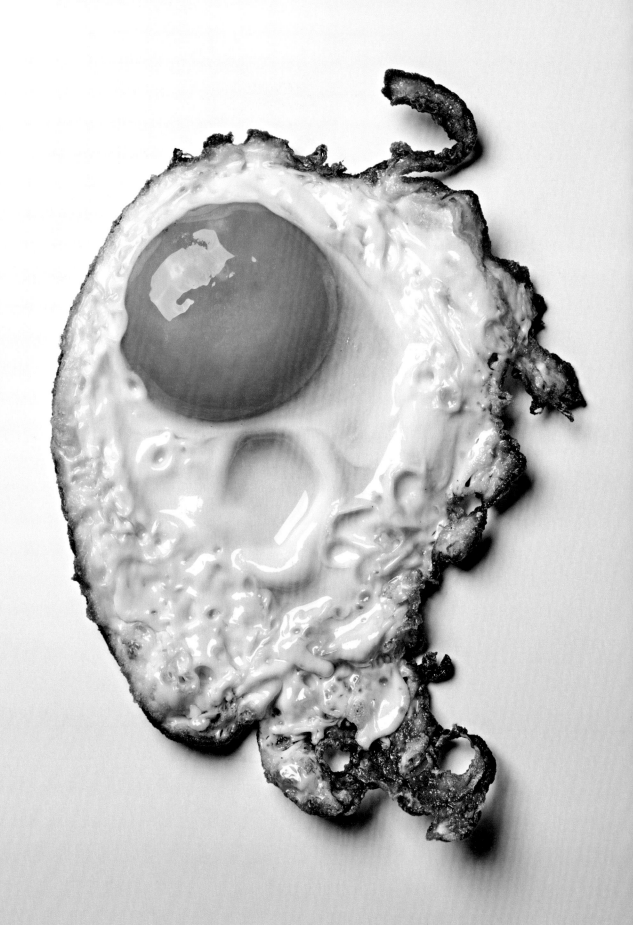

Recipes

PHOTOGRAPHY
Section openers by **Bobby Doherty**, set design **Jamie Kimm**
Recipes by **Matthieu Lavanchy,** set design **Hella Keck,** food styling **Iain Graham**

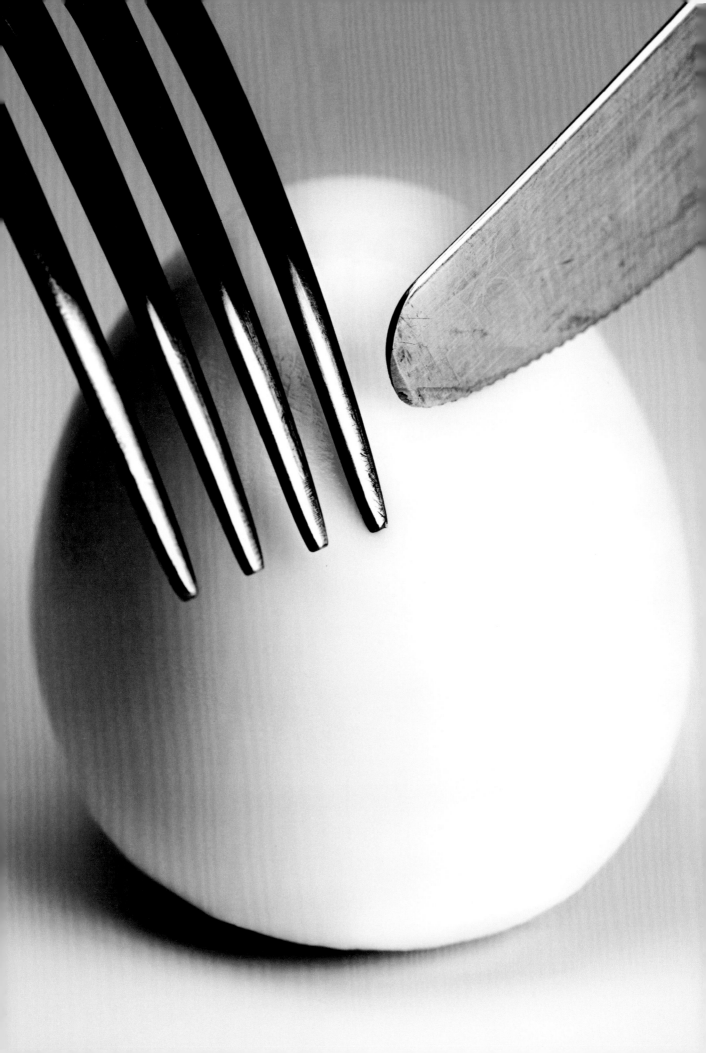

Simply Eggs

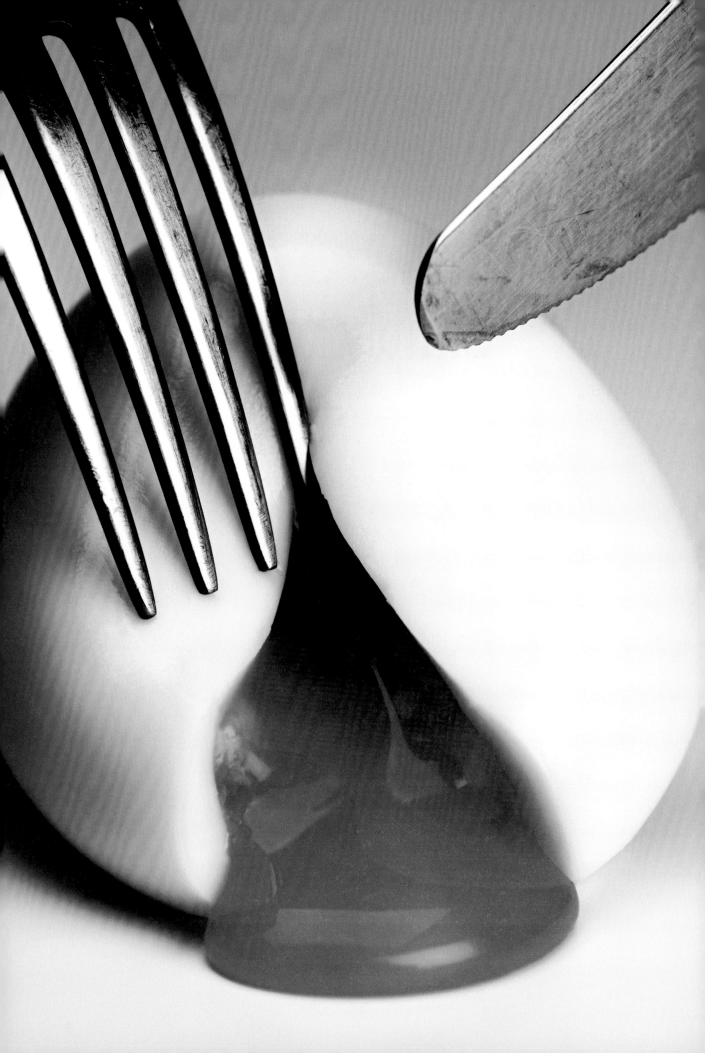

"Oh, the boundless joy of an egg.
It must of course be from the happiest
of hens, whose days are spent
with grass underfoot. The yolk shines the
requisite orange and when cooked
to the perfect degree, is referred to most
scientifically as 'runny'."

JEREMY LEE

Boiled Egg

Serves: 1 egg
Preparation time: see below

INGREDIENT
1 egg

EQUIPMENT
Small cooking pot

There are few things more disappointing than messing up a boiled egg. Overcooked, the yolk adopts an unpleasant chalkiness; underdone, the egg white's translucent stringiness will put you off your breakfast. And despite the condescending idiom that implies severe judgement of grander culinary skills — "can't boil an egg" — success requires timing and precision. While a guide for cooking times is helpful, unfortunately so is experience. Egg size varies considerably even among the same species, as does the thickness of the shell, depending on the welfare, diet and lifestyle of the bird — and all affect the cooking time.

Place a small pot of water on the stove on a high setting. Wait until the water comes to a rolling boil. Lower your egg into the water with the help of a spoon, to avoid cracking the shell. Set the timer for the required time (see below), allowing an additional 30 seconds or so for fresh farm eggs with thicker shells.

PERFECTLY BOILED

Quail:	2 min
Pheasant:	2 min
Bantam:	3 min 15 s
Gull:	3 min 30 s
Hen:	4–5 min runny, 6 min soft
Duck:	7 min
Goose:	10 min
Ostrich:	50 min

HARD-BOILED

Quail:	3 min
Pheasant:	5 min
Bantam:	7 min
Gull:	8 min
Hen:	9 min
Duck:	10 min
Goose:	13 min
Ostrich:	2 h

Poached Eggs

Serves: 1 portion
Preparation time: 10 min

INGREDIENTS
5 tbs vinegar
1 egg

EQUIPMENT
Small pot
Bowl
Slotted spoon

There are many schools of thought when it comes to poached eggs. All, however, require extremely fresh eggs to avoid loose and stringy whites. The choice of pot is particularly important — a small, tall pot will enable your raw egg to fall unimpeded into the water and cook in a nice shape. Cracking the egg from a height might be fun but is not recommended: a poached egg is a delicate thing, so should be cast into the cooking water very gently.

Bring a small pot of water to the boil and add 5 tbs of vinegar. Next, crack an egg in a small bowl without damaging the yolk.

Turn the heat right down on the pot, and stir the hot water. Gently transfer the egg from the bowl to the hot, vinegary water, and cook for 3–4 minutes. Use a slotted spoon to lift out the poached egg when ready.

Scrambled Eggs

Serves: 1 portion
Preparation time: 10 min

INGREDIENTS
3 eggs
25 ml milk
50 ml cream
Salt and pepper
1 knob butter

EQUIPMENT
Bowl
Frying pan
Spatula

Incredibly soft and rich, a good plate of scrambled eggs counts among the most comforting of dishes. But take heed, these should be executed with care and precision or woe betide — one can easily end up with a dried-out, unevenly cooked mess. There are many different ways to scramble eggs, with some recipes calling for a long, slow cook at a low temperature, while others, like this one, start with a piping hot pan and finish with residual heat. Whichever the preference, adding cream and milk provides a touch of luxury with a smooth, silky texture.

Beat three eggs with half a splash (25 ml) of milk and a splash (50 ml) of cream in a bowl. Season with salt and pepper.

Melt a knob of butter in a hot pan, then pour in the egg mix. When it starts to bubble vigorously, turn off the stove and cook the eggs by folding the mixture carefully and continuously with a spatula. The eggs will cook gently with the residual heat. Serve when they are soft and scrambled to your taste.

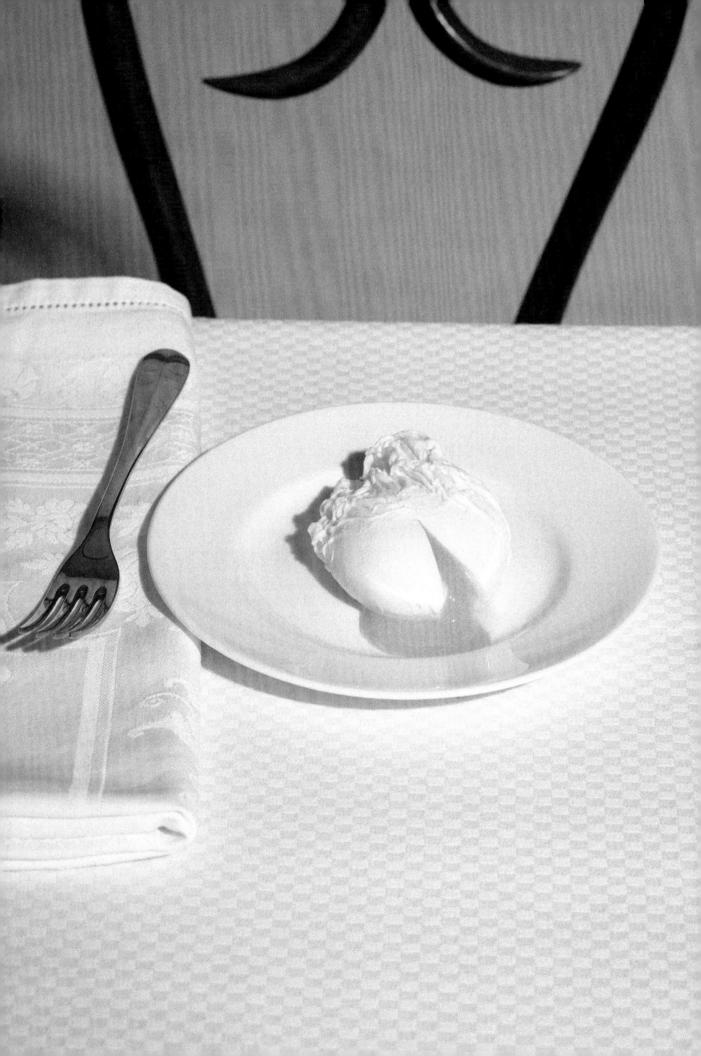

"To my mind, an egg perfectly poached is among the great, essential pleasures of one's eating life. The protein (the white) is fluffy and textured, shaped by the currents of the water it has been cooked in. The fat (the yolk) is held in place, just, by a thin membrane, looking like a piece of tropical fruit, and always a little surprising when it bursts under the tines of a fork. An egg poached is different from other egg preparations: it requires no grease for frying, no butter for scrambling, nothing at all besides salt and pepper. Rarely is a food that is so simple also so much fun to eat."

BILL BUFORD

Three-Egg Omelette

Serves: 1 person
Preparation time: 10 min

INGREDIENTS
3 eggs
1 tbs light cooking olive oil
Salt and pepper
Optional filling of your choice (grated gruyère, ham, cooked spinach, etc.)
1 knob butter (optional)

EQUIPMENT
Mixing bowl
Heavy-based frying pan
A spatula

An omelette isn't just for breakfast — it makes the perfect lunch or dinner too. And while it needn't be anything fancy, when it comes to preparing an omelette there really is nowhere to hide. Beautiful folds and satisfying crispy and soft textures require skill and technique, a certain flick of the wrist, if you will, but are undoubtedly worth practising and mastering.

Crack three eggs into a bowl, whisk together, and season well with salt and pepper.

In a heavy-based pan, heat a generous splash (around 1 tbs) of light cooking olive oil until very hot. Pour in the seasoned egg mix, and rotate the pan so that the whole surface is covered. Allow the eggs to cook for around 20–30 seconds, until they start to bubble. Using a spatula, push the outside of the omelette straight into the centre of the pan so that the mix folds, and then rotate so the remaining uncooked egg mix spills back out to the edge of the pan. Repeat the process until you have no more liquid, and your omelette's surface is ruffled with lovely folds created by your spatula.

Allow the omelette to cook for another 20 seconds or so, depending on how soft and runny you like it. At this point you can add an optional filling of your choice, then fold the omelette into two or three.

If you're feeling indulgent, add a little knob of butter to your pan and cook your omelette in bubbling butter for another 20 seconds.

Season your omelette with salt and freshly ground pepper, and serve straight away with a plain salad with lemon dressing and fresh herbs.

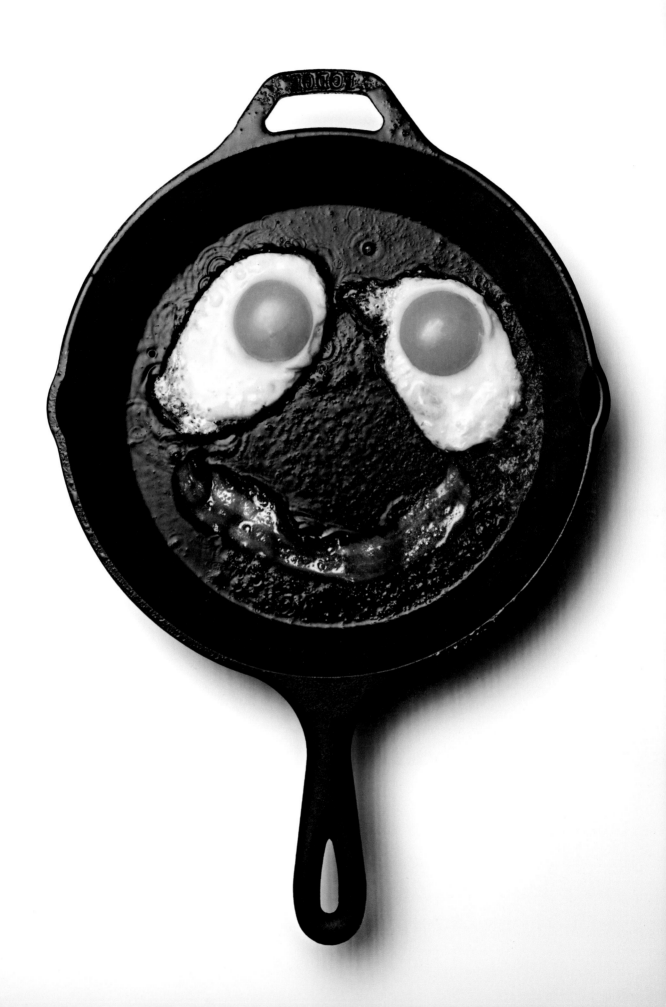

Breakfast and Brunch

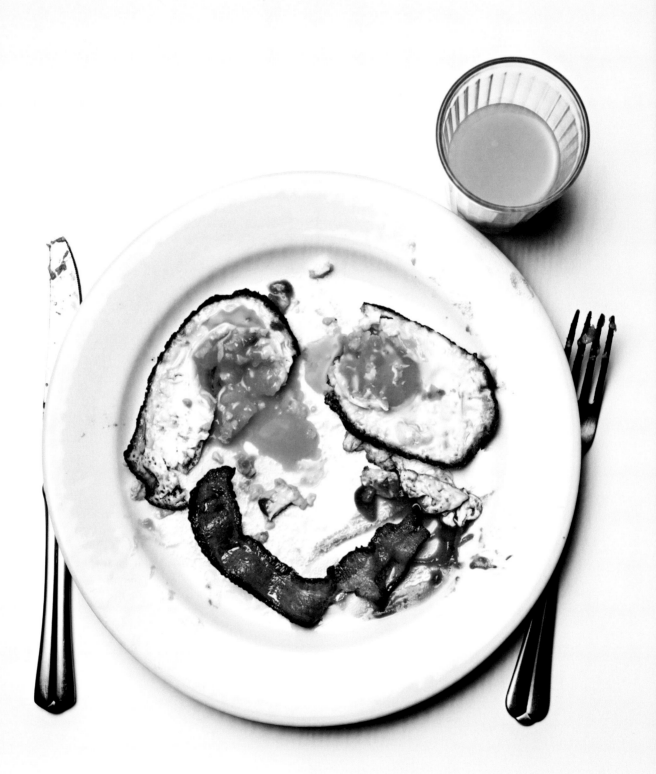

"I know, in exact detail, what my perfect chicken egg is like. In size it must be average, or even small. When it is broken into hot oil, it must spread no farther than three to four inches. The yolk must have the energetic, luminous complexion of yellow maize, and it must fall into the pan and not budge..."

YEMISI ARIBISALA

Eggs Benedict

Serves: 2–4 people
Preparation time: 45 min

INGREDIENTS
250 g butter
1 shallot, finely sliced
50 ml chardonnay vinegar
40 ml water
5 black peppercorns
1 sprig tarragon
3 medium egg yolks
50 ml white wine vinegar
4 eggs
2 english muffins
4 slices kassler ham
2 tsp chives, chopped

EQUIPMENT
Small saucepan
Small cooking pot
Sieve
Mixing bowl

Eggs Benedict is the iconic New York breakfast, reminiscent of the city's Golden Age; the indulgence of Art Deco skyscrapers and the Waldorf Astoria hotel. It's great for a group brunch, as it can be adapted to different dietary requirements: 'royale' with smoked salmon, and 'florentine' with wilted spinach for the vegetarians. This classic recipe asks for kassler ham, but bacon or other types of ham work too, as long as the chef is generous with the buttery hollandaise.

Start by preparing clarified butter and a vinegar reduction to make your hollandaise sauce. Melt 250 g butter in a pan very gently on a low heat until it separates. Remove any white fat that separates to the bottom and any flakes that sit on the top, so as to use only the golden, clarified, warm butter.

Next, prepare a vinegar reduction. In a small pan, combine one finely sliced shallot, 50 ml of chardonnay vinegar, 40 ml of water, five black peppercorns and one sprig of tarragon. Simmer gently, reducing the liquid by half. Strain the liquid in a sieve, and leave it to cool.

Now whisk up your hollandaise. Place three medium egg yolks in a mixing bowl, and begin to whisk them over a pot of simmering water. The water must not touch the bottom of the bowl. Gently add the vinegar reduction to the egg yolks, and continue whisking until the yolks thicken and increase in size. Now remove the bowl from the pot, and very gradually pour in some clarified butter while continuing to whisk. The butter must be added very slowly and gradually or the sauce will split. Once your hollandaise sauce is ready, cover it and leave to one side.

Fill a small pot with water and bring it to the boil. Add 50 ml of white wine vinegar, then poach four eggs for around 3–5 minutes until the whites are set and the yolk is still runny.

Cut two english muffins in half, and toast them under the grill, then butter them, using as much or as little butter as you prefer.

Place a slice of kassler ham on each half of the toasted muffins, spoon on the poached eggs, and finish with a good spoonful of hollandaise sauce. Scatter them with finely chopped chives.

Huevos Rancheros

Serves: 4 people
Preparation time: 30 min

INGREDIENTS
5 tbs vegetable oil
1 onion, finely chopped
4 cloves garlic, finely chopped
1 bay leaf
1 tsp ancho chilli flakes
1 tsp ground cumin
Salt and pepper
2 large vine tomatoes, roughly chopped
1 red pepper, roughly chopped
1 green pepper, roughly chopped
1 jalapeño, finely chopped
1 tsp chipotle paste
1 tin chopped tomatoes
250 ml vegetable stock
4 corn or flour tortillas
1 bunch coriander, roughly chopped
1 bunch fresh oregano, roughly chopped
4 eggs
½ lime (optional)

EQUIPMENT
Skillet or cast-iron frying pan
Frying pan

A good plate of huevos rancheros is a brunch option that's hard to beat. This dish from Mexico, originally eaten by farm labourers, is all about the heat from the jalapeños and smokiness from the chipotle paste. Pair it with good-quality corn or wheat tortillas, and don't hold back on the sides, traditional or otherwise: fried potatoes, chorizo, refried beans, guacamole, extra cheese — the list goes on.

In a skillet or cast-iron pan, warm 3 tbs of vegetable oil, then add one finely chopped onion, four finely chopped garlic cloves, one bay leaf, 1 tsp of ancho chilli flakes and 1 tsp of ground cumin, and cook gently until soft. Season with salt and pepper.

Add two roughly chopped large vine tomatoes, one roughly chopped red pepper, one roughly chopped green pepper, one finely chopped jalapeño and 1 tsp of chipotle paste. Once the vegetables start to soften, keep cooking them, making sure they are nicely flat on the bottom of the pan and cooking evenly.

Stir in a tin of chopped tomatoes and 250 ml of vegetable stock. Simmer the salsa for a good 10–15 minutes until it has reduced and is a dark, luscious, red colour.

While the salsa reduces, warm four corn or flour tortillas in a frying pan, then wrap them in a tea towel to keep from cooling. Roughly chop a bunch of coriander and another of fresh oregano. In the frying pan, fry four eggs in 2 tbs of vegetable oil.

Place a tortilla on each plate, add a fried egg, cover in salsa, and finish with the chopped coriander, oregano and a squeeze of lime.

Eljeh (Lebanese Herb Omelette)

Serves: 2 people
Preparation time: 15 min

INGREDIENTS
3 eggs
Salt and pepper
50 ml cream
1 tbs flour
1 handful flat parsley, chopped
1 scallion, chopped
1 handful tarragon leaves, chopped
1 handful mint leaves, chopped
1 small bunch chives, chopped
50 g butter
1 flatbread or wrap

EQUIPMENT
Mixing bowl
Whisk
Frying pan

This dish evokes sunny outdoor breakfasts in Beirut, where the liberal use of fragrant fresh herbs is at the heart of culinary tradition. And the traditional eljeh or ejjey — "omelette" in Lebanese — is no exception. The recipe calls for a bouquet of flat parsley, tarragon, mint and chives, but feel free to use whatever herbs you have around. If you like a sturdier consistency to your omelette, add an extra egg — just make sure your accompanying flatbreads are nice and hot when served.

Crack three eggs in a mixing bowl, season with salt and pepper, and beat enthusiastically with a whisk. Once your eggs have a nice even yellow colour, add 50 ml of cream, 1 tbs of flour, one handful of chopped flat parsley, one chopped scallion, one handful of chopped tarragon leaves, one handful of chopped mint leaves and a bunch of chopped chives, and whisk everything together into a thick custard.

Heat a frying pan on a high heat and melt half of the butter (25 g), then pour in the herby custard and begin to fry. Turn down the heat, and swirl the pan to even out the remaining uncooked custard.

While this cooks, rub your flatbread with butter and place it in the oven at 180℃ to heat. When the eljeh pancake has started to brown, flip it over and cook the other side until it has started to crisp and has cooked through. Take the warm, buttery flatbread out of the oven, and place your pancake on top of it.

American-Style Pancakes

Serves: a dozen pancakes
Preparation time: 10 min

INGREDIENTS
3 eggs
50 g sugar
100 g plain flour
125 ml full-fat milk
1 tsp baking powder
Splash vegetable oil

EQUIPMENT
Mixing bowl
Mixer (or electric whisk)
Large frying pan

Pancakes made of egg and flour have been eaten around the world for millennia. From the fluffy Japanese soufflé variety to the crispy French crêpe bretonne, they come sweet or savoury, in many delectable iterations. This recipe borrows from an icon: the traditional American diner-style pancake stack. It departs from what you'll find in most diners though, as baking soda has been omitted, but rest assured no fluffiness has been sacrificed as a consequence.

Start by separating three eggs and placing the egg whites in a mixing bowl. Keep the yolks for later. Whisk the egg whites until they can be sculpted into soft ribbons, but not yet stiff peaks. Slowly add 50 g of sugar as you continue to whisk, until you have shiny stiff peaks, then set aside.

In a mixer or using an electric whisk, blend the three egg yolks, 100 g of plain flour, 125 ml of milk and 1 tsp of baking powder into a thick paste. Spoon in about half of the stiff egg whites into your egg yolk mix, and fold carefully with a spatula so as to keep the batter light and airy. Take your time. Fold in the remaining stiff egg whites — your batter should now be fluffy and smooth.

Put a frying pan on a medium heat and add a tiny splash of vegetable oil. Spoon out the pancake batter so it is around 10 cm in diameter. Allow it to colour and brown, then flip it over and cook through. Depending on the size of your pan, you can cook several at a time. Stack your cooked pancakes and serve immediately with fruit, jam, yoghurt or ice cream.

Khai Jiao (Thai Omelette)

Serves: 16 canapés
Preparation time: 15 min

INGREDIENTS
5 tbs vegetable oil
4 eggs
1 tbs fish sauce
½ lime
Sriracha
1 handful bean sprouts
2 scallions, roughly chopped
1 handful coriander leaves,
roughly chopped

EQUIPMENT
Skillet (or wok)
Mixing bowl
Whisk
2 spatulas

Khai jiao is a Thai omelette and a firm street food favourite. It's quick to make, and chances are you'll have most of the ingredients at home. There's great drama to the high pour of the eggs into the hot oil and the imperfect shape it yields. There are many different combinations and additions to experiment with — try minced pork, minced shrimp, or fresh crab.

In a mixing bowl, beat four eggs with a fork, and mix in 1 tbs of fish sauce and the juice of half a lime. Whisk until all the ingredients have combined.

Heat 5 tbs of vegetable oil in your skillet or wok until it's very hot but not smoking. Now, start ribboning the egg mix into the oil and allowing it to start to bubble and colour and crisp, then pour the rest of the egg mix into the oil, starting from close to the pan and raising the bowl up to about 30 cm above the oil. The egg mix will start to bubble and swell. Once nicely browned, gently flip the omelette over using two spatulas, taking extra special care not to drop or splash the omelette as you turn it.

After a couple of minutes, remove the omelette from the oil and place it on two or three sheets of kitchen towel to soak up some of the excess oil.

Put your omelette onto a plate, then dress with lashings of sriracha, a handful of beansprouts and two roughly chopped scallions, finishing with chopped coriander and a splash of fresh lime juice.

Shakshuka

Serves: 4–6 people
Preparation time: 40 min

INGREDIENTS
4 tbs olive oil
2 onions, finely sliced
2 red bell peppers, sliced
4 cloves garlic
1 dried red chilli, flaked
1 tsp ground cumin
1 tsp ground coriander
1 tsp paprika
¼ tsp ground cinnamon
½ tsp chilli powder
2 tins chopped tomatoes
1 tsp tomato paste
1 tbs rose harissa (optional)
6 eggs
50 g butter
1 tbs chilli flakes

EQUIPMENT
Deep cast-iron pan with lid
Wooden spoon
Small pan

Like many old and storied dishes, there is no definitive recipe for shakshuka — a word that means "mixture" in the Tunisian dialect, and refers to the mélange of cooked vegetables that carries the eggs in the dish. Shakshuka for many evokes childhood memories, and with recipes so varied it can inspire passionate debate as to the primacy of one's family version over another. This recipe has a buttery finish and tempered chillies, but you can add harissa for extra spice.

Take a deep cast-iron pan, splash 4 tbs of olive oil in it, and gently fry two finely sliced onions, two sliced red bell peppers and four sliced cloves of garlic. Season well and cook until soft on a medium heat. Add one dried red chilli flaked with your fingertips, 1 tsp of ground cumin, 1 tsp of ground coriander, 1 tsp of paprika, ¼ tsp of ground cinnamon and ½ tsp of chilli powder. Cook for a couple of minutes until the spices exude a fragrant smell.

Mix in two tins of chopped tomatoes and 1 tsp of tomato paste, then mix well with a wooden spoon so that the spices generously coat your tomatoes, onions and peppers. Leave to simmer for 30 minutes until your sauce is a thick, dark red. Stir in an optional 1 tbs of rose harissa for extra spice and smokiness, depending on your palate.

Use a wooden spoon to create little valleys in your sauce, then crack six eggs into these depressions. Cover with the lid, and finish on the stove at medium heat for 5–10 minutes, depending on how soft you like your eggs (we recommend until they are wobbly — soft yet sufficiently cooked so that the whites are no longer translucent).

Melt 50 g of butter in a small pan until it browns and bubbles slightly. Add 1 tbs of chilli flakes, stir, then pour this spicy, buttery mix onto your shakshuka.

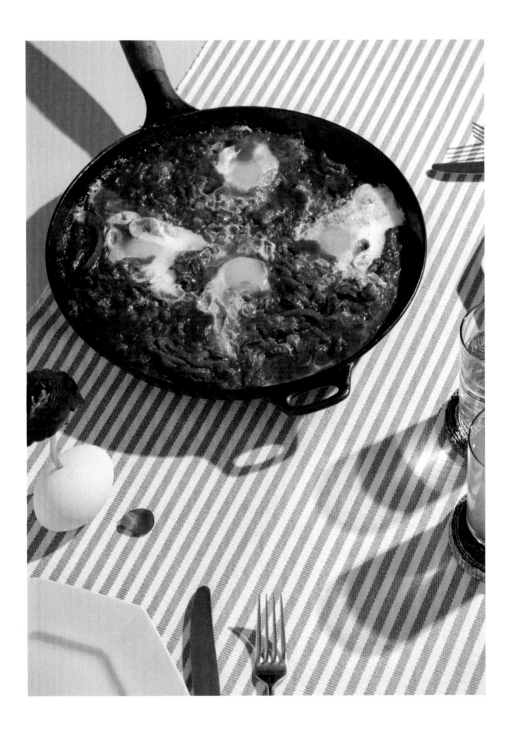

French Toast

Serves: 2 people
Preparation time: 10 min

INGREDIENTS
3 eggs
50 ml cream
20 ml milk
Caster sugar
4 slices of brioche or challah
Cinnamon sugar
(5 g cinnamon, 30 g
caster sugar)
1 generous knob butter

EQUIPMENT
Mixing bowl
Heavy-based frying pan

French toast, or pain perdu ("lost bread") as it's known in France, is a quick and hassle-free way of using up leftover bread — including enriched ones like Challah (p 228) and Brioche (p 230). Make sure you cut a nice thick slice, as it's easier to cook and will absorb more of the egg and cream mix. The recipe uses cinnamon sugar, but feel free to go wild — there's a whole world of agreeable toppings out there.

In a mixing bowl, crack three eggs, and add 50 ml of cream and 20 ml of milk. Whisk until all the ingredients have combined.

Dip slices of leftover brioche or challah into the creamy egg mix and allow them to soak up some of the liquid. Put these on a tray, and sprinkle each slice with some caster sugar.

Place a heavy-based pan on a medium heat, then melt a generous knob of butter. When it starts to bubble and brown, put in your egg-soaked brioche or challah. Fry until crisp and brown on the bottom, then flip them over. Scatter your French toast with cinnamon sugar and whatever berry takes your fancy.

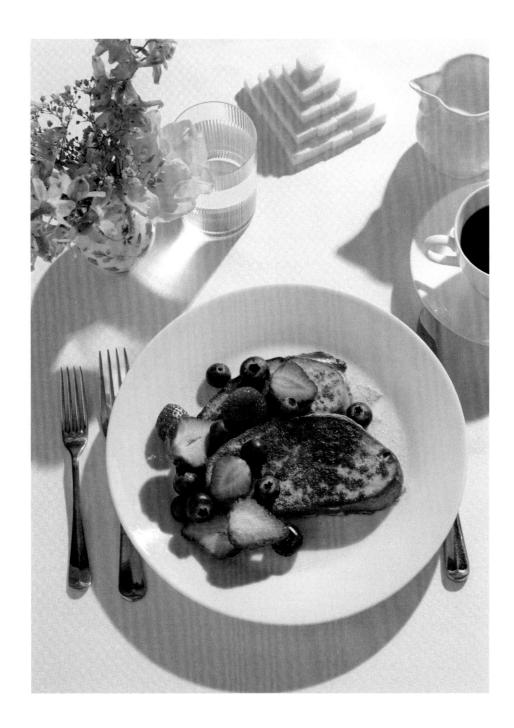

Egg Snacks

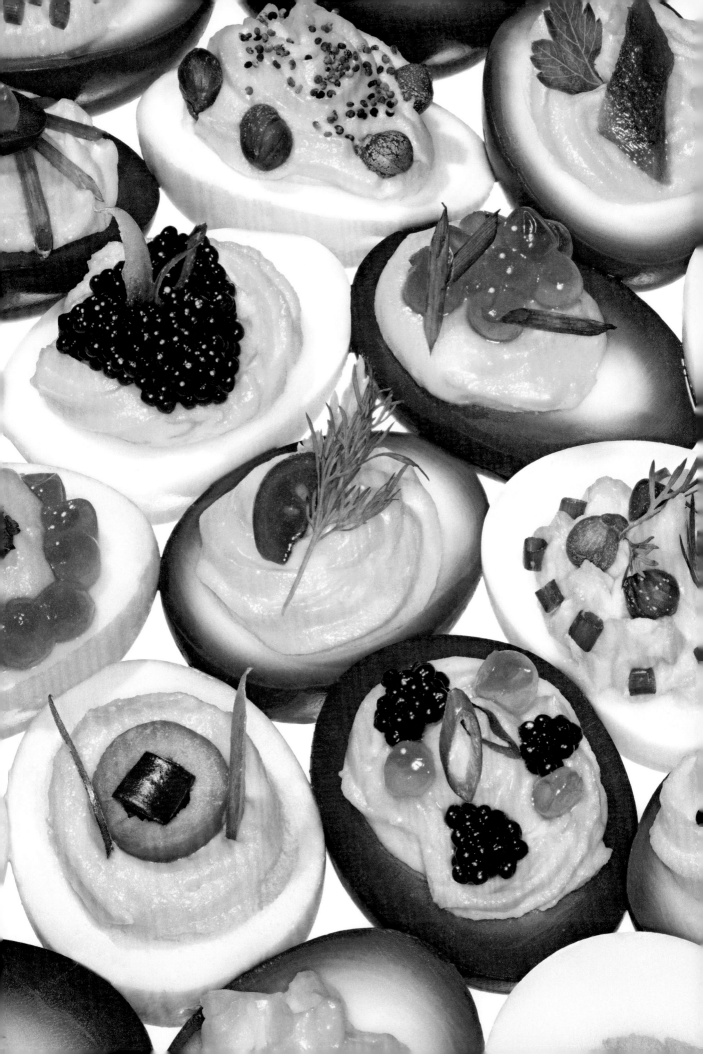

"An ode to the egg…
Eggs are great
Eat them rarely
Buy them well
Make them delicious."

ANNA JONES

Scotch Egg

Serves: 6 scotch eggs
Preparation time: 45 min

INGREDIENTS
7 eggs
1 handful plain flour
420 g best-quality sausages
Salt and pepper
50 ml milk
100 g panko breadcrumbs

EQUIPMENT
Cooking pot
Mixing bowl
3 small bowls
Deep fat fryer (or air fryer)

Whether enjoyed with a pint at a pub or at a summer picnic on a grassy lawn, this quintessential British snack is all about good times. A plethora of different recipes and flavours can be found these days — everything from vegan to fish scotch eggs — but pork and egg is a classic that's hard to beat. Make sure you source the best-quality sausage meat you can find — this will make all the difference to the flavour and texture.

In a pot of boiling water, soft boil six eggs for six minutes, then plunge them into cold water. Peel the eggs, then dust them in plain flour, and set aside.

Empty out 420 g of sausage meat from the casings. Place this in a mixing bowl, and season generously with salt and pepper. Divide up the sausage meat into 70 g pieces, and roll into little balls.

Oil the palm of your hand, then flatten each meat ball into a thin meat patty. Place the patty on the palm of your hand, then put a floured, boiled egg on the patty. Next, wrap the patty around the egg by closing your hand and pinching the patty together, ensuring that the meat is joined invisibly. Make sure there are no holes in the meat casing, otherwise it will split, and your scotch egg will be ruined.

Prepare your worktop with three bowls: one bowl with a handful of plain flour, another bowl with one egg beaten with 50 ml of milk and seasoned with salt and pepper, and the third bowl with 100 g of panko breadcrumbs.

Dust the balls in flour, then dip them in the egg and milk mix, then in the panko breadcrumbs.

Deep fry at 160°C for five or six minutes. Note: it's important not to cook these too fast or you will end up with raw sausage meat and a burnt crumb. When ready they should have a golden-brown colour.

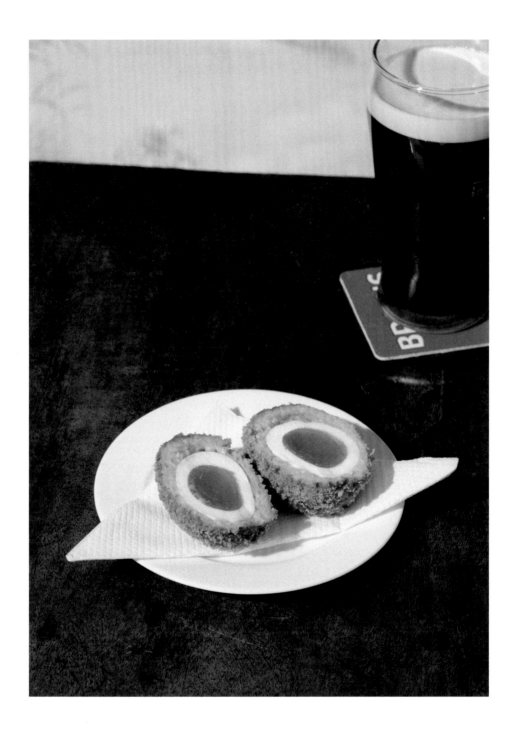

Smørrebrød

Serves: 4–8 people
Preparation time: 10 min

INGREDIENTS
200 ml mayonnaise
2 tsp curry powder
2 tsp turmeric
Salt and pepper
16 quails' eggs
12 pickled herrings
1 red onion, finely sliced
2 tbs fine capers, chopped
1 rye loaf
1 packet dill fronds

EQUIPMENT
Mixing bowl
Cooking pot
Mandolin
Small bowl

This Scandinavian open sandwich hails from Denmark, but has close cousins in Sweden and Norway. Sourdough rye bread is the bedrock of any smørrebrød, so source the best you can find. You can buy the remoulade, but making your own will lead to a very hygge lunch.

Start by making the remoulade. In a bowl, combine 200 ml of good mayonnaise (for a recipe, see p 192), 2 tbs of curry powder, 2 tsp of turmeric, and salt and pepper. Stir to combine, and put the remoulade to one side for later.

In a pot, soft boil 16 quails' eggs for two minutes and 30 seconds, then put them in cold water to cool. Peel the eggs, then cut them in half with a sharp knife, and season with salt and pepper.

Unroll 12 pickled herrings. Cut each fillet into three pieces, and reserve for later. Using a mandolin, carefully slice one red onion as fine as you dare. Chop 2 tbs of fine capers. Put the herring and onion aside for later.

Slice a loaf of rye bread laterally into eight thin slices. Spread a thick layer of the remoulade onto the rye bread, taking care to spread it right to the corners of each slice. Arrange the chopped herring to evenly cover the remoulade-covered bread, then scatter the sliced red onion and chopped fine capers over. Finally, arrange the eggs on top of the open sandwiches, and finish with dill fronds.

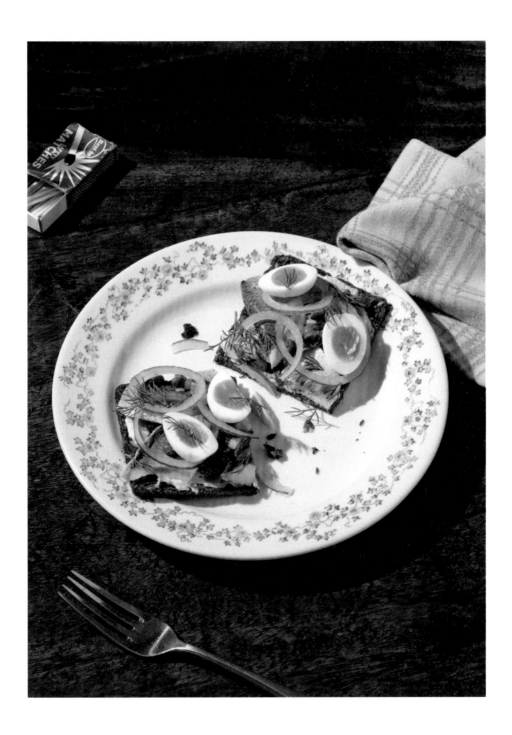

Devilled Eggs

Serves: 16 canapés
Preparation time: 15 min

INGREDIENTS
Mayonnaise (optional):
1 egg yolk
1 tsp smooth dijon mustard
25 ml chardonnay or cider
vinegar
1 pinch salt
75 ml olive oil
175 ml vegetable oil

Devilled eggs:
8 eggs
1 tbs water
1 tsp english mustard
1 tsp white wine vinegar
Worcestershire sauce
Salt and pepper
1 pinch cayenne pepper
Chives (garnish)

EQUIPMENT
Mixing bowl or blender
Cooking pot
Piping bag (or a freezer
bag makeshift)

Devilled eggs evoke the 1970s, a time of finger food and dinner party theatrics. But this canapé of choice predates the era of brown and orange crockery by centuries. In Ancient Rome, boiled eggs with spiced sauces were customarily served as a starter, hence the Latin expression *ab ovo usque ad mala* ("from eggs to apples") — meaning from beginning to end, referring to the order of courses. If you have leftovers, chop them up and enjoy on bread as a quick but satisfying treat.

Start by making your mayonnaise. This is optional, as the recipe will work with shop-bought mayonnaise.

In a clean mixing bowl or blender, mix one egg yolk, 1 tsp of smooth dijon mustard, 25 ml of chardonnay vinegar (or cider vinegar) and one pinch of salt. Then gradually and slowly add 75 ml of olive oil, and whisk or blend. Next, add 175 ml of vegetable oil gradually and slowly, until you have a thick, shiny, emulsion.

Hard boil eight eggs for seven minutes, cool in cold water, then peel. Slice the eggs in half, then scoop out the yolks and put these in a mixing bowl. Lightly season the egg whites, then put these aside.

Add 1 tbs of water to the egg yolks in the mixing bowl, then gently mash with a fork. Mix in 1 tsp of english mustard, 1 tsp of white wine vinegar, 1 tbs of water, 2 heaped tbs of mayonnaise and five splashes of worcestershire sauce. Season with salt and pepper, and stir until all the ingredients have combined.

For best results, place the egg yolk mix into the seasoned egg white casings using a piping bag or a makeshift equivalent. Add a pinch of cayenne pepper and some chives.

Quails' Eggs and Caviar

Serves: 10 canapés
Preparation time: 15 min

INGREDIENTS
10 quails' eggs
30 g Oscietra caviar
(or alternative)
Plain crackers or crisp
bread (optional)
1 handful chives, chopped

EQUIPMENT
Ice (for ice bath)
Large bowl (for ice bath)
Small cooking pot

This luxurious dish is a feast for the eyes with the matte black of the caviar against the pop of yellow from the quail's egg yolk. The caviar provides a saltiness against the richness of the yolk, and the whole thing just melts in your mouth. With such precious ingredients there's no need to overcomplicate things, but a little crisp bread adds texture. This recipe calls for Oscietra caviar, but it can be substituted with other types like keta or lumpfish caviar, which are more easily available and a lot more affordable.

Soft boil ten quails' eggs for two minutes. Then immediately plunge them in an ice bath, and peel carefully.

Slice the quails' eggs into two. Optionally, spoon them onto plain crackers or crisp bread. Carefully spoon the caviar on top of the eggs, and finish with a sprinkle of chopped chives.

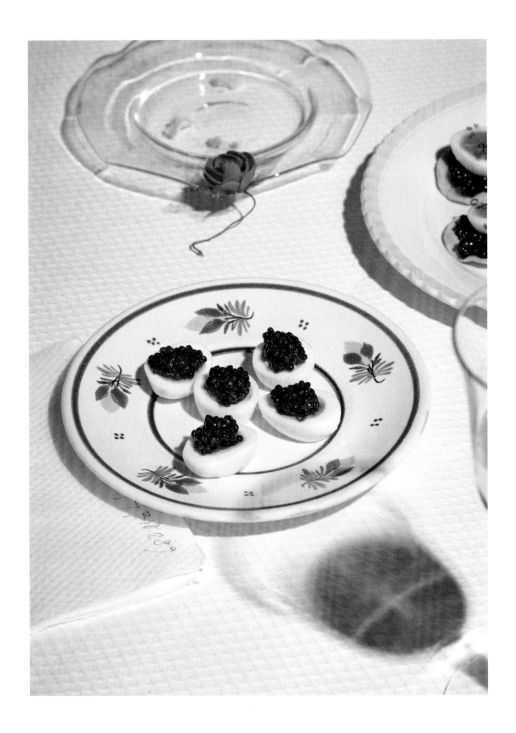

Egg Salad Sandwich

Serves: 5–6 sandwiches
Preparation time: 10 min

INGREDIENTS
Mayonnaise (optional):
1 egg yolk
1 tsp smooth dijon mustard
25 ml of chardonnay or
cider vinegar
1 pinch salt
75 ml olive oil
175 ml vegetable oil

Egg salad:
8 eggs
2 tsp dijon mustard
3 tsp chives, finely chopped
Salt and pepper
White bread or pain de mie
Salty butter
Cress or watercress

EQUIPMENT
Mixing bowl (or blender)
Small cooking pot

This might be the best method for making an classic egg salad sandwich. There's a glorious balance of creaminess from the soft-cooked yolks with the punchiness of the mustard and the silky mayonnaise. Sourdough is too robust for an egg salad sandwich; a simple white tin loaf or pain de mie is a better match. Try to use fresh free-range eggs, as this will make all the difference. Serve with copious amounts of black pepper and cress or watercress, for extra crunch.

Start by making your mayonnaise. This is optional, as the recipe will work with shop-bought mayonnaise.

In a clean mixing bowl or blender, mix one egg yolk, 1 tsp of smooth dijon mustard, 25 ml of chardonnay vinegar (or cider vinegar) and one pinch of salt. Then gradually and slowly add 75 ml of olive oil, and whisk or blend. Next, add 175 ml of vegetable oil gradually and slowly, until you have a thick, shiny, homogeneous emulsion.

Bring a pot of water to the boil. Cook eight eggs for seven minutes, then plunge them into ice cold water, and peel. Roughly chop the eggs, then place them in a mixing bowl with 6 tbs of mayonnaise, 2 tsp of dijon mustard and 3 tsp of finely chopped chives. Season very generously.

Assemble your sandwich by smearing white bread or pain de mie with salty butter, layering on a generous dollop of the egg mayonnaise mix and a blanket of cress or fresh watercress.

FOLLOWING **Bobby Doherty**, *Untitled*
PAGE 173 **Carl Kleiner**, *Pills*

Quail Egg Arancini

Serves: 6 arancini
Preparation time: 3 h

INGREDIENTS
Risotto:
1 litre water
1 white onion, finely sliced
30 g dried mushroom
selection
4 tbs extra-virgin olive oil
1 white onion, finely diced
4 cloves of garlic, finely diced
2 sticks of celery, finely diced
Salt and pepper
250 g arborio rice
100 ml white wine
50 g butter, diced
50 g parmesan, finely grated
1 handful flat parsley, chopped

Arancini:
6 quails' eggs
1 tsp fennel seeds, chopped
1 tbs pumpkin seeds, chopped
2 tbs unshelled sunflower
seeds
50 g panko breadcrumbs
2 tbs linseeds
2 tbs nigella seeds
1 tsp amaranth seeds (if you
can get them)
2 eggs
75 ml milk
Salt and pepper

EQUIPMENT
Large cooking pot
Cast-iron saucepan
Sieve
Wooden spoon
3 bowls
Deep-fat fryer

Arancini, originally from Sicily, are balls of risotto (often leftover) with savoury (often cheesy) centres, coated in crispy bread crumbs. They're made to celebrate the December feast of Santa Lucia, the patron saint of the blind. Usually the size of a big citrus fruit —*arancia* means "orange" in Italian — they're bought by inhabitants of Palermo from street vendors, local bars and restaurants. This version with a quail's egg is like a long-distance cousin of the original, and is also related to the scotch egg. Smaller than the usual arancini — these are about the size of a mandarin — the seeded crumb adds great crunch and the tiny egg is a lovely surprise. There's a recipe here for a mushroom risotto you can make the night before, but any other variety should work too.

To make the risotto, start with the stock. Boil 1 litre of water in a pot with a finely sliced white onion, and 30 g of a dried mushroom selection. Reduce to a low heat, and infuse for as long as possible.

Warm 4 tbs of extra-virgin olive oil in a large cast-iron pan on a medium heat, and sweat one finely diced white onion, four finely diced cloves of garlic and two finely diced sticks of celery. Season generously with salt and pepper. Once the alliums turn clear, add 250 g of arborio rice, and allow the rice to fry gently until the edges turn translucent. Pour in 100 ml of white wine, and allow it to reduce, then gradually add the stock using a sieve, to catch any onion or mushroom pieces. Stir continuously and patiently at a simmer until the stock is almost all absorbed.

Remove the pan from the heat and add 50 g of diced butter, 50 g of finely grated parmesan, and a handful of chopped flat parsley. Now set the pan to one side, to allow the rice to rest and lightly swell. After a couple of minutes, use a wooden spoon to stir the butter and parmesan vigorously until emulsified, then leave overnight to cool. If you don't have time, cool the risotto quickly by covering a table with baking paper, and then spread the risotto over it.

To make the arancini, cook six quails' eggs in boiling water for 2½ minutes, then transfer them to iced water. When cool, peel the eggs and dust in flour.

Once the risotto has cooled, split the rice into 40 g balls. Lightly oil your palm to prevent the rice from sticking, and flatten a rice ball onto it. Place a dusted quail's egg in the centre, and fold the rice around it. Add a bit of risotto if necessary to make sure the egg is fully sealed. Put your rice balls in the freezer for an hour or two if you can: this makes them easier to coat and prevents disintegration when coated and cooked — a very real risk!

Next, coat the rice balls before frying them. Clean your worktop, and organise three bowls with each of the ingredients for coating. Prepare the seed mix by chopping 1 tsp of fennel seeds and 1 tbs of pumpkin seeds. Mix these in a bowl with 2 tbs of unshelled sunflower seeds, 50 g of panko breadcrumbs, 2 tbs of linseeds, 2 tbs of nigella seeds and 1 tsp of amaranth seeds. Season with salt and pepper.

Prepare three bowls: one with 50 g of plain flour; one with two eggs that have been beaten and 75 ml of milk, seasoned generously with salt and pepper; and one with your crumb mix. Dust the balls in flour, then roll them in the egg wash and then in the crumb — making sure they are coated all over. Fry at 150°C in a deep-fat fryer until a golden brown. Then sprinkle with coarse salt.

Substantial Eggs

"The egg can be your best friend if you just give it the right break."

JULIA CHILDS

Egg Fried Rice

Serves: 2 people
Preparation time: 15 min

INGREDIENTS
250 g rice
2 tbs vegetable oil
2 eggs
Salt and pepper
3 tsp sesame oil
4 scallions, chopped

EQUIPMENT
Cooking pot
Wok
Mixing bowl

Egg fried rice is quick, convenient and comforting. Originally from Yangzhou in China, egg fried rice is enjoyed across Asia and beyond, paired with fried greens, other vegetables and all manner of proteins, pickles, seeds, seasonings and sauces. For best results use leftover rice, as it will have dried out and be easier to crisp when fried, but if you're cooking with fresh rice, spread it out on a baking tray and let the moisture evaporate for as long as you can before it hits the pan.

Start by cooking rice in a pot according to the instructions on the packet, then allow it to cool. Place a wok on a medium heat, then add 2 tbs of vegetable oil. Add the rice, and stir fry, moving the rice around the pan as it fries.

Crack two eggs in a mixing bowl and beat with a fork. Season with salt and pepper. Add 3 tsp of sesame oil, and season with salt and pepper. Drizzle the egg into the rice, stirring constantly. Once the egg is cooked through, remove it from the pan, season with salt and pepper, and serve with chopped scallions.

Salade Niçoise

Serves: 4 people
Preparation time: 15 min

INGREDIENTS
Mixed fresh salad leaves
(radicchio, Bibb lettuce,
Batavia lettuce)
4 eggs
150 ml olive oil
45 ml red wine vinegar
½ lemon
1 sprig thyme
1 garlic clove
200 g green beans
250 g baby potatoes
4 radishes, finely sliced
300 g cherry tomatoes, finely
sliced
8 marinated artichokes
12 anchovies
16 black olives
500 g tuna in olive oil (canned)

EQUIPMENT
Jar
Small cooking pot
Mixing bowl
Deep cast-iron frying pan

Nothing tastes of the South of France quite like a salade niçoise served with a generous glass of rosé. This working-class dish traditionally included tomatoes, anchovies, oil and whichever fresh seasonal ingredients were available and inexpensive to purchase. To many purists' horror, it was French culinary god Escoffier who first added potatoes and green beans, one of many iterations served around the world today. This recipe calls for the best-quality tuna in olive oil you can find, but the unpolished spirit of the dish can be honoured by adapting the vegetables and herbs to the fresh and seasonal.

First prepare some fresh salad leaves (radicchio, Bibb lettuce and Batavia lettuce), trimming any undesirable and fibrous bits and washing the leaves carefully. Scatter the leaves in a tea towel, then roll up the tea towel into a sausage and put the leaves to dry in the bottom of the fridge for later.

Boil four eggs for seven minutes, then plunge them into cold water to cool. Peel the eggs and set them aside for later.

For the vinaigrette, mix 150 ml of olive oil, 45 ml of red wine vinegar, the juice of half a lemon and a sprig of thyme in a jar. Peel and smash one clove of garlic with the back of a knife and the palm of your hand, and add it to the jar. Close the lid, and shake vigorously.

Next, prepare the vegetables before assembling the salad niçoise. Blanch 200 g of green beans, then refresh them in cold water. Boil 250 g of baby potatoes until they are cooked, and allow them to cool down slightly. Then, finely slice four radishes and 300 g of cherry tomatoes, and loosely chop eight marinated artichokes. Slice the eggs into two with a sharp knife.

In a mixing bowl, combine the salad leaves with the vinaigrette, mixing lightly and tumbling the leaves in the vinaigrette, taking care not to smash or bruise the leaves. Divide the leaves across four plates.

Distribute the baby potatoes, blanched green beans, sliced radish slices, sliced cherry tomatoes, marinated artichokes, 12 whole anchovies and 16 black olives across the four plates.

Break 500 g of tuna (canned in olive oil) into small bite-sized pieces, and scatter these on the salad (don't worry if you get a bit of the oil into the salad too). Finally, place the halved eggs on top of the salad, and serve.

Doro Wat

Serves: 6–8 people
Preparation time: 1 h 30 min

INGREDIENTS
Berbere spice mix:
4 dried bird's eye chillies
½ tsp black peppercorns
1 tsp fenugreek seeds
1 tsp ground coriander
1 tsp ground cumin
1 tsp ground cardamom
¼ tsp ground cloves
1 tsp smoked paprika
1 tsp paprika
1 tsp ground ginger

Main dish:
6 eggs
6–8 chicken thighs
(with skin and bone)
50 g butter
2 tbs tomato paste
1 thumb minced ginger
5 garlic cloves
1 tsp dried basil
1 tsp paprika
3 onions, finely sliced
Olive or vegetable oil
Salt and pepper
500 ml water or stock
½ lemon

EQUIPMENT
Bowl
Cooking pot
Mixing bowl
2 frying pans
Cooking pot

This wat, or stew, hails from Ethiopia and Eritrea and is one of the few dishes in this book that contains both chicken and egg. Traditional doro wat is consumed convivially as one of many other delicacies around a communal bowl with injera, a fermented flatbread. Like several dishes from the region, the flavour derives from the fragrant berbere spice mix, which infuses the boiled eggs when left to cool overnight.

As this recipe has a lot of ingredients, organise your worktop before you begin.

Flake the dried bird's eye chillies in to a bowl then add all of the remaining spice mix ingredients. Stir to combine.

Soft boil the eggs for six minutes, and set aside to cool before peeling. Put the peeled eggs to one side to return to later. Next, in a hot pan, fry the chicken thighs (with their skin and bone) in 50 g of butter until crisp, then put the chicken in the pan to one side to use later.

In a mixing bowl, combine the berbere spice you prepared earlier with 2 tbs of tomato paste, one thumb of minced ginger, five minced garlic cloves, 1 tsp of dried basil and 1 tsp of paprika, to form a paste.

In the second pan, fry three finely sliced onions with a splash of olive or vegetable oil on a high heat until they are nicely caramelised. Season with salt and pepper. The next steps will consist of building your stew in this pan with the various elements.

First, add your berbere paste to the fried onions, and cook for a couple of minutes on a medium heat. Next, transpose the crispy fried chicken along with all of the juices to the onions and spices. Deglaze your chicken pan with 500 ml of water or stock, then add the liquid to the chicken, onion and spices. Allow this to simmer for 5–10 minutes, then add the peeled soft-boiled eggs. Squeeze in half a lemon, cover and allow to simmer on a low heat for 20 minutes.

Kefta Mkaouara

Serves: 6 people
Preparation time: 1 h 30 min

INGREDIENTS
300 ml water
2 onions
1½ tsp ground cumin
1 tsp paprika
¼ tsp cinnamon
1 tbs salt
1 tsp ground fennel
1 kg lamb mince
½ cup flour
2 tsp olive oil
6 eggs

Tagine:
2 onions, finely sliced
2 cloves garlic, minced
60 ml olive oil
1 tbs tomato paste
1 tsp ground cumin
1 tsp ground coriander
½ tsp chilli powder
½ tsp black pepper
1 cinnamon stick
2 tins whole tomatoes
200 ml water

EQUIPMENT
Frying pan
Mixing bowl
Tagine or heavy-based
Dutch oven
Wooden spoon

The Moroccan kefta mkaouara is a fragrant spiced egg and meatball tagine. The tall lid of the traditional berber clay pot keeps condensation at the bottom during cooking so less liquid is needed. If you don't have a tagine, you can use a Dutch oven with a tight fitting lid and add a little more water to the tomato sauce if needed.

First make your meatballs by finely chopping two onions and place them in a mixing bowl. Add 1½ tsp of ground cumin, 1 tsp of paprika, ¼ tsp of cinnamon, 1 tbs of salt and 1 tsp of ground fennel. Combine the ingredients with 1 kg of lamb mince, mix well, then shape into small 60 g balls by rolling in the palm of your hand. Place the balls on a tray or large plate, and dust with flour. Heat 2 tsp of olive oil in a heavy-based pan, and fry the meatballs on a medium heat. When nicely browned, place the cooked meatballs to one side.

In your tagine gently fry two finely sliced onions and two minced cloves of garlic in 1 tbs of olive oil until sticky and golden. Mix in 1 tbs of tomato paste, 1 tsp of ground cumin, 1 tsp of ground coriander, ½ tsp of chilli powder, ½ tsp of black pepper and one cinnamon stick and stir until the flavours combine.

Next, add two tins of whole tomatoes and their juice. Cook on a medium heat for 15 minutes, breaking them down with a wooden spoon until they have reduced in volume and become rich.

Reduce the heat to low, add the meatballs and cook for a further 30 minutes with the lid on until they are cooked through.

Crack six eggs on top. Cover with the lid, and cook on a medium heat for 7–10 minutes until the egg whites are just about solid and the yolk is soft and just beginning to set.

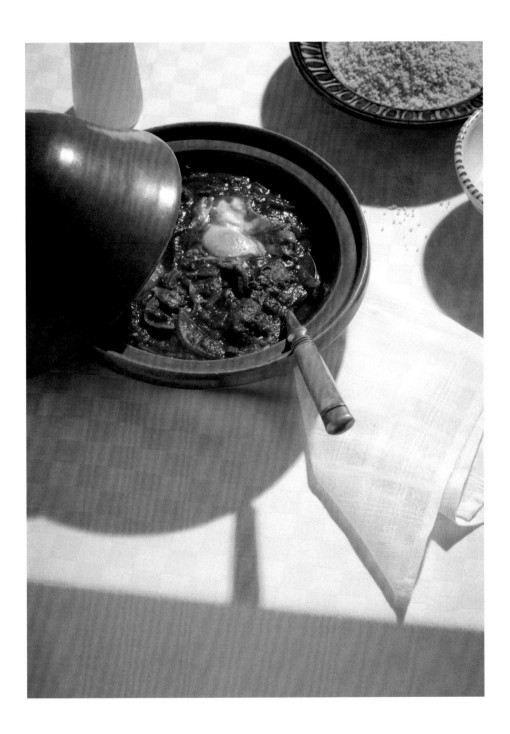

FOLLOWING **Maisie Cousins**, *Egg*, 2018
PAGE 189 **Bobby Doherty**, *Scrambling Yolks*, 2016

Cheese Soufflé

Serves: 6 people
Preparation time: 2 h

INGREDIENTS
100 g soft butter
245 g parmesan, finely grated
30 g butter
80 g plain flour
300 ml milk
1 tsp english mustard
90 g mature (18-month-old)
cheddar cheese
Salt and pepper
9 egg whites
1 tsp cream of tartar
300 ml full-fat cream
1 tbs (heaped) mascarpone
5 ml white truffle oil (optional)

EQUIPMENT
6 ramekins, 7.5 cm diameter
(or dariole moulds)
Saucepan
Mixing bowl
Electric mixer
Bamboo steamer (or impro-
vise using a large pot,
a metal-bottomed colander
and a large bowl)

The cheese soufflé is a culinary icon, evoking the glamour of old-world dinner parties and grand hotels. This classic recipe is somewhat laboursome, yet quite convenient when hosting, as most of the preparation can be done in advance. The soufflés are assembled then steamed, and will keep for a couple of hours before a final short bake in the oven. For the best results use a bamboo steamer, but if you don't have one you can improvise using a large pot, a metal-bottomed colander and a large bowl. The egg whites must be stiff for your soufflé to rise and a fan oven helps to ensure an even bake. Use up your egg yolks by making a mayonnaise for Devilled Eggs (p 166) or an Egg Salad Sandwich (p 170).

Start by preparing your ramekins: rub some soft butter into the lining of the dishes, then sprinkle the insides with grated parmesan. Each ramekin should be evenly coated with a thin layer of butter and cheese. Cover with a tea towel, and put these to one side.

Place a saucepan on a medium heat, and gently melt 30 g of butter. Stir in 80 g of plain flour until it forms a smooth paste, or a roux, and let it cook through for a couple of minutes, stirring occasionally. Gradually add 300 ml of milk, one splash at a time, stirring constantly to get rid of the lumps before adding more milk. It's important to add the milk gradually, and stir patiently, so that your sauce achieves a lovely, thick, almost glossy consistency.

When your sauce is ready, take it off the stove and stir in 1 tsp of english mustard, and then fold in 90 g of grated mature cheddar, and season generously with salt and pepper.

In a mixing bowl, whip nine egg whites to soft peaks. Add 1 tsp of cream of tartar, and whisk until you have stiff peaks. Using a large serving spoon, scoop out a third of the firm egg whites, and fold them into your cheesy white sauce. Repeat the process until all the stiff egg whites have been incorporated. Spoon the airy mix into your butter and parmesan-lined moulds.

You now need to steam your cheese soufflés so that hot evaporating water will cook the airy cheesy mix. You can do this in a water-filled pan and a bamboo steamer. (Or improvise an apparatus: a large pan partly filled with boiling water, and a metal-bottomed colander resting on the pot edges above the water, with a large bowl acting as a lid). You may need to steam these in batches of two or three, depending on the size of your apparatus.

Steam the cheese soufflés for ten minutes. Allow them to cool before you demould. Place these in the fridge if you are serving later that day.

When you are ready to serve, place a saucepan on a medium heat, and pour in 300 ml of full-fat cream. Simmer until it has reduced by half. Stir in 125 g of grated parmesan, 1 heaped tbs of mascarpone and, optionally, 5 ml of white truffle oil. Stir gently at medium heat. Don't rush the process or your sauce might split.

Now heat your oven to 180°C, and place the soufflés in it for 12 minutes so they rise to double their original size and are piping hot. Serve immediately with a side of cheese sauce.

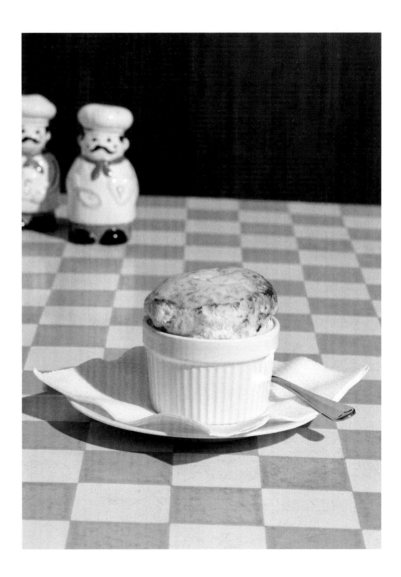

Keralan Egg Curry

Serves: 4 people
Preparation time: 45 min

INGREDIENTS
8 eggs
1 knob butter
3 green cardamom pods
1 pinch turmeric
2 tbs coconut oil
1 tsp black mustard seeds
2 onions, finely sliced
1 green chilli, finely sliced
1 tbs curry leaves (fresh
or dried)
6 cloves minced garlic
½ thumb grated ginger
1 tsp turmeric
1 tsp ground cumin
1 tsp chilli powder
½ tsp fennel seeds
½ tsp black pepper, cracked
2 red dried chillies, chopped
¼ tsp garam masala
2 tins thick coconut milk

Tempering:
3 tbs coconut oil
1 tbs mustard seeds
2 dried red chillies, crushed
1 tbs curry leaves, chopped
½ lemon

EQUIPMENT
Small cooking pot
Cast-iron frying pan
Cooking pot

Commonly known as nadan mutta, or just egg roast, this dish adorns the simple egg with an array of spices and a rich masala sauce. Like with all dishes that include coconut milk, don't increase the temperature to save time, as you run the risk of the sauce splitting. Pair with rice, chapati, paratha flatbreads, or appam (fermented rice and coconut pancakes) for Keralan authenticity.

Hard boil eight eggs for seven minutes in a small pot. Place them in cold water, then peel.

Melt a knob of butter in a cast-iron pan, then add three green cardamom pods, and warm for a couple of minutes until fragrant. Gently place the eight hard-boiled eggs in the cardamom butter with a pinch of turmeric, and fry until the eggs have a fragrant crunch on the outside. Leave to one side to cool.

Slowly heat 2 tbs of coconut oil in a pot on a medium heat, then cook 1 tsp of black mustard seeds to release their flavour. Next, add two finely sliced onions, one finely sliced green chilli and 1 tbs of curry leaves. Once the onions have softened, incorporate six minced cloves of garlic, half a thumb of grated ginger, 1 tsp of turmeric, 1 tsp of ground cumin, 1 tsp of chilli powder, ½ tsp of fennel seeds, ½ tsp of cracked black pepper, two chopped dried red chillies and ¼ tsp of garam masala. Cook these down slowly and gently for five minutes.

Pour in two tins of coconut milk, and turn the heat up to medium. When the curry starts to simmer, turn the heat back down to low. Take your cardamon butter-fried eggs, discard the cardamon, and add to the curry. Cook on a gentle heat for ten minutes.

While your curry is simmering with the eggs, prepare the tempering mix to drizzle over it before serving. Heat 3 tbs of coconut oil in a pan until warm and runny, then spoon in 1 tbs of mustard seeds. When the mustard seeds start to pop and fizz, add two crushed dried red chillies and 1 tbs of chopped curry leaves. Fry these gently and cautiously for a few seconds only, or they will darken and burn. Now, add the juice of half a lemon—the mixture should sizzle and spit. Turn off the heat and allow to cool.

Serve two eggs per person, with a drizzle of your spicy coconut and lemon tempering.

Spanish Tortilla

Serves: 6 people
Preparation time: 1 h

INGREDIENTS
600 g potatoes
½ onion
250 ml light cooking olive oil
5 eggs
Salt and pepper

EQUIPMENT
Cast-iron frying pan (or skillet)
Slotted spatula
Mixing bowl
Wooden spoon
Plate (2–5 cm wider than the
pan, with a rim)

Quintessentially Spanish, a good tortilla is a marvel of texture and flavour. Although a little messy to make, and requiring a sizable quantity of oil, it's definitely worth it. Every cook has their favourite plate and pan combination for performing the "flip", which can be a little nerve-racking at the start. Tortilla is perfect with a salad for lunch, as a tapas, or even cold in a baguette as children in Spain enjoy.

Peel 600 g of potatoes, then cut them into thin slices. Chop half an onion.

Heat 250 ml of light cooking olive oil in a cast-iron pan or skillet. When the oil is piping hot, pour in half of the sliced potatoes and onions, and deep fry until soft, occasionally stirring with a wooden spoon. When ready, remove the cooked potatoes and onion with a slotted spatula and place them on a to a paper towel. Then, deep fry the second batch of potatoes and onions. Pour the excess oil out of your pan, retaining about 2 tbs to fry the tortilla.

In a mixing bowl, beat five eggs seasoned with salt and pepper. Transfer the fried potatoes and onion to the egg mix, and stir to combine and coat the potatoes.

Heat the pan on a medium to high setting and pour in the egg, potato and onion mix. This should bubble and fry vigorously. Move the ingredients around with a wooden spoon so that the mix cooks a little, then turn the stove down to a low-medium heat. When the edges are golden and start to set but the centre and top are still runny, it's time to flip your tortilla.

Now place the rimmed plate on top of the pan, with your hand firmly on the plate for support, flip it over as fast and safely as you can. Your tortilla should be sitting in runny egg mix on the plate, and have a lovely golden top. Slide the tortilla back into the hot pan as neatly as possible. You should hear it bubble and fry.

Now use a spatula to tuck in the edges and shape your tortilla, so the sides are mounded. After a couple of minutes, when the edges are firm, your tortilla will be cooked and ready to be slid off the pan onto a serving plate with the help of a spatula. A classic tortilla should retain a silky runny texture at the centre.

Asparagus Sauce Gribiche

Serves: 3 people
Preparation time: 15 min

INGREDIENTS
3 eggs
10 chopped cornichons
1 handful flat parsley, chopped
1 handful chives, chopped
1 clove garlic, crushed
1 tsp fine capers
1 tsp dijon mustard
1 tbs lemon juice
5 tbs olive oil or rapeseed oil
Salt and pepper
1 bunch fresh asparagus

EQUIPMENT
Large cooking pot
Small cooking pot

Fresh eggs and young asparagus make fine partners, and there's no better dance for the two than a sauce gribiche. It's quick to execute, and best prepared in April to take advantage of the short asparagus season when produce is plentiful and bursting with flavour. As many of these ingredients — garlic, capers, cornichons and chives — are strong in flavour, you can adjust how they are chopped according to your taste: finely for a rounded, blended flavour, to coarse for a more pronounced taste.

In small a pot, boil three eggs for seven minutes. Cool under a cold tap, then peel. Slice in two with a sharp knife, then separate the cooked egg yolks from the whites. Chop the egg whites chunkily and leave to one side. Mash the yolks with a fork in a bowl, then add ten chopped cornichons, a handful of chopped flat parsley, a handful of chopped chives, 1 clove of crushed garlic, 1 tsp of fine capers, 1 tsp of dijon mustard, 1 tbs of lemon juice, 5 tbs of olive oil or rapeseed oil, and a generous seasoning of salt and pepper. Stir together and add in the chopped egg whites.

Bring a large pot of salted water to the boil. Gently snap off the bottoms of the asparagus with the tips of your fingers, discarding the woody, fibrous bits. Make sure to use minimal pressure so the asparagus breaks at the correct point. Blanche the asparagus in boiling water for 2–4 minutes until cooked but firm — they should be a lovely, vibrant green.

Serve with the sauce gribiche spooned over the asparagus.

FOLLOWING SPREAD **Marius W Hansen**
Eggs from *Hey Siri! Yes, Whasen?*, 2019

197

Nitamago
for Ramen

Serves: 4
Preparation time: Overnight

INGREDIENTS
Nitamago marinated eggs:
4 eggs
50 ml mirin
50 ml soy sauce
1 tsp ginger, grated

EQUIPMENT
Medium cooking pot
Small saucepan
Large bowl
Large resealable food bag

Traditionally used to top a classic tonkotsu ramen (bone broth with braised chashu pork or barbecue pork belly), the succulent, marinated nitamago egg can also bring a sense of occasion to any other ramen variety. Once you start marinating the eggs you'll find plenty of other reasons to use them — be it on rice, or some blanched greens with toasted sesame seeds.

Soft boil four eggs for seven minutes, then plunge them into ice water and leave to sit for five minutes. Carefully peel the shells, keeping the eggs in the water. While the eggs cool, take a small saucepan and heat 50 ml of mirin, 50 ml of soy sauce and 1 tsp of minced ginger. Place the eggs and the marinade in a large resealable bag or container, and gently rotate to ensure they are coated. Leave this in the fridge overnight.

When ready to serve remove the marinated eggs, and slice each into two before placing on top of your chosen ramen.

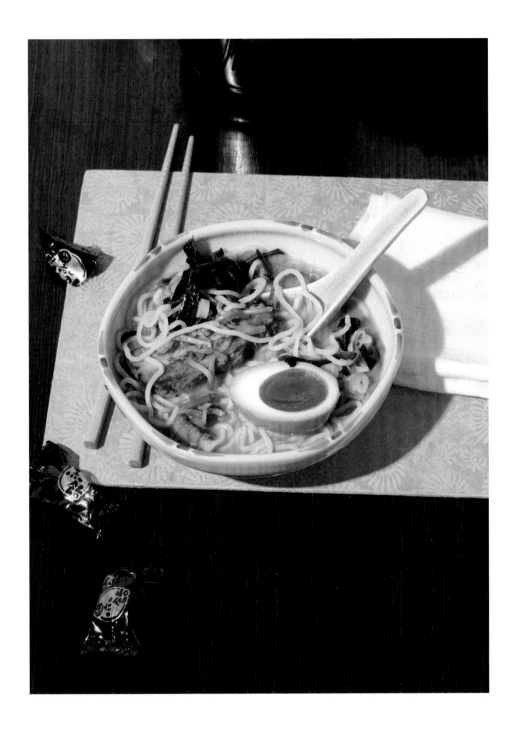

Spaghetti Carbonara

Serves: 4 as a primo,
2 as a generous main course
Preparation time: 20 min

INGREDIENTS
3 tbs salt
350 g dried spaghetti
150 g guanciale, chopped
(or pancetta or lardons)
4 egg yolks
70 g pecorino romano, or
Parmesan or a mixture of
both, finely grated
Fresh parsley, chopped
(optional)
Salt and cracked pepper

EQUIPMENT
Large cooking pot
Mixing bowl
Tongs
Heavy-duty or cast-iron
frying pan
Measuring jug
Wooden spoon

Spaghetti carbonara is a queen among classics. Deeply satisfying, it has a creaminess from the parmesan and egg yolk and an indulgent saltiness from the fatty cured pork. The trick of emulsifying starchy pasta water with dry cheese to a smooth sauce can be applied to all sorts of pasta dishes, including the exquisitely rich Roman speciality cacio e pepe. This traditional recipe calls for chopped guanciale, cured pork cheek, but pancetta or lardons can also be used with the addition of a little extra cooking fat. You can also swap the salty pecorino romano with Parmesan or use a mixture of both. Thee leftover egg whites can be used by whipping up a Pavlova for dessert (p 220).

Bring a large pot of water to a rolling boil, then add 3 tbs of salt. Consult your spaghetti packkaging for the cooking time, then plunge it into the boiling water, stirring so it doesn't stick.

Add 150 g of chopped guanciale to a cold pan and cook on a low to medium heat until the fat renders and the meat turns golden. Take a mixing bowl and beat four egg yolks with a fork. Stir 70 g of finely grated pecorino cheese into the mix, and set to one side.

When the spaghetti has a couple of minutes to go and is cooked almost al dente, use tongs to lift the spaghetti out of the pot, straight into your guanciale pan. Reserve 100 ml of pasta water in a measuring jug. Add around 50 ml of pasta water to the spaghetti-filled guanciale pan, and continue to cook on the stove on a medium heat for the remaining two minutes or so.

Meanwhile, add the remaining 50 ml of pasta water to the egg yolks and pecorino mix, stirring gently to combine. This will avoid shocking the yolks and causing them to scramble when they meet the spaghetti in the pan.

Take your spaghetti-filled guanciale pan off the stove, and add the egg yolk and pecorino mix, stirring vigorously and continuously with a wooden spoon. It should thicken with residual heat until you get a rich, shiny, creamy sauce that generously coats your spaghetti. If the sauce is still too watery, persevere! Or return it to low heat — but at the peril of scrambling the eggs.

Serve immediately with lots of freshly ground pepper.

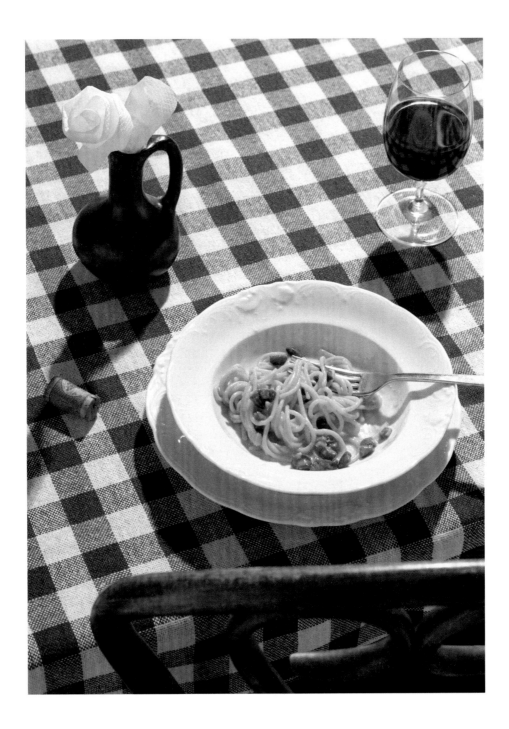

Thit Kho

Serves: 4–6 people
Preparation time: 4 h
(or overnight)

INGREDIENTS
6 duck eggs
1.3 kg pork belly
Salt and pepper
2 tbs sugar
1 lemon
1 orange
4 litres water
100 ml fish sauce
50 ml soy sauce
2 discs palm sugar, chopped
1 bunch scallions, chopped
2 cloves garlic, chopped
1 thumb ginger, minced
400 ml coconut water

EQUIPMENT
Cooking pot
Large cooking pot
2 mixing bowls
Casserole dish

Thit kho is Vietnamese comfort food through and through. It's the dish a loved one might prepare to welcome you home after a long stint away. Like many traditional recipes, there are endless variations, but the foundation is braised Vietnamese pork belly and eggs in a caramelised coconut water-based sauce. For best results, prepare it the day before, and let the pork belly sit in the stock overnight. While the flavours, ingredients and methods of this recipe are traditional, there's an added step to grill the fat for those so inclined. But if you want to chew on some delicious pork belly like you're in Hanoi, ignore this step.

Soft boil six duck eggs for seven minutes, then plunge them into cold water to cool, and peel. Put these aside for later.

Prepare the meat by scoring both side of 1.3 kg of pork belly, and seasoning both sides generously with salt and pepper. In a mixing bowl prepare the marinade using 2 tbs of sugar, the juice of a lemon, and a pinch of salt and pepper. Cover the seasoned pork belly in the marinade, place a tea towel over the bowl, and leave in the fridge for around 30 minutes.

Next, place the pork belly in a large pot, and add the peel of one orange. Pour 4 litres of water over the meat, and turn the stove to a high heat. Once the water begins to bubble, turn the heat down to medium, and allow the meat to simmer in the liquid for two hours. Turn off the stove, and allow the liquid to cool. For best results, let the pork belly sit in the stock overnight.

In a mixing bowl, combine 100 ml of fish sauce and 50 ml of soy sauce. Cut the pork belly into about 16 pieces, and marinade these in the fish and soy sauce mix while you prepare the rest of the ingredients. However, do not throw out the precious stock!

Chop two discs of palm sugar, and add these to a casserole dish, along with 250 ml of the stock used to cook the pork belly. (Note: the casserole dish will need to fit under your grill.) Keep the rest of the stock for later. Turn the stove to a medium heat, and simmer this mix for 15 minutes until it starts to brown.

Add the six peeled soft-boiled duck eggs, a bunch of chopped scallions, two chopped cloves of garlic, one thumb of minced ginger, and any leftover pieces of orange peel from the stock.

Then, add the sliced pieces of pork belly, along with all of the fish sauce and soy sauce marinade, to the casserole. Allow this to simmer for ten minutes until it has reduced a little, then pour in a further 750 ml of the pork stock, and 400 ml of coconut water. Simmer

for one hour. The liquid should reduce slowly until the pork protrudes from the top of the stock. Make sure to turn the pork belly and eggs. Once the liquid has reduced by three-quarters and starts to look sticky, turn off the heat. It should taste sweet and have a wonderful depth of flavour.

Turn your pork belly skin side up, then place your open casserole dish under a hot grill for five minutes until the fat chars and crisps up.

Quiche Lorraine

Serves: 6 people
Preparation time: 1 h

INGREDIENTS
400 g puff pastry
1 onion, sliced
Olive oil
200 g lardons or pancetta,
diced (or 8 rashers smoked,
dry-cured streaky bacon,
chopped)
9 eggs
250 ml double cream
125 ml full-fat milk
Black pepper
200 g gruyère and emmental
cheese mix, grated

EQUIPMENT
25 cm tart ring
(or 25 cm × 18 cm baking tray)
Baking beads (or dry pulses)
Frying pan
Cooking pot
Mixing bowl
Whisk

The classic quiche lorraine is the finest expression of any quiche. The pancetta or lardons add a fatty saltiness to the combination of eggs, cream and cheese that balances the dish. A quiche lorraine can be enjoyed hot or cold, ideally alongside a fresh salad with a lemony dressing to cut through the creaminess.

Prepare a pastry casing before you cook and mix the filling. Heat your oven to 180°C. Roll out 400 g of puff pastry into a tart ring or baking tray, and gently fork the pastry to stop it puffing, but not right through so that your egg will leak. Then, blind bake with baking beads to prevent puffing for 20 minutes until the base is cooked — it should be dry and golden, not wet or greasy. Retrieve the casing from the oven, take the beads out and make sure the centre is evenly cooked — if not, return the pastry to the oven without the beads for another five minutes. When ready, set the casing aside, then turn your oven down to 140°C.

On a low heat, sweat one sliced onion in a pan with a splash of olive oil until soft and tender.

If you don't have lardons or cubed pancetta (200 g), roughly chop eight smoked, dry-cured streaky bacon rashers. Cook the meat slowly on a medium heat, stirring every now and then until all the fat has turned golden and crispy.

In a mixing bowl, combine nine eggs, 250 ml of double cream and 125 ml of full-fat milk, and whisk together vigorously until you see some foam and bubbles on the surface. Season generously with black pepper, but no salt as the meat provides saltiness.

Combine the cooked meat and onions in a bowl. Sprinkle half of this filling onto the blind baked pastry case — do this gently and in small quantities at a time with your fingertips so that the mix is evenly spread, airy and not compacted on the pastry. Pour in half of the eggy mix, and then sprinkle in the remainder of the meat and onion filling. Pour in the rest of the eggy mix, and then scatter the top with 200 g of grated gruyère and emmental cheese.

Bake the quiche lorraine at 140°C for around 40 minutes, until the top is slightly brown and golden.

Sweet Eggs

"It is a humble ingredient, inexpensive and seemingly not complex to prepare. But make no mistake about it: there is nothing simple about an egg. Skeptics, beware."

DENA KLEIMAN

Île Flottante

Serves: 6 people
Preparation time: 1 h 45 min

INGREDIENTS
40 g flaked almonds
Icing sugar
8 eggs, separated (250 g egg
whites, 200 g egg yolks)
475 g caster sugar
600 ml milk

EQUIPMENT
Small baking tray
2 mixing bowls (1 glass
or metal)
Electric whisk
Deep saucepan
Slotted spoon
Sieve
Measuring jug
Heavy-based saucepan
Wooden spoon
Thermometer
Shallow serving bowls

There's no way to sugar coat it: this recipe requires patience, attention and precision, and will generate piles of washing up. It's best reserved for dinner parties — many of the elements can be prepared in advance — but these lovely little meringue islands floating on a sea of custard will bring any meal to an elegant close. Some like their îles flottantes cold, but served warm they offer a more luxurious texture. If you favour the former, prepare the custard first so it has a chance to cool down.

Put one of the empty mixing bowls in the freezer for later. Toast 40 g of flaked almonds on a baking tray in a 180°C oven for eight minutes. Dust with icing sugar and put aside for later.

To make the meringues, start by separating eight eggs. Whisk together 250 g of egg whites and 375 g caster sugar in a glass or metal mixing bowl (a plastic bowl may have a trace of fat, preventing the egg whites stiffening) for a good 10 minutes until you have nice and shiny stiff peaks.

Prepare the poaching liquid by bringing 600 ml of milk to the bubble in a deep saucepan. Turn down to a low heat — too-hot milk will break up your egg whites.

Start poaching a single fluffy "île" until you master the technique. Using two spoons, "quenelle" the stiff egg whites into the poaching milk. This doesn't have to be perfect, but a smooth surface is easier to handle, and less likely to break. If need be, smooth with your index finger.

Poach each île for one minute on each side, remove it with a slotted spoon and place on a tray to cool. These will hold for around three hours.

Sieve the milk you used for poaching into a measuring jug. Check the milk volume is still 600 ml; if not, top up with fresh milk. Place the milk in a heavy-based saucepan on a high heat to scald then turn down to a low heat.

Whisk 200 g of egg yolks and 100 g of caster sugar in a mixing bowl. Stir in the warm milk, then pour the mix back into the pan on a low heat for 1–2 minutes. This mix must stay below 80°C or it will curdle. Remove the mixing bowl from the freezer. Once the custard has thickened to a pancake batter-like thickness, pour it into the cold bowl, to stop it from continuing to cook.

To assemble your dessert, pour the warm custard into shallow bowls, and delicately place two little îles meringues on top. Sprinkle with the sugary flaked almonds.

Crème Brûlée

Serves: 6 people
Preparation time: 1 h

INGREDIENTS
3 vanilla pods
600 ml double cream
120 g caster sugar
150 g egg yolks (7–8 eggs)
50 g golden sugar

EQUIPMENT
Saucepan
Mixing bowl
6 shallow, wide moulds
(4 cm deep)
Blow torch

This classic dessert can be found in bistros and restaurants across France. Despite its gallic popularity, Spain and England also lay credible claims to crème brûlée: the Spanish have enjoyed crema catalana for hundreds of years, and a recipe for "burnt cream" can be found in 17th-century Trinity College Cambridge cookbooks. In fact, this indulgent dessert is consumed in various guises across all five continents. Aim to use shallow and wide crème brûlée ramekins to avoid the invariably messy bain marie, but also to allow for the correct silky-custard-to-crisp-sugar-coating ratio in each delectable spoonful.

Slice the three vanilla pods lengthways, and scoop out the vanilla seeds. Pour 600 ml of double cream into a saucepan, then add the vanilla seeds and emptied pods. Heat the cream and vanilla pods gently, and remove the pan from the heat when it starts bubbling. Set aside for the vanilla to infuse the cream.

In a mixing bowl, combine 120 g of caster sugar and 150 g of egg yolks, and start whisking immediately and continuously until pale and fluffy. Add the hot vanilla-infused cream, and stir to combine. For best results, cover the bowl with a clean tea towel or a beeswax lid, and allow it to rest in the fridge overnight.

Remove the vanilla pods the following day, and pour the mixture into low, wide moulds and bake at 100°C for 45 minutes. If using deeper ramekins, place these on a baking tray and pour hot water into the tray up to two-thirds of their height, to use as a bain marie.

When ready, your crème brûlée should be very nearly set — not too firm, and with a slight wobble. Allow these to cool and firm up in the fridge for an hour.

For the caramelised sugar topping, place a teaspoonful of golden sugar in the centre of each crème brûlée, and twirl your mould so as to evenly coat the surface. Wipe off any excess sugar from the sides of the moulds, and then *brulé* the sugar with a blow torch until it bubbles, becoming crisp and golden when it cools.

Vanilla Ice Cream

Serves: 20 scoops
Preparation time: 2 h

INGREDIENTS
185 ml double cream
250 ml full-fat milk
1 vanilla pod
125 g egg yolks
125 g caster sugar

EQUIPMENT
Saucepan
Food mixer
Mixing bowl
Wooden spoon
Ice cream maker

Vanilla is the safe-pair-of-hands ice cream flavour that sits without fuss with your jellies, tarts and crumbles. But when done well, it's anything but ordinary. There are many recipes for vanilla ice cream — even US President Thomas Jefferson penned one, which sits in the Library of Congress. All, however, involve a combination of eggs, cream, sugar and vanilla. Using the best-quality eggs is crucial for attaining a flavourful and fine-textured result. Salt was often added in the past to help with the freezing process. This practice is now back en vogue, so include a pinch if you fancy.

In a saucepan bring half of the double cream (90 ml), 250 ml of full fat milk and one vanilla pod (sliced lengthways with the seeds scooped out and included) to the boil on a low heat, then remove the pan from the heat and allow it to stand.

In a mixer, whip 125 g of egg yolks and 125 g of sugar until the mix has doubled in size, then pour it into a clean bowl.

Pour one ladle of your hot cream into the egg and sugar mix while stirring continuously with a wooden spoon. It's important you do this very slowly and progressively to avoid scrambling the eggs. Do this again a couple of times — so that the ingredients are combined while the temperature increases progressively — then add the rest of the egg mix. Make sure you stir continuously and vigorously.

Rest the mix in the fridge overnight with the vanilla pod.

Remove the vanilla pod the following day, and churn the mix in an ice cream maker until it indicates it's ready.

Spanish Flan

Serves: 6 people
Preparation time: 1 h 45 min

INGREDIENTS
Caramel:
200 g caster sugar
50 ml water
1 tbs liquid glucose (or golden syrup or honey)

Crème:
4 eggs
125 g sugar
375 ml milk
150 ml double cream
3 egg yolks
150 ml dark rum
1 vanilla pod
1 lemon

EQUIPMENT
Saucepan
Thermometer (optional)
6 ramekins
Mixing bowl
Whisk
Baking tray

There are many things to love about this dessert — the wobbly texture, the decadent custard enhanced with dark rum and lemon zest, and the sweet caramel sauce spilling into your plate. This recipe uses a "wet" caramel, to allow for a greater evaporation time and a larger margin of error, plus a squeeze of glucose or honey to help prevent the dreaded crystallization of the sugar.

Start by making the caramel. Pour 200 g of caster sugar and 50 ml of water into a saucepan, and begin to heat the mix gently. Once this starts to bubble, add 1 tbs of liquid glucose (or golden syrup or honey) to prevent crystallization. Without stirring, allow the mix to bubble and boil (the mixture should heat to 160°C), swirling it gently in the pan until it starts to brown, then pour it quickly into six ramekins. This can be a little tricky, so don't rush. Remove the pan from the heat if the caramelised sugar is browning too quickly. If it burns don't worry, just start again.

To make the crème, prepare a cold mix and a hot mix. For the cold mix combine four eggs, 125 g of sugar and 50 ml of milk in a mixing bowl. Whisk until smooth.

For the hot mix, put 325 ml of milk, 150 ml of double cream, three egg yolks, 150 ml of dark rum, one vanilla pod sliced lengthways with the seeds scooped out and stirred in, and the zest of a lemon into a saucepan. Gently bring this to the boil. Take the pan off the heat, then slowly combine the hot mix in the cold mix, and whisk them together into a custard.

Pour the custard into the caramel-lined ramekins, and place them in a baking tray. Create a bain marie by pouring hot water into the baking tray, making sure it reaches the top of the moulds so they will cook evenly.

Bake the flans at 120°C for 20 minutes until they are cooked in the centre. They should feel soft and wobbly, not too firm. When the flans have cooled, put them in the fridge to set for a couple of hours. Retrieve one hour before serving. Use a sharp knife to release the edges, then flip the flans over on a plate before serving.

Pavlova

Serves: 8–10 people
Preparation time: 90 min

INGREDIENTS
3 egg whites (room temperature)
3 tbs cold water
200 g caster sugar
1 tsp vinegar
1 tsp vanilla essence
3 tsp corn flour
Double cream, whipped
Fresh seasonal fruit

EQUIPMENT
Mixing bowl
Electric whisk (or mixer)
Baking tray lined with baking paper

There is much debate as to the origin of pavlova, with both New Zealand and Australia laying credible claims to the showstopping dessert. This particular recipe was taken from the slim ring-bound classic *Edmonds Cookbook*, first published in 1908 in New Zealand.

In a clean and dry mixing bowl, whisk three egg whites until they form stiff peaks. Add 3 tbs of cold water, and continue to whisk, then patiently add 200 g of caster sugar one spoonful at a time, until the egg whites are stiff and shiny. Don't be tempted to accelerate the process, as the heavy sugar will sink your meringue.

Next, mix in 1 tsp of vinegar, 1 tsp of vanilla essence and 3 tsp of corn flour, and whisk on a lower setting until all the ingredients have combined.

Preheat your oven to 150°C.

Spoon the stiff egg white mix into one big blob or giant cloud onto a baking tray lined with baking paper. Bake the meringue for 45 minutes, then turn off your oven. Do not, under any circumstances, open your oven until the meringue has cooled down.

Your meringue should be chewy in the middle and crunchy on the outside. Serve with whipped double cream and seasonal fresh fruit of your choice.

Zabaglione

Serves: 6–8 people
Preparation time: 20 min

INGREDIENTS
8 egg yolks
180 ml marsala wine
40 g caster sugar

EQUIPMENT
Large cooking pot
Round-bottomed stainless-steel (or copper) bowl
Whisk

Zabaglione dates back to the late 15th century and is said to have been a favourite of the Medicis. Like all emulsions, be it mayonnaise or hollandaise sauce, using a very clean bowl is key. A manual whisk is great for allowing you to feel how the custard is developing. This recipe needs slightly more eggs than traditional iterations, but yields smooth, delicious results. It uses marsala wine, though you can opt for dry moscato — either is fine. Use your spare egg whites for a cheese soufflé (p 190) or a pavlova (p 220).

Bring a pot of water to the boil, and turn down the heat to a low setting until it simmers. In a round-bottomed stainless-steel bowl, whisk eight egg yolks, 180 ml of marsala wine, and 40 g of caster sugar together gently until the ingredients have combined.

Place the bowl on top of the pot of hot water, making sure the bottom of the bowl does not touch the water. Whisk until the mix starts to thicken and froth. Continue until you can draw a figure-of-eight with the mixture that holds for a few moments, or until it sticks to the whisk. Your zabaglione should then be pastel yellow, smell deliciously boozy, and feel thick and airy.

Serve on its own or poured over fresh fruit of your choice.

Egg Baking

"In Jewish lore the egg is a symbol that represents the cycle of life. It is a food of mourning, expressing sorrow and anguish as well as the continuation of life."

CLAUDIA RODEN

Challah

Serves: 1 loaf
Preparation time: 1 h 45 min

INGREDIENTS
10 g yeast
3 tsp sugar
2 tbs plain flour
250 ml warm water
850 g strong flour
2 eggs
1 egg yolk (keep the
white for topping)
30 ml oil
2 tsp fine sea salt
80 ml honey

Topping:
Untoasted sesame seeds

EQUIPMENT
Large jar
Mixer with a dough hook
Pastry brush
Baking tray

Challah is traditionally defined as any bread made for use in Jewish ritual. It represents the portion, or *challah* in Hebrew, of all the bread that God asked the Israelites to set aside to show their gratitude for entering the Holy Land. In modern parlance, it refers to an enriched dough of Eastern European Ashkenazi Jewish tradition. Consumed on ceremonial days, challah can be braided in any number of symbolic ways, with as many as six strands. It can also be flavoured with varied ingredients such as poppy seeds, raisins or even saffron. This traditional recipe made with three strands and topped with sesame seeds. It's strongly recommended you use a mixer with a dough hook. Any leftovers will make excellent croutons, or even French Toast (p 156).

In a large jar, mix 10 g of yeast, 3 tsp of sugar and 2 tbs of flour in 250 ml of warm water, stirring it all together so that it incorporates. Close the jar and allow the yeast mix to activate for 15 minutes. When ready, you should notice some slight bubbling on the surface and a mild yeasty smell. If your mix has not activated, wait another ten minutes, then try again.

While your yeast is activating, pour 850 g of strong white flour into the machine mixing bowl, and set aside. In another bowl, combine two whole eggs and one egg yolk, and mix together.

Pour your egg mix over the flour with 30 ml of oil, 2 tsp of fine sea salt, 80 ml of honey and your bubbling yeast from the jar, and start to mix using a dough hook on a medium setting. Mix for around ten minutes until the dough is soft, glossy and smooth.

Pour the dough into a clean bowl, and cover with a tea towel. Leave the dough to prove at room temperature until it has doubled in size — this should take about an hour.

Once your dough has risen, gently knock some air out of it with your knuckles so as to shrink the dough back into the bowl slightly, then pour it out onto a lightly floured worktop.

Divide your dough into three equal parts, rolling each into a long sausage-like strand of around 3 cm in diameter and 30 cm long. Place these side by side and pinch the three strands together at the top. Separate each strand and plait them together, by crossing the leftmost strand over the middle strand, then the right strand over the middle strand, and so on. Pinch the strands together at the bottom of the plait, and tuck the ends under your dough. Then tuck in the ends of the dough at the top as well, so as to have a neat and somewhat symmetric plaited dough. While baking, the dough will

rise and slightly loosen the strands, so it's important that the extremities are well tucked under.

Beat your leftover egg white and brush your dough with it, then sprinkle generously with untoasted sesame seeds. Bake for ten minutes at 180°C, then turn down to 160°C. Add an optional second egg wash, then bake for another 20 minutes. When ready it should have risen, look deeply browned and sound hollow when tapped on the back.

Leave to rest for at least ten minutes before serving.

Brioche

Serves: 1 loaf
Preparation time: 1 h 45 min

INGREDIENTS
50 ml milk
500 g plain flour
25 g caster sugar
25 g dried yeast
10 g salt
7 eggs
250 g softened butter

EQUIPMENT
Jar
Mixing bowl
Mixer with a dough hook
Parchment paper
900 g brioche tin (or loaf tin)

Fresh brioche is the archetypal French *petit déjeuner*, rivalled only by the croissant. The dough is enriched with butter and eggs, which makes for a light, fluffy, extremely buttery crumb. In its country of origin, the shape of the loaf and its ratio of flour to butter designates the type of brioche. This recipe falls under the banner *brioche ordinaire* — though there's nothing ordinary about this light and savoury creation. It's recommended to use a mixer with a dough hook, as the wet dough requires a lot of kneading and is tricky to handle. Old brioche is perfect for French Toast (p 156).

Key to all successful bakes is well-activated yeast, so start by mixing 50 ml of warm (but not hot) milk, 50 g of flour, 25 g of caster sugar and 25 g of dried yeast in a jar. Cover and allow the yeast to activate at room temperate for 15 minutes. When ready, you should notice some slight bubbling on the surface and a mild yeasty smell. If your mix has not moved, wait another ten minutes. If that doesn't work, try again.

While your yeast is activating, place 450 g of flour in a mixing bowl, along with 10 g of salt and six eggs. Then pour the activated yeast mix over the ingredients, and start to mix the dough on a medium setting for a good ten minutes until all the ingredients are well combined and you have a nice, yellow, wet dough.

Divide the softened 250 g of butter into three equal clumps. The butter should be so soft that you can stick your finger into it with little resistance. Add a clump of butter to the dough and mix, then repeat for the other clumps. Mix the dough for ten minutes on a medium setting until it's smooth, soft and shiny.

Take the dough from the mixer and place it in a clean mixing bowl, and cover with a tea towel for 45–60 minutes at room temperature until the dough has risen to about 1½ times its original size. You can also prove the dough overnight in the fridge if you have time. After the first proving, the dough is now ready to be shaped and placed into a baking tin for its final prove before baking.

Tip the dough out onto your floured worktop, and gently knock it down with your knuckles. To shape the dough, pinch a side and pull it towards the centre, working your way around to the north, west, south and east — as if folding a piece of paper into a circular envelope. Then flip the dough over, so that the folds are tucked under, and shape it into a ball by turning the dough in the palm of your hands on your worktop.

Place some parchment paper in the brioche or loaf tin. Roll the dough out flat into a rectangle that is slightly longer than your tin. Fold it in 2 cm from each of the two ends. Then, roll the dough up into a sausage shape, and place it into the tin for the final prove, with the seam of the dough on the bottom of the roll as it sits in the tin. Allow it to prove for 45 minutes at room temperature.

Preheat your oven to 200°C. Beat the remaining egg, and paint egg over the top of the brioche to glaze it. Bake for 10 minutes at 200°C, then turn down to 180°C and bake for another 20 minutes. When your brioche is ready, it should be a beautiful golden colour, exude a sweet, buttery smell, and sound hollow if you tap it gently. Rest it for five minutes before serving.

FOLLOWING SPREAD **Gustav Almestål**
Untitled, 2021

Parker House Rolls

Serves: 16 rolls
Preparation time: 1 h 45 min

INGREDIENTS
230 ml warm milk
60 ml warm water
2 tbs sugar
7 g dried yeast
1 tbs plain flour
435 g strong white flour
4 tbs butter, softened
1 egg
1 tsp salt
3 tbs butter, melted
Sea salt

EQUIPMENT
Large jar
Mixing bowl
Mixer with a dough hook
Pastry brush
Heavy-based (or cast-iron)
baking dish

Traditional Parker House rolls hail from the Parker House Hotel in Boston. As legend would have it, a pastry chef had a fight with an unreasonable customer, and in a fit of pique threw some unfinished rolls into the oven. To his surprise, the buttery rolls that emerged proved a hit, and have been enjoyed since 1870 as an accompaniment to seafood towers and rich soups. Make sure you serve them warm to enjoy them at their best.

In a jar, mix 230 ml of warm milk, 60 ml of warm water, 2 tbs of sugar, 7 g of dried yeast and 1 tbs of plain flour. Put on the lid, and shake to mix.

Take a mixing bowl and put in 435 g of strong white flour, 4 tbs of softened butter, one egg and 1 tsp of salt. Cover and allow the yeast to activate at room temperate for five minutes. Now open your jar and inspect the yeast mix. If it has activated it will have grown in size and started to bubble and froth. If it has not activated, wait a little longer. If nothing happens, start again.

Pour the yeast mix into the bowl, and affix the dough hook to your mixer. Mix the dough on a high setting for at least ten minutes until it's smooth, stretchy and elastic. Remove the bowl from the mixer and cover it with a cloth, and allow the dough to prove at room temperature for around an hour. It should double in size.

Pour the dough onto a floured worktop, and knock some air out with your knuckles. Divide the dough into four equal parts, then roll out each quarter into a 20 cm × 30 cm rectangle. Brush the dough with melted butter and fold each rectangle in half along its horizontal axis, so you now have four 10 cm × 30 cm rectangles with butter in the middle.

Square the edges with a knife, and cut each of your four rectangles into four equal pieces. You will now have 16 equal rectangles that measure roughly 10 cm × 7 cm each.

Preheat your oven to 180°C. Place each folded rectangle into a heavy-based or cast-iron baking dish making sure they are snug enough to cuddle when they rise. Allow them to prove for 20 minutes. You will now have what looks like one loaf with 16 ridges.

Bake the rolls in the oven for 20 minutes, until they have risen, and the top is lovely and evenly golden. Remove from the oven, brush with more melted butter, flake on some sea salt, and serve warm.

Karjalanpiirakka with munavoi (Karalian pie with egg butter)

Serves: 16 rolls
Preparation time: 1 h 45 min

For the filling:
200 g short-grain rice (arborio)
250 g water
500 ml full fat milk
1 pinch salt

For the crust:
200 g rye flour
100 g plain flour (or mix of spelt and plain)
1 pinch salt
50 g butter
For the topping:
3 eggs
Chives, chopped
100 g good-quality butter
Salt and pepper

EQUIPMENT
Large saucepan
Two mixing bowls
Rolling pin
2 baking trays

Originating in Karelia, a large territory divided between Finland and Russia, this Nordic breakfast or snack is made from a rye crust with a rice filling and topped with munavoi, a buttery egg spread. The name karjalanpiirakka ("Karelian canoe") alludes to the boat-like shape of this baked treat. The rye crust is folded then crinkled around the rice filling, and bakeries are known to devise their own spin on the design. As an old Finnish proverb claims, each karjalanpiirakka looks like its maker.

Start by making the rice porridge filling. You can do this the night before to ensure it's completely cold before using.

In a saucepan combine 200 g of short-grain rice and 250 g of water. Bring this to a boil then let it simmer until all the water is absorbed. Add 500 ml of full-fat milk, season with salt and pepper, bring to a boil, then turn down to low heat and simmer, stirring occasionally until all the milk has been absorbed and the rice has the consistency of rice pudding. Then allow it to cool until completely cold.

Preheat the oven to 220°C. In a clean mixing bowl combine 200 g of rye flour, 100 g of plain flour, 150 ml of water and a pinch of salt. Knead together until you get a dry dough, adjusting with extra water or flour as required. The dough should be dry but not flaky, and should not crack when rolled out. Shape the dough into a long sausage-like shape with a diameter of around 5 cm, then slice it into rondelles 1.5 cm thick, like large dough coins.

On a well rye-floured countertop roll out each dough rondelle with a rolling pin. Take your time rolling the dough into thin pancakes about the size of a medium-sized hand.

Spoon roughly equal amounts of the rice mixture into the middle of the dough pancakes, about 1.5 cm from the edge, then fold over the dough, crinkling with your thumb and index finger to create a wavy ridge around the pie.

Place the pies on baking trays, and bake for 15 minutes. Melt 50 g of butter and brush this onto the pies with a pastry brush.

Now prepare the topping by hard boiling three eggs for nine minutes. When ready, peel, cool and chop thinly. Combine the chopped eggs with 100 g of good-quality butter until you have a chunky spread. Add salt and pepper to taste.

To serve, lather a generous layer of the spread onto each pie and garnish with chopped chives.

Cramique

Serves: 2 loaves
Preparation time: 1 h 45 min

INGREDIENTS
220 g currants or raisins
25 g dried yeast
320 ml full fat milk
500 g plain flour
45 g caster sugar
1 pinch salt
2 eggs
100 g softened butter
100g pearl sugar (sugar nibs)

EQUIPMENT
Large jar or jug
Small bowl
Mixer with a dough hook (food mixer recommended)
Mixing bowl
Parchment paper
2 brioche or standard loaf tins

The cramique, or kramiek in Flemish, hails from Belgium where it is eaten either for breakfast, the goûtez (afternoon snack), or even at Christmas dinner, slightly toasted with foie gras. While a traditional brioche is slightly savoury, a cramique is unequivocally sweet, with a slightly denser crumb. Some early recipes include corinthian raisins (currants) but standard raisins are a juicier substitute. This classic recipe uses raisins softened in water – or soak them in rum for a boozy alternative. Smother in butter to serve and use leftovers for a bread-and-butter pudding.

Soften the dried currants or raisins in a bowl of lukewarm water.

Activate 25 g of dry yeast by combining 50 ml of warm milk, 50 g of flour and 25 g of caster sugar in a large jar or bowl. Mix, cover and let sit at room temperature for 15 minutes. When ready you should notice some slight bubbling on the surface and a mild yeasty smell. If the mix has not moved, wait another ten minutes.

Place the remaining 450 g of flour, a generous pinch of salt and the remaining 20 g of caster sugar into the mix, carving out a little well in the centre. Add a full egg and an additional egg yolk (preserving the egg white in a small bowl to glaze the cramique later) and 270 ml of full fat milk.

Pour the activated yeast mixture over the ingredients and start to mix the dough on a low-to-medium setting for a good ten minutes, until all the ingredients are well combined and you have a wet, yellow dough.

Divide 100 g of softened butter into two little clumps. The butter should be so soft that you can stick your finger into it with little resistance. Add one clump of butter to the dough and mix, then the second, and mix for a good ten minutes on a medium setting until the dough is smooth, soft and shiny.

Remove the softened currants or raisins from the water, and dry with a paper towel. Add 220 g of plumped raisins or currants and 50 g of pearl sugar to the dough mixture. Mix the dough on the lowest setting for a minute or two.

Remove the dough from the mixer and place it in a clean mixing bowl, and cover with a tea towel for 45 minutes to an hour, until the dough has risen by half its size. The dough is now ready to be shaped and placed into baking tins for final proving.

Pour the dough out onto a floured worktop and knock it down with your knuckles gently. To shape the dough, pinch a corner and pull

it towards the centre, working your way around, starting from the north, then west, south and east. Flip the dough over and shape it into a ball by turning the dough with the palm of your hand on the worktop.

Place some parchment paper in two brioche or loaf tins, and tip in the dough. Allow it to prove for another 45 minutes at room temperature, until it has almost doubled in size. Brush on beaten egg white for glaze, and scatter the remaining 50 g of pearl sugar over the loaves.

Preheat the oven to 200°C. Bake for ten minutes at 200°C, then turn down to 170°C and bake for another 25–30 minutes. When the cramique is ready it should be a beautiful golden colour, and sound hollow when lightly tapped.

Rest the loaves for five minutes before serving.

Egg Cocktails

Prairie Oyster

Serves: 1 cocktail
Preparation time: 5 min

INGREDIENTS
1 egg yolk
Vinegar
1 tsp worcestershire sauce
1 tsp tomato ketchup
Black pepper

EQUIPMENT
Shaker
Lowball glass

There are a surprising number of versions for the prairie oyster, but all include an egg, and most a dash or more of worcestershire sauce. This recipe is taken from *The Savoy Cocktail Book,* and while P. G. Wodehouse's Jeeves might not agree with a teaspoon of ketchup, it works a treat.

Carefully separate the yolk from the white of an egg, making sure not to break the yolk. Place the yolk in a lowball glass. In a shaker combine two dashes of vinegar, 1 tsp of worcestershire sauce, 1 tsp of tomato ketchup and a dash of black pepper. Shake with ice, and pour over the egg. Drink down in one go.

Pisco Sour

Serves: 1 cocktail
Preparation time: 5 min

INGREDIENTS
50 ml pisco
20 ml lime juice
15 ml simple syrup (1:1 water
and sugar)
1 egg white
Ice cubes
3 drops Angostura bitters

EQUIPMENT
Shaker
Coupe glass

Both Chile and Peru claim the pisco sour as their national drink—
and it's not difficult to see why. This cocktail is light, perfectly bal-
anced, not too sweet, and will give you a funny frothy moustache if
imbibed too enthusiastically. Its preparation requires the pur-
chase of a bottle of pisco—Peruvian or Chilean brandy—not always
cheap or easy to find, so you might consider it for a special occa-
sion. If you want some canapés with your cocktails, try Devilled
Eggs (p 166).

Chill a glass with cubed or crushed ice.

Put 50 ml of pisco, 20 ml of lime juice, 15 ml of simple syrup and one
egg white into a shaker, and dry shake vigorously to emulsify the
egg white. Then add ice cubes, and shake again.

Empty the ice from the chilled glass and pour your sour. It should
be smooth, thick and frothy.

Garnish with three drops of Angostura bitters before serving.

Eggnog

Serves: 6 cocktails
Preparation time: 20 min

INGREDIENTS
3 eggs, separated
75 g caster sugar
250 ml whole milk
200 ml double cream
175 ml dark rum
1 nutmeg
Grated cinnamon (optional)

EQUIPMENT
2 mixing bowls
Electric whisk
Microplane (or grater)
Lowball glasses

A classic North American cocktail, eggnog is an intrinsic part of the season to be jolly. It can also be found at Christmas parties in different permutations further south, be it coquito with coconut milk in Puerto Rico, or ponche crema with a touch of lemon in Venezuela. Aficionados of the spiced and spiked egg-based cocktail will say you can't pass judgement until you've tried the real deal — so this recipe is for the classic short cocktail. Eggnog can be served hot or cold, but whichever you choose, make sure your eggs are fresh.

Separate three eggs, keeping both the yolks and whites. In a mixing bowl, combine the egg yolks with 50 g of caster sugar. Whisk until the ingredients have combined, then stir in 250 ml of whole milk, 200 ml of double cream, 175 ml of dark rum and a single grate of nutmeg. Chill in the fridge until ready to serve.

Place the three egg whites in another mixing bowl, and start whisking. Gradually add 25 g of sugar, and continue to whisk until the egg whites start to firm and ribbon. Remove the chilled, boozy, spiced egg mix from the fridge, and fold in the egg whites until you have a light and airy eggnog cocktail. Pour into lowball glasses, and serve with a grate of nutmeg or cinnamon.

Flip

Serves: 1 cocktail
Preparation time: 10 min

INGREDIENTS
1 egg
½ tbs icing sugar
60 ml rum, brandy, port,
sherry or whisky
1 nutmeg

EQUIPMENT
Shaker
Coupe glass

The flip dates back to the 1600s, and is thought to be one of the very first mixed cocktails. Celebrated in William Congreve's *Love for Love* in 1695: "We're merry folks, we sailors: we han't much to care for. Thus we live at sea; eat biscuit, and drink flip." Drinking while at sea may no longer be in vogue, but flips are still very much part of many a cocktail connoisseur's repertoire. The recipe has thankfully evolved from old ale to any fortified spirit, so if you have an egg, you can likely make a flip. In cold weather, go ahead and add a dash of ginger.

Put one egg, ½ tbs of icing sugar, and 60 ml of your preferred spirit into a shaker. Shake well, and strain into a medium-sized glass. Grate a little nutmeg on top.

Coquito

Serves: 1 batch (15–20 portions)
Preparation time: 40 min

INGREDIENTS
2 large egg yolks
1 can evaporated milk
1 can coconut milk
1 can sweetened condensed
milk
1 can cream of coconut
1 vanilla pod, split and seeded
2 whole cinnamon sticks
2 cups rum
1 dash brandy (optional)

EQUIPMENT
Whisk or blender
Large bowl or jug
Pot

Coquito, meaning 'little coconut' in Spanish, is Puerto Rico's most famous festive beverage. This creamy, boozy coconut rum drink is best served very cold in a shot glass, and enjoyed at the end of a meal. There is much debate regarding the addition of an egg, as well as rum-soaked raisins. This recipe includes the egg but abstains on the raisins. Make a batch the night before serving to let the flavour steep, and enjoy with dessert or as a digestif at Christmas — or any time, really.

Whisk or blend two egg yolks, one can of evaporated milk, one can of coconut milk, one can of sweetened condensed milk and one can of cream of coconut. Transfer this mixture to a pot and add one vanilla pod, split and seeded, and two cinnamon sticks. Bring to a simmer, then remove from the heat and allow to cool and infuse for half an hour. Remove the cinnamon sticks and the vanilla pod, and pour the mixture into a large bowl or jug. Mix in two cups of rum and an optional dash of brandy before refrigerating. Serve very cold.

Tom and Jerry

Serves: 1 cocktail
Preparation time: 5 min

INGREDIENTS
1 egg
30 ml Jamaican rum
1 tbs powdered sugar
30 ml brandy

EQUIPMENT
Whisk or mixer
Two bowls
Glass or china mug

This cosy cocktail is a lighter alternative to eggnog. It takes a bit of work to beat the egg yolks and whites separately, but it'll yield a lovely, frothy texture.

Separate the egg yolks from the whites (one egg per person) and place in two different bowls. Whisk the whites to stiff peaks and beat the yolks with the rum and brandy. Gently fold the whites into the yolk mixture then add to a stem glass or mug. Top up with a little boiling water or hot milk and sprinkle with grated nutmeg.

Red Eye

Serves: 1 cocktail
Preparation time: 5 min

INGREDIENTS
Lager beer
Tomato juice
1 egg

EQUIPMENT
Pint glass

This breakfast cocktail was popularised by the 1988 film *Cocktail*, in which aspiring bartender Brian Flanagan (Tom Cruise) is asked by Doug Coughlin (Bryan Brown) if he has ever mixed a red eye. He hasn't. Unlike the version in the film, it's advisable to serve an aspirin separately, not in the actual drink.

Pour lager beer and tomato juice into a pint glass in a ratio of 2:1. Crack a whole egg in, stir gently.

Clover Club

Serves: 1 cocktail
Preparation time: 5 min

INGREDIENTS
3 vanilla pods
½ lemon or 1 lime, juiced
1 egg white
Grenadine
Dry gin

EQUIPMENT
Shaker
Cocktail glass

This foamy, pre-Prohibition classic heralding from Philadelphia had all but disappeared before re-emerging this century on the roster of the eponymous cocktail bar in Brooklyn. Always gin-based, some recipes use raspberry syrup while others suggest grenadine. For extra kick add a dash of dry vermouth and make sure you shake vigorously.

Place all the ingredients in a cocktail shaker, with the grenadine and dry gin in a ratio of 1:3. Shake vigorously and strain into a medium-sized glass.

Eggcessories

The bewildering array of implements and utensils designed to prepare seemingly simple eggs all but rivals the multitude of ways they can be cooked. In fine human fashion, we have devised tools that can shape, protect and gently lift the egg, but also dreadful objects of torture that allow us to beat, slice and decapitate it. Whatever its intent, each tool is aesthetically and practically fascinating in its own right.

PHOTOGRAPHY
Robin Broadbent

Slicer

Before the jostling mess of egg mayonnaise or smashed avocado, there was a time
when the self-respecting sandwich maker insisted on using the taught wires of an egg slicer.
What better way to create cross-sections of picture-perfect yolk and whites?

Tongs

You may be tempted to pluck that newly boiled egg right out of the water.
But chances are the water is boiling, and that egg is hot. Luckily, tongs have been
designed to save you from yourself.

Rings

Once cracked, a fresh egg's white tends not to be so unruly as to run from the shell to all corners of the pan. And without a ring, like snowflakes, no two fried eggs are alike. But for the aesthete and lovers of order, a ring provides reassuring consistency.

Topper

In an appetizing demonstration of Hooke's law of 1676, an egg topper uses the scientific principle of elastic energy to jiggle the atoms and bring force upon the crown of an egg to shatter it, so the fragments can be removed, and the egg merrily devoured.

Boiled-Egg Tongs

Few things match the simplicity of egg tongs for safely placing a fresh egg into roiling waters. Extrication is a doddle, and marks an end to fruitless, fingertip-scalding chases between glinting spoon and the evasive tumbling egg. What is held fast is soonest eaten.

Whisk

Its predecessor was bound twigs. Today, the whisk takes many forms. A proper egg whisk
will have at least eight rings of steel. Flexible but strong, the balloon shape reaches every part
of a mixing bowl, and the more the rings, the more the air in the meringue.

Timer

Sand was just fine for the longest time. Silently, slowly counting eggs to the perfect set.
Then kitchens became noisier, and egg-timing followed suit. Designed and shaped for the task,
today's timers twist then tick, then toll their tiny bell above the din.

Spatula

What is that imperceptible space between frying egg and frying pan? Whatever it is called,
it is the spatula's job to move effortlessly within it, leaving no trace on either egg or pan, and remove
what is sunny, or — in one turn — begin the transition of yolk from easy to hard.

Cup

A collector, admirer and devotee of the eggcup is more properly categorised as a pocillovist.
The term was reputedly coined by the doyenne of the sport, Mrs Winnie Freeman, author of 1984's
definitive, and difficult to find, *Collecting Egg Cups: An Introduction to Pocillovy.*

Cutter

Fancy Victorian egg openers, which pierced the shell of the recently boiled egg, looked like instruments of torture. That was until 1907, when the Austro-Hungarian Ferdinand Fleischmann tucked the tool's vicious teeth inside a steel halo, to be revealed by scissor grips — thus inventing a friendlier face of decapitation.

Index

Acknowledgements

Food is the surely world's most universal subject. It brings us together regardless of race, gender, age, wealth, status or belief. Since its birth in 2012 *The Gourmand* has been a truly collaborative project, and this book is no exception. Whilst it was conceived by ourselves, many people have worked tirelessly to realise it, and to them we are truly indebted.

We would first like to thank our publisher, specifically Marlene Taschen, who, from our very first conversation, believed in our vision and whose insights and ideas have been so helpful. Also Sarah Southard, our editor at TASCHEN, whose experience and patience have made a complex process efficient and enjoyable, and Frank Goerhardt and Thomas Grell, whose work on the production and reproduction have created the beautiful, tactile volume you hold in your hands.

Among the team at *The Gourmand* our thanks must go to Didi Ronan, whose energy, expertise and friendship helped us form this idea into a reality. To Ananda Pellerin, our editor with whom we have worked for many years and whose exacting standards and attention to detail have helped shape the tone for which *The Gourmand* is known. To Rich Cutler, our copy editor who is always so precise, patient and kind. To Kate Suitor, our picture editor and producer, who invested so much time in this project and will probably never look at an egg again, and to Adriana Cavena, who assisted greatly with both the design and art direction of the book.

Our thanks must also go to Luke Ingram, our literary agent, who has always held our best interests at heart, and whose expertise and insight has proved invaluable, and to the wider team at The Wylie Agency, especially Maïa Hruska, for her tireless work behind the scenes.

Special thanks must also go to Ruth Reichl, who so kindly penned the foreword and who stands as an exception to the rule that you must never work with your heroes. And to Jennifer Higgie, with whom we so love working, whose wonderful introduction elevated this book so much.

We would also like to extend our thanks to the photographers with whom we have collaborated for many years and whose work has helped form *The Gourmand*'s unique visual style. Specifically Bobby Doherty, whose bold and iconic egg adorns the cover, Matthieu Lavanchy, who expertly captured our recipes with beautiful spontaneity, Gustav Almestål, whose emotive and visceral imagery illustrates many of the essays, and to Marius Hansen, who brought his refined minimalism to our subjects.

Also Iain Graham, who developed and cooked the recipes for us with utmost professionalism, and Hella Keck, whose sets brought so much elegance and humour to their images.

We would also like to thank writers Hannah Lack, Patrick Baglee and Kadish Morris who willingly covered such varied topics with great intelligence and ease.

We must also thank Gunnar Vilhjálmsson at type foundry Universal Thirst for working with us on the beautiful set of bespoke fonts used throughout this book, cover guru David Pearson, who has been so helpful discussing the minutiae of the design, and Simon Esterson, who has always supported the work that we do.

Finally we would like to thank all of our friends and family who who have helped us with this special project. We have been blessed to have met and worked with many wonderful, clever and funny people, all of whom have brought something unique, lasting and tasty to the table.

David Lane and **Marina Tweed**,
The Gourmand

OPPOSITE **Gustav Almestål**, *Untitled*, 2021
FOLLOWING **Jenny Van Sommers** *Unititled*, 2015, set design **Rachel Thomas**
From "As Thick as Ketchup", *The Gourmand*, Issue 06, 2015

Editorial and Creative Direction
David Lane and **Marina Tweed**

Editorial Director
Didi Ronan

Editor
Ananda Pellerin

Sub Editor
Rich Cutler

Design & Art Direction
David Lane and **Adriana Caneva**
at **Lane & Associates**

Picture Editor
Kate Suiter

Writers
**Patrick Baglee, Hannah Lack, Kadish Morris,
Ananda Pellerin, Didi Ronan**

Recipe photography
Matthieu Lavanchy

Recipe set design
Hella Keck

Cover photography
Bobby Doherty

Food Stylist
Jamie Kimm

Recipe development and food styling
Iain Graham

Contributing photographers
**Gustav Almestål, Robin Broadbent,
Bobby Doherty, Marius W Hansen**

Each and every TASCHEN book plants a seed!
TASCHEN is a carbon neutral publisher.
Each year, we offset our annual carbon
emissions with carbon credits at the Instituto
Terra, a reforestation program in Minas Gerais,
Brazil, founded by Lélia and Sebastião Salgado.
To find out more about this ecological partnership,
please check: www.taschen.com/zerocarbon
Inspiration: unlimited. Carbon footprint: zero.

To stay informed about TASCHEN and our
upcoming titles, please subscribe to our
free magazine at www.taschen.com/magazine,
follow us on Instagram and Facebook, or
e-mail your questions to contact@taschen.com.

© 2022 TASCHEN GmbH
Hohenzollernring 53, D-50672 Köln
www.taschen.com

ISBN 978-3-8365-8589-7
Printed in Italy

"My brother thinks he's a chicken —
we don't talk him out of
it because we need the eggs"

JULIUS HENRY "GROUCHO" MARX